P9-DMG-816

WITHDRAWN

BRUNSWICK COUNTY LIBRARY
109 W. MOORE STREET
SOUTHPORT NC 28461

DISCOVERING
OIL PAINTING

HICKMANS

DISCOVERING
OIL PAINTING

George Cherepov

BRUNSWICK COUNTY LIBRARY
109 W. MOORE STREET
SOUTHPORT NC 28461

WATSON-GUPTILL PUBLICATIONS, NEW YORK
PITMAN PUBLISHING, LONDON

First published 1971 in the United States and Canada by Watson-Guptill Publications,
a division of Billboard Publications, Inc.,
1515 Broadway, New York, N.Y. 10036

Published in Great Britain 1974 by Pitman Publishing, Ltd.,
39 Parker Street, Kingsway, London WC2B 5PB
ISBN 0-273-00829-3

Library of Congress Catalog Card Number: 73-137423
ISBN 0-8230-1345-6

All rights reserved. No part of this publication may be
reproduced or used in any form or by any means—graphic,
electronic, or mechanical, including photocopying, recording,
taping, or information storage and retrieval systems—without
written permission of the publishers.

Manufactured in U.S.A.

First Printing, 1971
Second Printing, 1971
Third Printing, 1974
Fourth Printing, 1976
Fifth Printing, 1977

Foreword

At a very early age, George Cherepov gave promise of being the broad and versatile artist he is today. He was born in Lithuania and received his early art training in Riga, Latvia. He traveled extensively throughout Europe, studying with leading artists and teachers, and today he is equally proficient in portraiture, still life, seascape, or landscape in whatever medium he uses, whether it be charcoal, pencil, pastels, watercolors, or oils.

Because of his intimate knowledge of color and his true rendering of nature's palette, Cherepov's paintings are in great demand. They have won him numerous laurels and prizes from such art associations as Allied Artists of America, Academic Artists, American Artists' Professional League, the Hudson Valley Art Association, and many others. He has had many one-man exhibitions, both in the United States and abroad.

The reader will find a very broad approach to painting in this book, suited to the needs of both the art student and the mature artist. The author is able to convey the basic as well as the advanced aspects of his subject in a clear text and illuminating step-by-step color demonstrations which develop the painting technique from the first to the final stage.

I am pleased to recommend this informative and richly illustrated book to student and practitioner alike, and to commend the author on an excellent presentation of the fascinating elements and techniques of oil painting.

Wendel Clinedinst, President,
Allied Artists of America

Acknowledgments

I would like to express my deepest appreciation to my wife Klara and my daughter Gisela for their great help in getting the material for this book together, and for their infinite patience.

Contents

Color Plates

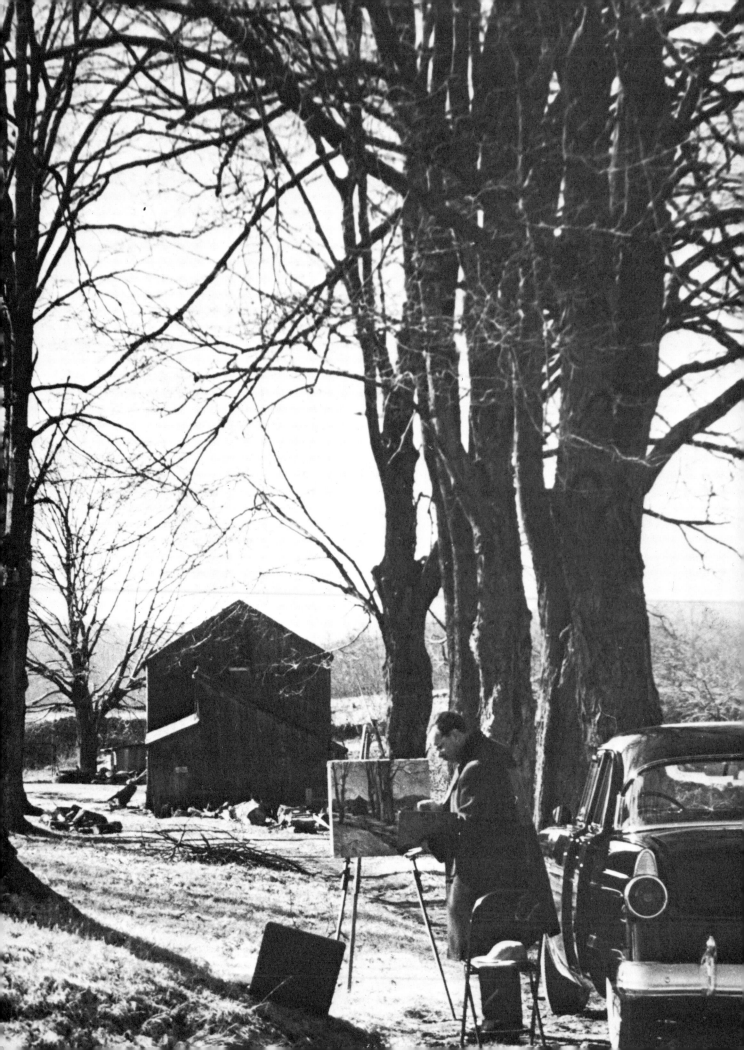

PART ONE: OIL PAINTING MATERIALS AND HOW TO USE THEM

My primary concern in this section is to introduce you to the essential materials and equipment necessary to begin painting in oils, and at the same time to spare you the confusion and expense of purchasing superfluous materials. It is of the utmost importance that you learn how to use these materials properly from the very beginning. Your equipment should not distract you from your work, but rather help you accomplish it. The art of oil painting is difficult enough to master, without complications.

1. Materials and Equipment

If you have never painted in oils, I advise you to keep your equipment and colors to a minimum. The following list specifies all the essentials you need to begin:

A List of Essentials

Paintbox (standard size, 12" x 16")

Easel

Stool

Wooden palette (to fit into the standard size, 12" x 16", paintbox)

Palette knife (trowel type)

Palette cups (two, for medium and turpentine)

Bottle of linseed oil (purified)

Bottle of turpentine (rectified)

Vine charcoal (soft, thin, for sketching)

Canvas boards (12" x 16", to fit into paintbox)

Painter at Work. *Painting outdoors requires the necessary equipment. The folding field easel you see here supports a 20" x 24" canvas; a wooden palette, a paintbox, and a folding chair complete the setup. The standing position enables me to control my painting by stepping back, but the chair is helpful for working on details and for taking an occasional rest. The painting is* Country Road, *shown in a step-by-step color demonstration, pp. 79-81.*

Brushes (No. 10, long, flat bristle; No. 7, long, flat bristle; No. 7, long, round sable)

Oil colors (see list of basic nine in Chapter 8, *Color*)

Art supply stores offer a wide selection of all the materials listed above. Perhaps the following information will help you make the right choice.

Paintbox

A paintbox serves two functions: it keeps your paints, brushes, and palette in proper order and condition; and it serves as a portable studio for outdoor sketching.

Fig. 1 shows an open paintbox. Several compartments in the bottom half are designed to hold tubes of paint, brushes, and two bottles. They also offer a place for cups, palette knives, and other equipment. The contents are all held firmly in place by the palette, which is placed on top. When the box is closed, the palette fits securely between the cover of the box and its bottom, and so keeps everything in order. The cover of the paintbox has grooves on both sides to hold 12" x 16" sketching boards or canvas panels. Beginners sometimes push the palette through these grooves. It is not necessary to do so, for even if fresh paint has been left on the palette, there is enough space provided to keep it from touching the sketchboard.

A paintbox is very convenient for outdoor sketching. Everything you need is neatly contained in one easy-to-carry box. I have met students who carry their equipment in baskets, bags, and even suitcases. If you resort to such haphazard containers, you will waste time and effort finding the right item at the right moment.

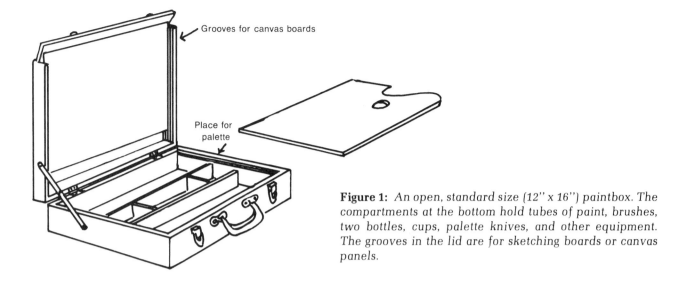

Grooves for canvas boards

Place for palette

Figure 1: *An open, standard size (12" x 16") paintbox. The compartments at the bottom hold tubes of paint, brushes, two bottles, cups, palette knives, and other equipment. The grooves in the lid are for sketching boards or canvas panels.*

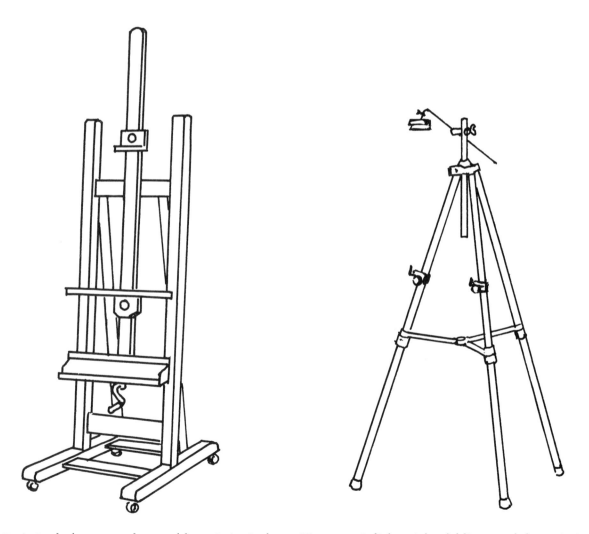

Figure 2: *A sturdy, heavy wooden easel for painting in the studio.*

Figure 3: *A lightweight, folding easel for painting outdoors.*

If bad weather does not allow you to paint outdoors, you can make yourself comfortable in your car. Just open your paintbox and in no time at all you will be ready to start sketching. The cover of the paintbox will serve as an easel, the bottom as a table on which to rest your palette. After completing the sketch, you can simply close the box, without being concerned that the sketch will be damaged.

You will have quite a few different models of paintboxes to choose from at the art supply store. A variety of wooden and metal boxes, as well as combination boxes which have attached legs and which double as easels, is usually available. Prices vary considerably according to model, wood, and finish. My advise is to purchase a metal box. You will find it inexpensive, lightweight, and easy to carry and to keep clean. As for fancy paintboxes with folding legs — after seeing students struggle with screws and bolts to set them up, I hesitate to recommend them.

Easel

It is not easy to decide what kind of an easel to select. Basically, two kinds of easels are made for two different purposes: sturdy, heavy wooden easels to studio painting (Fig. 2), and lightweight folding easels — either wood or metal — for outdoor painting (Fig. 3). If you have room enough in your work area, an upright wooden studio easel is really best for indoor painting. Its sturdy construction can support a large canvas, and it can be easily adjusted to accommodate and hold the canvas in the desired position.

For outdoor painting, where you often have to carry equipment for some distance, a lightweight folding easel is desirable. It should have both lightness and stability. Most of my students prefer the aluminum model because it combines these qualities. Naturally, such a folding easel can also be used indoors.

The opened easel provides a convenient place to rest the paintbox — on the three bars between the three legs. So placed, the paintbox increases the stability of the easel with its own weight. You can easily reach into the box for anything you need. Also, the palette is right in front of you.

Stool

It is preferable to paint standing up so that you can step back and see your work from a distance — a perspective which helps you control space and color relationships as you paint. If you choose to paint in a

Figure 4: *A high stool for painting in the studio.*

Figure 5: *A lightweight, folding stool for painting outdoors.*

Figure 6: *A folding chair for maximum comfort when painting outdoors.*

sitting position, however, it is important that you have the proper stool.

For indoor painting, use a high stool which will allow you to maintain the same eye level as your subject, whether you sit or stand (Fig. 4). An adjustable stool is best. Correct stool height will help you control form and perspective in your painting.

For outdoor painting, a lightweight folding stool is more practical, especially if you have far to walk and must carry all your equipment (Fig. 5). But if you can reach your painting site by car, then bring a folding chair (Fig. 6). A folding chair is higher and much more comfortable than a stool. Sitting cramped on a stool will only add to your painting problems.

Palette

A 12" x 16" wooden palette which will fit into your paintbox is the best choice. If the wood is unfinished, you must prepare its surface several days before you use it. To finish the wood of your palette, apply two or three coats of linseed oil generously on both sides, allowing two days between applications for the oil to penetrate the wood thoroughly. Before you use the palette, wipe off excess oil with a soft rag.

Students are often attracted to paper palettes because, unlike wooden palettes which must be cleaned, paper is disposable. Unfortunately, palette pads have two distinct disadvantages: they are not as firm as wood and cannot hold the contents of your box in place; and if you use them in outdoor painting, the wind may tear loose a sheet — a hazard which can very much interfere with your work. And, after all, cleaning a wooden palette is not such a big problem if you follow the directions given in Chapter 2, *Taking Care of Equipment*.

A large palette is convenient for studio work. A glass plate, lined underneath with white or gray paper or cardboard, or the smooth side of a piece of Masonite primed with oil, serve well as studio palettes. Such a palette can be kept in front of the easel on a small table.

The word *palette* has two meanings: it means the piece of equipment described above; but it is also the term used to describe a painter's choice of colors. The expression, "He has a brilliant palette" refers to an artist's choice of brilliant colors. The expression, "He works with a narrow, or limited, palette" means that he paints with only a few colors.

Palette Knife

A palette knife is used primarily to mix paint on the palette and to scrape off excess paint from the palette. A trowel shaped palette knife is best for these purposes. In addition, an assortment of palette knives of different sizes and shapes is used to apply paint to the canvas. Artists favoring the technique of palette knife painting are attracted to it by the brilliance of color which this flat application of paint achieves. The trowel shaped palette knife can be used in conjunction with brush technique to obtain different effects — for instance, to simulate the roughness of tree bark, or the shape and texture of rocks.

Medium

The material used to thin oil paint is called *medium*. Since tube oil paint is usually ground into a rather heavy paste, most painters add a medium to make it more workable. Medium gives paint a smoother texture and therefore makes it easier to apply to the canvas. A variety of mediums is available, but the one I'd like to suggest to beginners is the one most widely used by experienced painters, purified linseed oil mixed half and half with rectified gum turpentine.

The composition of this medium is organically related to the paint, which is itself ground with linseed oil. Linseed oil alone is too fat (too rich) and must be diluted with turpentine. On the other hand, turpentine, being primarily a solvent, is not in itself suitable as a medium. Turpentine takes away the intensity of color and the permanence of the paint. Mixed together, the two ingredients do the job. Avoid the cheap turpentine sold in hardware stores for housepainting. Be sure to buy rectified gum turpentine.

Medium can influence the drying time of paint, and this drying process can have a significant effect on the quality and permanence of an oil painting. For example, adding a few drops of copal varnish to the medium will speed up the drying process. But to control the drying process, a painter must first understand it. Not only the medium, but also the primer and the amount of paint applied affect the drying process. A more extensive analysis of medium and how it relates to the drying process is dealt with in Chapter 9, *Technique*.

Cups

Two cups are usually attached to the right side of the palette: one to hold medium for thinning your paint; the other for turpentine to wash your brushes. To avoid spilling, do not fill the cups more than half way to the top.

Vine Charcoal

The first stage of an oil painting is often the charcoal sketch, worked directly on the canvas. To correct a mistake or make changes, lightly brush the charcoal off with a soft rag. Before you begin to paint, lightly spray the drawing with a fixative to isolate the charcoal from the paint and fix the drawing.

Canvas and Canvas Board

Your first sketches can be painted on canvas board. This material is not the most permanent surface, but it serves well for the purpose of study. Canvas boards (thin white canvas pasted onto cardboard) are widely sold and inexpensive. For this reason, students use them less hesitantly for experimental work than more expensive canvas. Often, fearful of spoiling a canvas, beginners apply their paint in a very timid manner when working on canvas.

As soon as the quality of your painting improves, you can discard canvas board and turn to better and more durable materials. A variety of supports for painting is on the market, including linen canvas, cotton canvas, wooden panels, and Masonite board. Linen canvas, pulled taut and tacked onto a wooden stretcher frame, is regarded as the best support for oil paintings. Linen canvases are available in a variety of grains (textures), from fine, smooth surfaces, to rough, heavily textured ones.

There is no longer any need to buy raw linen and prime it (coat it with white paint) yourself, since manufacturers today offer a great selection of primed canvases. The painter may make his choice according to his painting technique and style.

Brushes

There are basically two types of oil painting brushes: *bristle* and *sable*. Bristle brushes are made of hog's hair, sable brushes of hair from a sable pelt. Both come in long, short, flat, and round varieties. Stiff and sturdy, the bristle brush produces a more vigorous brushstroke, creating a variety of textures and a rich vibration of colors. Sable brushes are used for smoother strokes, to blend the colors to a finer surface. A painter makes his choice of brush to suit his style of painting. Better quality brushes last longer and are more satisfying to paint with.

There is a big temptation to take a clean brush for each new color you are mixing. I have seen painters with their hands full of dirty brushes, holding one in their mouth, and still reaching for a new one. Obviously, this habit will hinder rather than help your work.

The three brushes which I rely on most, and which I recommend to you, are these: a large (No. 10) long hair, flat bristle brush; a medium (No. 7) long hair, flat bristle brush; and a small (No. 7) long hair, round sable brush (Fig. 7). All brushes are numbered by size, from 1 through 12, small to large. Sable brushes, however, are made smaller than their bristle counterparts — a No. 7 sable is noticeably smaller than a No. 7 bristle.

In case you are puzzled, let me explain why I consider three brushes sufficient. I use the small (No. 7) sable first, to indicate space and to outline the objects. I then employ the large (No. 10) bristle to cover large areas of the canvas, and to distribute and establish the basic colors and their tonal relationships. The medium (No. 7) bristle, which is less important, is used for further adjustments and modifications of forms. Precise details are again defined with the small (No. 7) sable.

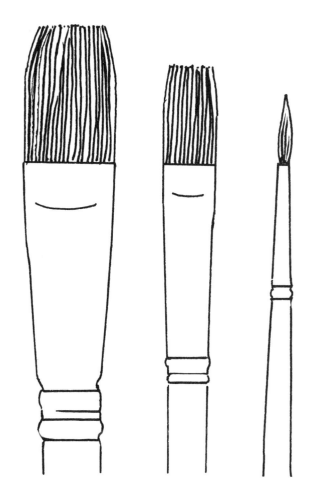

Figure 7: *Three basic brushes are (from left to right) a large (No. 10), long hair, flat bristle brush, a medium (No. 7), long hair, flat bristle brush, and a small (No. 7), long hair, round sable brush.*

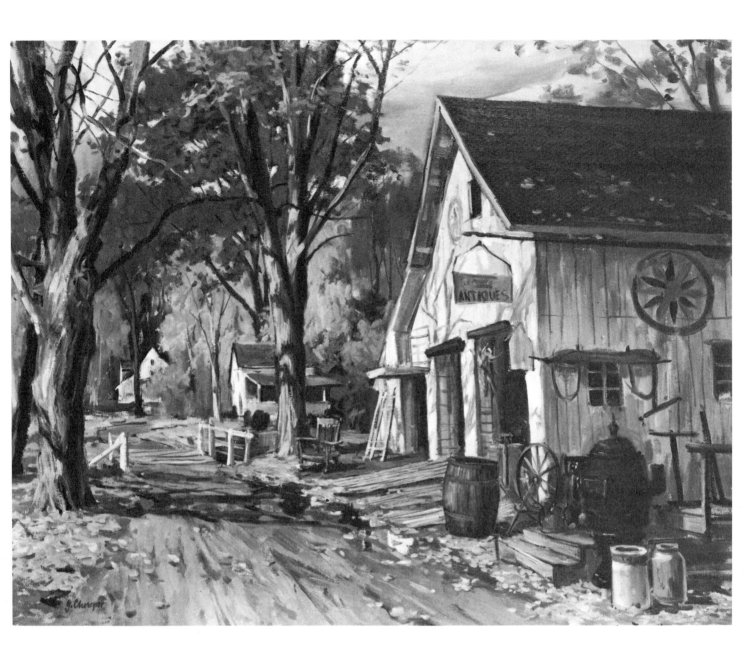

Autumn in New England, *30" x 36". Typical of the New England countryside is the presence of antique shops. I could not resist the desire to capture the nostalgic mood of this one. Sunlight, amplifying the color intensity of the foliage and the buildings, interplayed with shadows. To capture this relationship, I worked a great deal directly on the spot. Several interesting compositions could be made from this subject. For instance, you could eliminate the surrounding trees and paint only the large entrance of the barn, with the light playing on the antiques. When painting such motifs outdoors, fast-changing light limits the time and forces you to work fast. You have to make your decisions quickly. In these tense moments you will appreciate how important it is to have your equipment ready, in clean condition, so you can pick up brush, paint, or medium without having to look around for pliers to open a cover or having to warm up the cap of a tube of paint with a match in order to unscrew it!*

2. Taking Care of Equipment

Some readers — especially those who are impatient by nature — may regard these pages as unimportant. They would rather look for shortcuts and for "secrets" about how to paint a portrait, or about what color to use for flesh tones. Whatever their expectations, I must first emphasize the importance of keeping equipment in good order. What can be more discouraging, in a moment of high inspiration, than to be handicapped by stiff brushes, a messy palette, or a badly stretched canvas? By the time you have remedied the situation, your light has changed and your enthusiasm has waned.

You should not have to fight your equipment; it should be ready to serve you at the moment of inspiration. Therefore, it is in your own interest to maintain your tools properly. Pay special attention to the correct way of caring for your equipment now — at the very beginning. Once formed, bad habits are usually difficult to correct.

Cleaning the Palette

Your palette must be cleaned at the end of each working day. Remove all paint with a palette knife, wiping the knife on a paper towel. Then pour a little turpentine on the palette and wipe off its surface with an absorbent rag (old sheets serve best). Finally, rub a few drops of linseed oil into the wood to nourish and polish the surface.

If you want to preserve the unmixed paint on your palette for the next day's session, use a palette knife to transfer all clean paint onto another palette or clean board. Then remove and dispose of the mixed paints and clean the palette thoroughly with turpentine and a soft rag. Replace the clean, unmixed colors on the palette in the same order as they were before. These colors can be used again the next day.

If you know ahead of time that you will not be able to paint for a day or two, it is better to clean the palette completely, rather than to preserve the paint. If dried paint has accumulated on your palette, you can still save the palette by cleaning it with ordinary paint remover, sold in any paint or hardware store. (Carefully read the warning on the label; paint remover can harm your skin.) When the palette is thoroughly clean, treat the surface with linseed oil. Scraping off layer after layer of dried paint is a painstaking and time consuming job, so make it a habit to clean your palette each time you use it. Not only will the job of cleaning be much easier, but your palette will always be ready for your next painting session.

Handling Paint

The helpless statement, "I don't know how I got so messed up with paint — it always happens to me!" can be heard in any art class. The only solution to this elementary problem is to handle tubes of paint correctly from the very beginning.

Always squeeze the paint from the end of the tube onto the palette. Roll the end of the tube progressively forward as it empties. Close the tube tightly, making sure the thread is clean before you replace the cap.

Should you get paint on your fingers or on the handle of the brush, take the time to wipe it off immediately. By taking these elementary precautions, you can avoid getting paint all over everything.

Care of Brushes

While it is important to clean your palette, it is even more important to attend to your brushes after you finish painting for the day.

First, squeeze all paint from the brush onto absorbent paper. Wipe the bristles with a soft rag. Now the brush is free of paint, but the bristles are not yet clean. Wash the brush with soap in lukewarm (never

hot) water. Generously soap the brush and rub it vigorously in the palm of your hand, using a circular motion. Rinse under lukewarm, running water.

Repeat this operation several times until the bristles are completely clean and the soap lathers. Be very sure that you have removed all the paint that is buried deep down in the bristles. Now shape the brush with your thumb and forefinger and lay it flat to dry.

If you paint every day, or very frequently, you can save this work by placing the brushes in either kerosene or in liquid soap. A specially designed container is available for this procedure (Fig. 8). When you use this container, hang the brushes on the wire, making sure that the bristles do not touch the bottom. If you prefer, you may lay the brushes down flat (Fig. 9). Either method will preserve the shape of the brush.

Before you use a brush which has been suspended in liquid soap or kerosene, wipe it thoroughly dry with a cloth. If your brush has lost its shape and its bristles are pointing in all directions, you can reshape it when it is wet by wrapping it very tightly in newspaper and leaving it to dry.

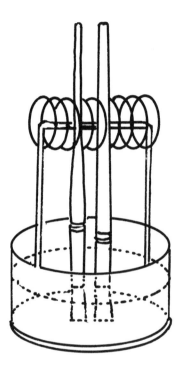

Figure 8: *A specially designed container for holding paintbrushes.*

Figure 9: *Brushes may also be laid down flat.*

(Right) Happy, *30" x 24". He was watching me paint a harbor scene, but seeing him, I was more inspired to paint this colorful sea-bound fellow than the whole harbor! This painting was done in a very short time with a large bristle brush in a direct, alla prima manner. A few characteristic details were indicated with a small sable brush. The rough texture of the brushstrokes and the absence of a background emphasize the model's rugged, weatherbeaten character. Collection Otto Wideman, Wangen, West Germany.*

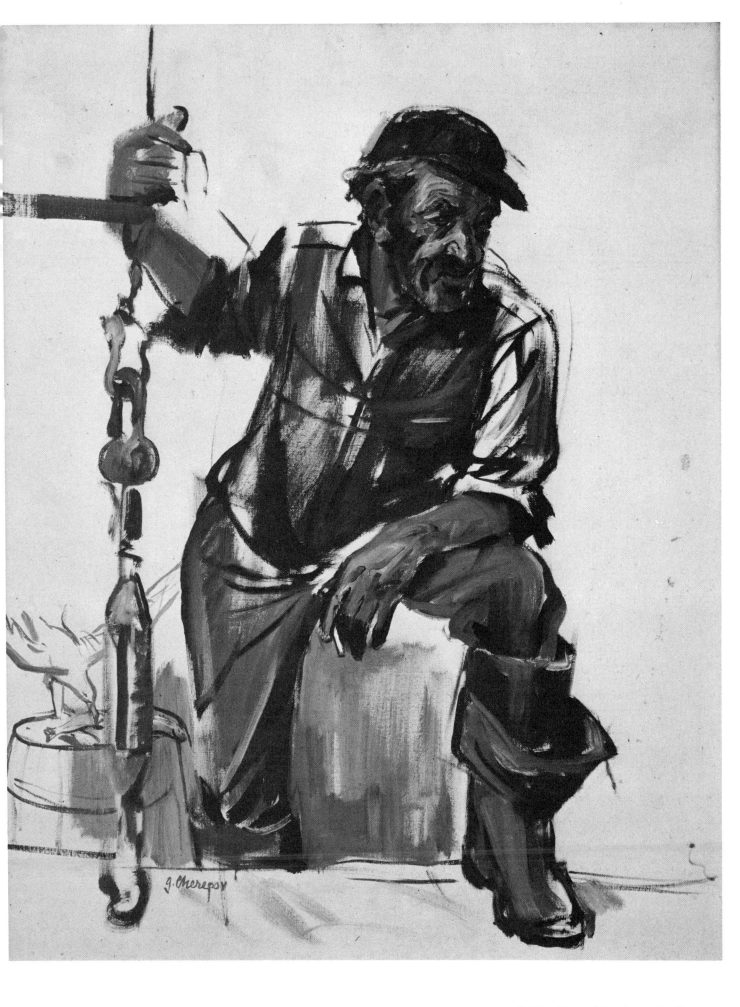

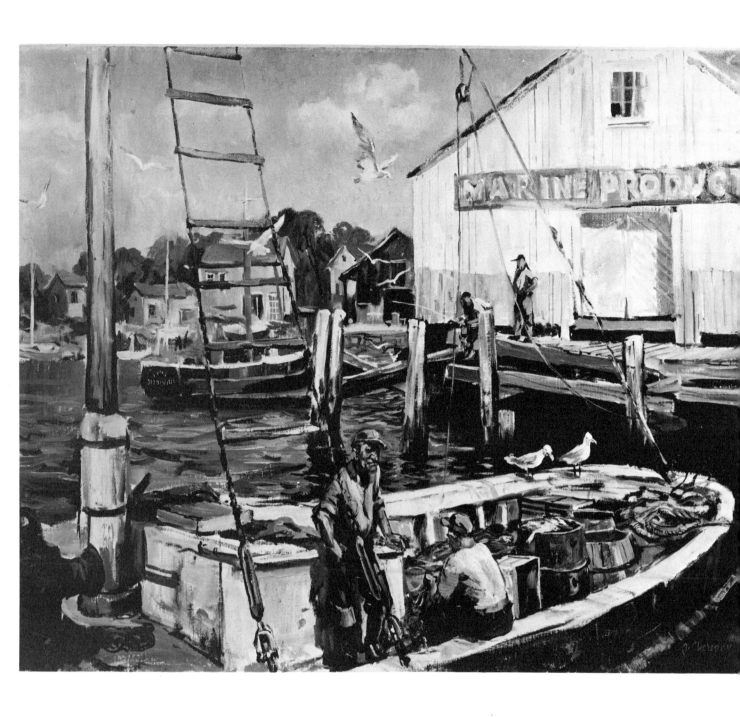

Stonington Harbor, *24" x 30". Everything in this old harbor is influenced by the sea: buildings, boats, poles, rusty barrels, seagulls, fisherman, the smell of salt water and fish. These things enrich the atmosphere of the sea and offer endless material for design in painting.*

3. Stretching a Canvas

The technique of stretching a canvas is explained in numerous manuals, but because it is very important not to miss a step — especially when working with a large canvas — I would like to go into the procedure in detail. Although many sizes of ready-stretched canvas are commercially available, the quality and grain of the linen may not satisfy you, or you may have a special size in mind which is unavailable. And, of course, stretching your own canvas has definite economic advantages.

Tools for Stretching a Canvas

In addition to the canvas itself, which comes in rolls, you will need the following things to stretch your own canvas:

Pair of special stretching pliers with flat lips

Narrow hammer and 1/2" tacks (you can also use a staple gun)

Wooden stretchers (with wedges or keys)

Wooden strips, called stretchers, are sold in inch sizes. I suggest that you get acquainted with these established, standard measurements and plan your painting accordingly. It is easier to find a suitable, ready-made frame for your work if you use standard sizes when you stretch your canvas. Using standard measurements also cuts down on waste of canvas.

Stretchers are designed not only to hold the canvas, but also to increase tension as it is needed. The stretcher frame gives tautness and resiliency to the canvas. Large canvases (30" x 36" and over) need a center reinforcement in the stretcher frame, consisting of a third short strip.

Stretching a Canvas, Step-by-Step

For our purpose here, let us use two wooden strips, or stretchers, 16" long, and two longer ones, 20" long.

Your finished stretcher frame will measure 16" x 20". See Fig. 10 for a step-by-step illustration.

(1) Assemble the stretchers to form a frame by gently hammering them together until the corners fit tightly into one another. Check the perpendicular sides with a triangle. The corners must form an exact 90° angle; then you can be sure that the painting will fit into a picture frame when you have finished.

(2) Unroll the canvas, primed side down, on a large table or on the floor. Make sure that it lies absolutely flat. Place the assembled stretcher frame on top of the canvas, and outline the needed size of the canvas with a pencil (Fig. 10A). An allowance of 1 1/2" for folding must be added to all four sides (in our case, with stretchers measuring 16" x 20", a piece of canvas 19" x 23" is required). When you are sure that you have established the correct size of your canvas, cut it out with a pair of scissors.

(3) Now we are ready to stretch the canvas. Hold the stretcher frame and the canvas together in an upright position and distribute the canvas equally over the frame. (Make sure the printed numbers on the stretchers, indicating their size, are on the back side and not covered from view by the canvas.) Fold a margin of canvas (the 1 1/2" margin you have left for this purpose) over the edge of the stretcher frame and place the first tack in the center of the strip (Fig. 10B).

(4) Turn the stretcher frame upside-down, pull the canvas tight, and place the second tack in the center of the opposite strip (Fig. 10C).

(5) Do the same on the two remaining sides (Fig. 10D). The four tacks, one in the center of each strip, create a diamond-shaped wrinkle on the canvas.

(6) The next step — a crucial one, which I want to emphasize — is to tighten the corners. Hold the stretcher frame, with the canvas tacked to it, in an

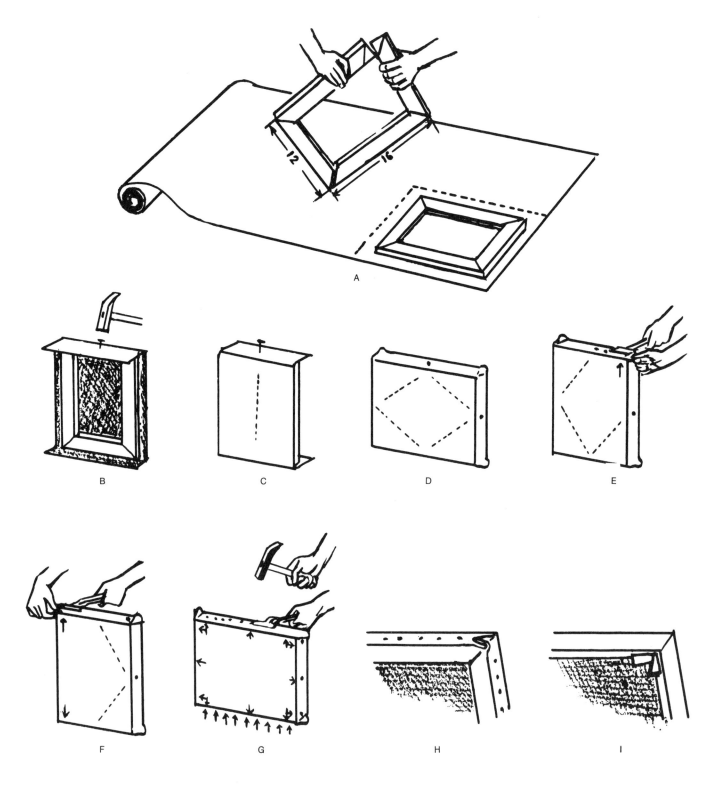

Figure 10: *The following procedure should be followed to stretch a canvas. Assemble the stretchers to form a frame, place the frame on top of the canvas (place primed side down), outline the size of canvas needed (allowing 1 1/2" extra canvas on each side), and cut the marked piece of canvas out with a pair of scissors (A). Fold the 1 1/2" margin of canvas over the edge of the stretcher frame on one side and tack it in the center of the strip (B). Turn the stretcher frame upside-down and tack the opposite margin of canvas in the center of the opposite strip (C). Do the same with the two remaining sides of the canvas (D). To tighten the corners of the canvas, pull it straight up from* the center and over each corner of the stretcher frame with a pair of pliers and place a tack approximately 3/4" in from the edge (E and F). Now that each side of the canvas is tacked to the center of each strip of the stretcher frame, and all the corners are secure, tack the canvas down along the entire length of each side, maintaining a space of about 3" between the tacks (G). Surplus canvas is cut off with a pair of scissors or a razor blade and the corners are finished by folding the canvas under and tacking (H). Keys wedged into the grooves of the corners of the stretcher frame control the tautness of the canvas (I).

upright position. The shorter sides (in our case, the 16" strips) are horizontal, and the longer sides (the 20" strips) are vertical. To fasten the upper left corner, pull the canvas straight up from the center and over the corner with your left hand. Simultaneously, with a pair of pliers which are held in your right hand, grasp the corner of the canvas and pull it tight over the upper left corner of the frame (Fig. 10E). Then place a tack approximately 3/4" in from the edge of the upper left corner to hold the canvas.

(7) The right side corner on the same strip must be tacked in the same way — but stretch the canvas with the pliers held in your left hand, and with your right hand pull the canvas up from the center and over the upper right corner of the stretcher frame (Fig. 10F). Again, place a tack 3/4" in from the edge of the corner.

(8) After you have tacked the canvas to the stretcher frame in the center of each side and in both corners of one of the short strips, turn the frame upside-down and repeat the same procedure on the opposite short side. Now, all four corners of the short sides are securely fastened with tacks. This has removed the diamond-shaped wrinkle from the canvas, and it gives the proper tension for tacking the longer sides (in our case, the 20" strips).

(9) Turn the canvas so that one of the long sides is on top (Fig. 10G). The corners on both the 20" sides must be tacked just as you have tacked the corners on both 16" sides. This step is very important, especially in stretching a large canvas. When you tack the center and the corners of each of the four sides of the stretcher frame, be certain the canvas is pulled tight; this gives you the assurance that the canvas is properly distributed so that you can proceed with the stretching. Tack first one long side (one of the 20" strips), maintaining a distance of approximately 3" between the tacks.

(10) Turn the frame upside-down and repeat this tacking procedure on the opposite side, making sure to give the canvas an even pull, or tension. Complete both the short sides (the 16" strips) in the same way.

(11) To finish the corners, fold the canvas under and tack it (Fig. 10H). Surplus canvas may be cut off with a pair of scissors or tacked to the back of the stretcher frame.

12) Along with the stretchers, you also purchased eight wooden wedges — the so-called "keys." After you have completed stretching your canvas, place two keys in the grooves which you will find in each corner of the stretcher frame (Fig. 10I). The temperature and dampness of the air will influence the tension of the canvas, and these keys are your way of adjusting the frame, and thus the tension of the canvas, to these changeable conditions. The more deeply the keys are hammered into the corners of the stretcher frame, the more tightly the canvas will be stretched. (Commercially stretched canvas sometimes has the corners stapled in the back in order to keep the frame at a right angle; these staples must be removed to make the keys effective.)

For those students who wish to build their own stretcher frames, one detail is essential: notice that the molding of a strip is designed with the outside edge wider than the inside edge. This is so that the canvas will not touch the inside edge of the frame and leave a mark, or ridge effect, on the surface of the painting.

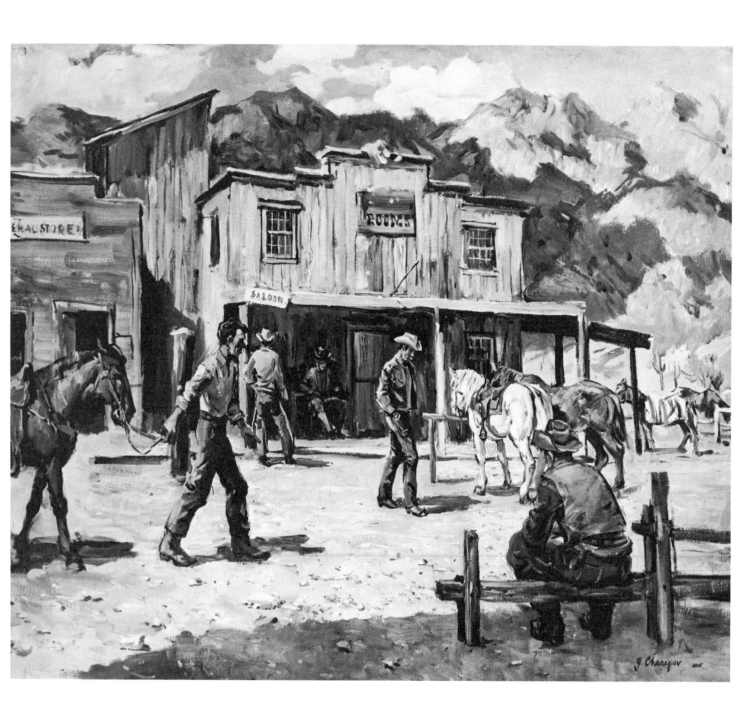

Arizona Cactus Range, 30" x 36". Western life of the past has inspired many painters, and a great tradition of Western art has been created under the influence of this subject. Painting the desert landscape of Arizona, I felt a need to include figures in the composition. This ranch, built to imitate the past, with horses and men moving about in the hot sun, suggested a subject for painting. I came back several times with my canvas to study the life of the ranch, the movements of the cowboys, and their characteristic clothing and mannerisms.

PART TWO: THE FIVE ELEMENTS OF PAINTING

The description of the equipment needed for painting and the discussion of its use and maintenance in the preceding chapters are obviously a necessary technical part of painting; these things can be learned without much difficulty, but are useless without an understanding of the elements of painting. No matter what medium we use — oil, watercolor, pastel, acrylic colors — a painting is made up of five elements: (1) *subject*, (2) *composition*, (3) *form*, (4) *value*, and (5) *color*. Each of these elements will be discussed separately in the following chapters. Studying them will enable you to make a constructive analysis of your own work as well as that of other painters. It will also lead you (hopefully) to creative freedom in your painting.

4. Subject

There is a great variety of possible subjects for painting. These can be divided into the following major groups: still life, flower painting, landscape, seascape, portrait, and figure. These large groupings can naturally be extended further into many subdivisions.

Choice of Subject is Individual

The question, "What makes a good subject for a painting?" is difficult to answer. The approach to subject matter is highly individual. Where one person may not find a specific subject interesting enough to paint, another may find the same subject fascinating.

If the choice is so broad and the selection of subject matter so individual, what helping hand can we give to the art student in his selection of a subject? One of the most important factors in this choice, of course, is the painter's strong emotional impulse. This generates the urge to communicate a particular impression or idea. After the selection of the subject is made, the process of presenting it on the canvas depends largely on the painter's knowledge and on his ability to handle the other elements of composition, form, value, and color.

Learn to See

You can increase your ability to see and widen your choice of subject through practice, and through studying your surroundings. Observe and sketch everything that attracts your attention in your immediate environment.

Learn to really *see* trees, clouds, rocks, buildings, water, reflections; observe people and animals; study them and try to capture their characteristic movements; sketch birds in flight; study the interior of your home in changing light; draw yourself. Learning to see involves discerning the essential characteristics of things, their structure, their uniqueness.

Essential Virtue of the Subject

One often runs into the idea that the subject for a painting should be attractive, spectacular, or glamorous. This is certainly not true. Numerous examples of paintings in museums, and also in this book, show that the subject can be a very modest one. Through the painter's ability to handle the elements of composition, form, value, and color, a painting of artistic quality can be made from any subject at all.

It is important to define the essential virtue of the subject and to plan the whole painting around this point, to emphasize it. For example, while a bright summer bouquet of flowers primarily calls for very intense, pure-hued color contrasts, a subject like *Mother* (p. 29), calls for quite a different focus of attention. The colors are reduced to very simple grays to concentrate attention on the psychological mood of the face and on the expression in the eyes.

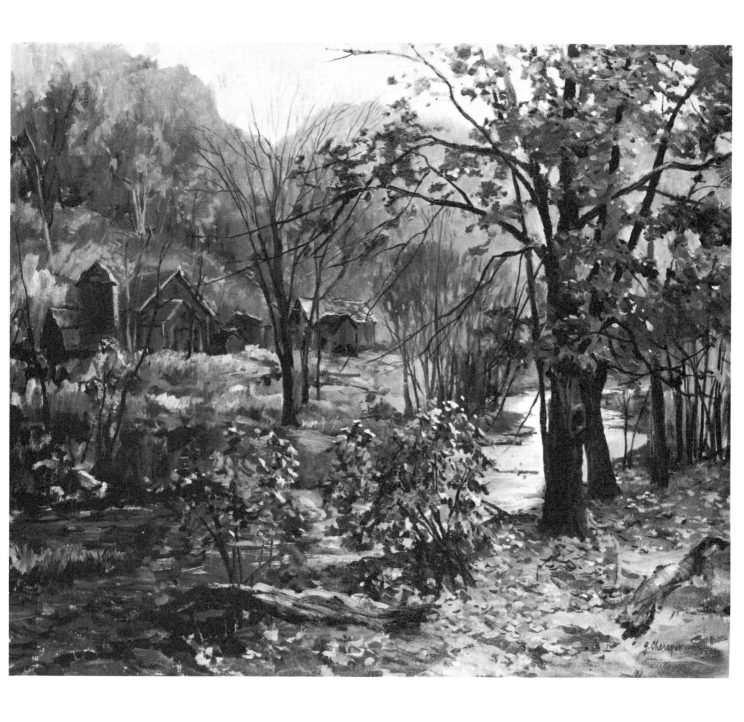

Countryside, *30" x 36". In this motif, the high humidity in the air softened the contrasts and emphasized the depth (the aerial perspective). The morning sun was still low, creating a reflected light on the brook and partly highlighting the roofs of the houses across the brook and the branches of the trees in the foreground. The painter should be aware of these elements when considering subjects for painting; he should always keep the location of the light source in mind. The light source determines the shadows and the reflected light — both essential for indicating light.* Private Collection.

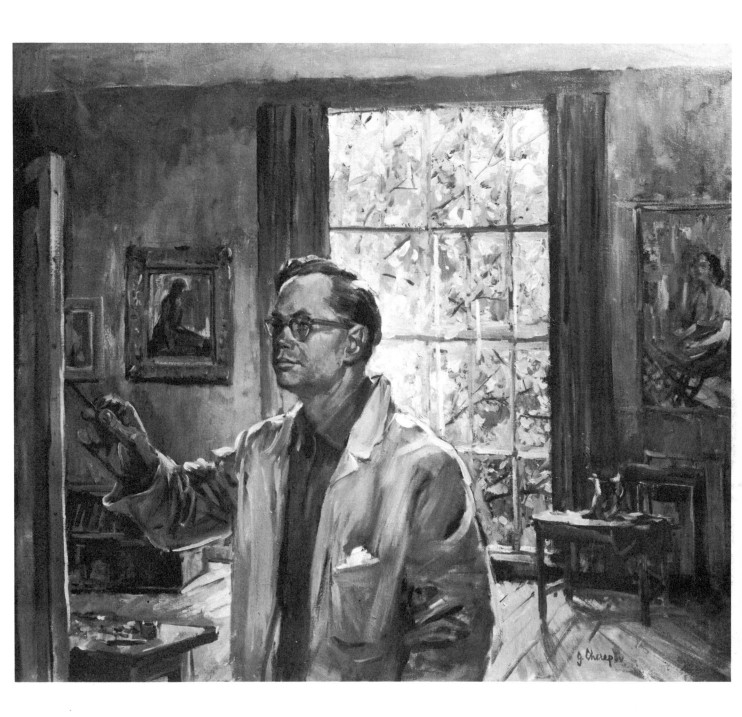

Self-portrait, *30" x 36". Here is one of the best subjects for the painter, and one which is always available! One autumn day, I noticed that the maple tree in front of my studio window was all gold. This large area of yellow against the light gray color of the walls of the interior set the theme for the painting. This color composition brought to my mind another idea, the association between myself and my favorite subject in landscape, autumn. The area of the window was my first idea for the painting, and is the dominant element; the painter in his studio becomes the second element. The color combination of the two large areas, yellow and gray, was the main theme which sparked my desire to paint this scene.*

Composition in Nature

Nature, a great source of study and inspiration for the painter, rarely offers a subject which is complete and perfect as far as composition is concerned. One should not even waste time searching for a "perfect" subject. Rather than trying to paint exactly what is in front of your eyes, take the liberty of rearranging the objects on the canvas to achieve a satisfying solution in terms of composition and color.

Subject Influences Technique

The subject may often suggest and influence the technique of the painting. Objects with a rough surface, for example, may suggest heavier impasto brushstrokes than smooth textured objects would. Capturing the nuances of colors outdoors requires a direct, fast *alla prima* method, while a still life or portrait painted in the studio might be done by a very slow method, involving many sessions

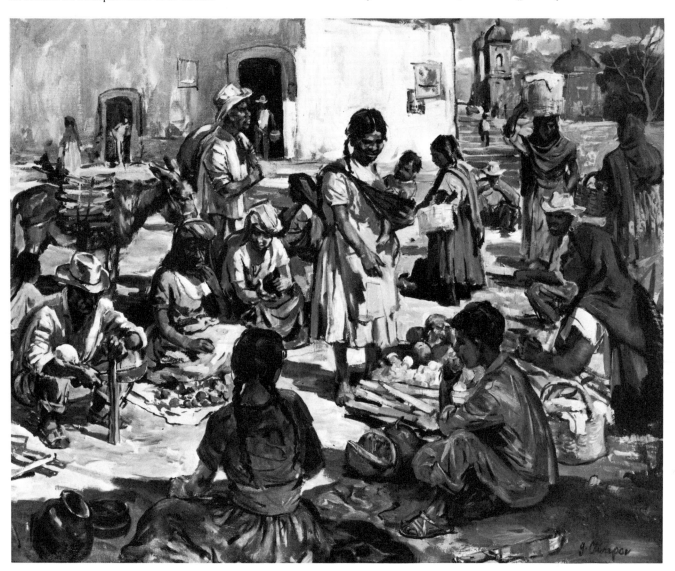

(Above) Market near Oxaxa, *30" x 36". Walking through a market in a village of southern Mexico, I observed this colorful crowd. To emphasize the brilliance of the colors, highlighted by the sun in the center of the canvas, the first plane, with the figures done in some detail, was placed in shadow. The seated figures beyond were more roughly painted. I made several sketches on the spot (two of them are shown in Figs. 59 and 60) which were of help in finishing the painting in the studio. This is a case in which memory and spontaneous drawing of figures in motion is of irreplaceable value. Private Collection.*

(Right) Mother, *20" x 16". Here is the face of a person who has suffered a great deal in her life, and the expression of the eyes reflects that grief. The psychological importance of the eyes required the greatest simplicity in the surrounding areas of the picture as well as in the style of the painting. The soft edges around the mouth, cheeks, and head were done with a bristle brush and a palette knife without smooth blending of the colors.*

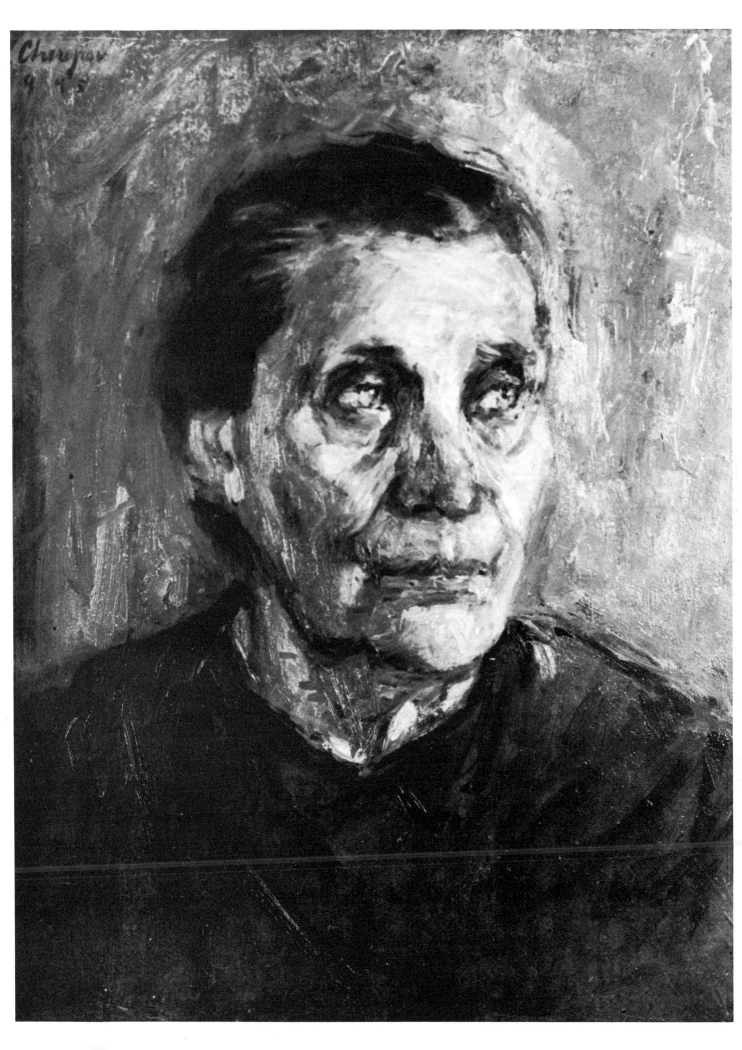

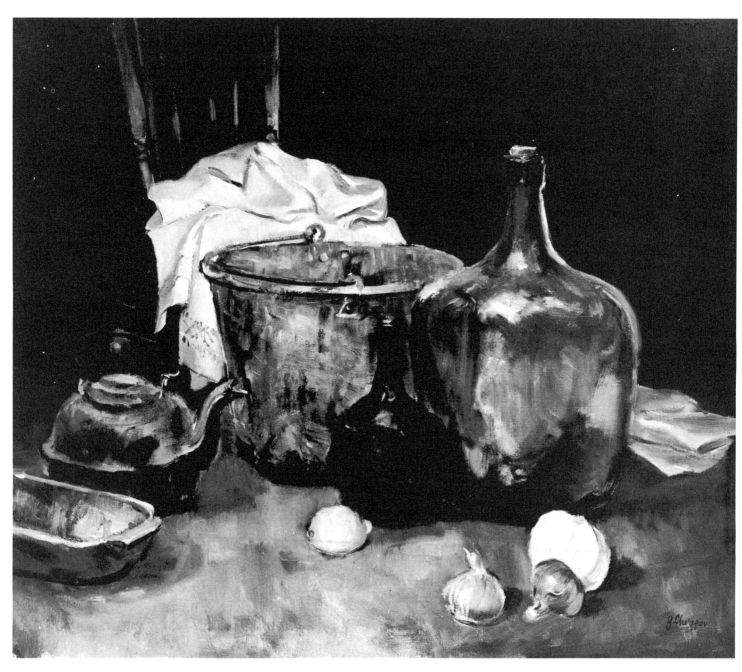

Antiques, *30'' x 36''. I wanted to achieve a variety and harmony of colors as well as of textures in this still life. The objects have been placed so that the larger, more dominant areas (the brass kettle and the large bottle) are in the visual center. The chair behind and the piece of cloth unify this group and add a vertical line. All the objects overlap or touch each other, forming a unit: the cast-iron teapot with the spout facing the center overlaps the brass kettle; the wooden dish on the left is brought out of the picture frame to create a feeling of continuing space. The onions in front are a necessary part of the design; they add to the three-dimensional quality of the picture and lead the eye toward the center group of objects. The light color of the lemon is amplified by the dark color of the bottle — this is the highest point of contrast in this composition.*

5. Composition

The second element of painting is composition. The painter is faced with the problem of composition the moment he places any arrangement of forms on the canvas. Special attention must be given to the spacing of *large areas*, before details are added.

Similar to an architect who faces the problem of planning a building, the painter does not start with the doorknob, but first plans the layout of the large spaces in proportion and relationship to each other, and only then turns his attention to details. Those who underestimate the importance of this first step must often pay the consequences by scraping and removing all the work they have done to correct the composition. But those who continue a painting while they are aware of a weakness in the composition are in even greater trouble.

Because art is a creative process, it is impossible to dictate exact rules. And composition cannot be taught by rules only. But extensive study of the possibilities of varied arrangements, as well as an increasing familiarity with the problems and principles of composition, will enable you to make the right decisions more easily in each individual case.

Center of Interest

First, analyze the subject you intend to paint and try to find out which part you consider most important. Avoid presenting two objects of equal importance. Figs. 11 to 14 illustrate the schematic variety of space arrangements facing painters.

In landscape, where we deal with the ground and sky, and in seascape, where water and sky occupy the two chief areas, check and decide which part has attracted your attention and inspired you to paint. If it is the sky, obviously you show more sky by lowering the horizon (Figs. 11 and 15); and, on the contrary, if it is the water, more emphasis will be given to the water by raising the horizon.

The same rules can be applied to vertical (Fig. 12) and diagonal (Fig. 13) space divisions as well.

The four edges of a painting are also important (Fig. 14). If an object in your picture is so close to the edge of the support that it touches (or almost touches) it, either move the object in, leaving space between the edge of the object and the edge of the support or move it further out, cutting the edge of the object off altogether. Examples of this second possibility can be seen in *Antiques* (p. 30). Note how the dish to the left is cut almost in half by the edge of the support. The top of the chair and the tip of the napkin are also cut off.

Visual Versus Geometrical Center

As I said before, decide which object is the dominant one, the "hero" of your painting, and place it in the *visual* center of the canvas. There is a distinct difference, by the way, between the visual center and the precise geometrical center. The geometrical center divides the canvas in equal areas, while the visual center is occupied by a prominently placed dominant object. This visual center is *not* actually in the geometrical center of the composition; it is usually just off to one side or the other.

Symmetry and Asymmetry

In Fig. 18 (above), abstract blocks are used to demonstrate a formal, symmetrical composition, with the dominant block in the geometrical center. Fig. 18 (below) shows superiority of freely spaced blocks. Fig. 19 is based on the same principle, using the familiar objects of a still life. The coffee pot in the example to the right is placed in the visual center.

The Triangle

Often we see a composition based on the triangle form (Fig. 19, below). We see this composition used

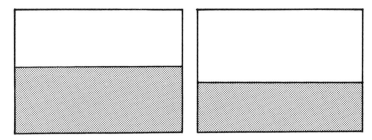

Figure 11: *The division of a space horizontally into equal areas is a weakness when composing a painting; the areas compete with each other and negate each other's importance (left). By lowering the dividing line, the balance of the space is very much improved (right).*

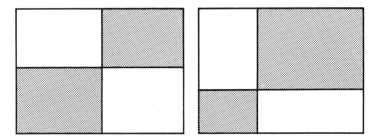

Figure 12: *Just as dividing a space horizontally into equal areas weakens the space, so does dividing it vertically into equal areas (left). When the vertical line is shifted to one side or the other, the space is more interesting (right).*

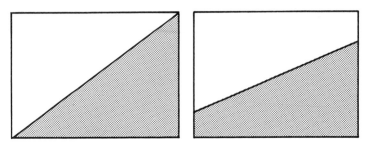

Figure 13: *Here, the space has been divided diagonally, with the line running into the corners of the picture (left). When the diagonal line is shifted slightly and taken out of the corners, we have the beginning of a hill (right).*

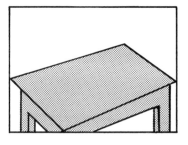

Figure 14: *Avoid bringing an object, such as the table shown here, to the edge of the painting (left). Either get an object well into the painting or cut it off (right), but don't try to squeeze it in so that it looks cramped.*

in so many prominent masterpieces that it may be regarded as a classical compositional device. It is logical to have the wide base of the triangle on the bottom; the side lines start from here and move to their culmination point. To prove the superiority of this spacing, try to turn the triangle upside-down, and see how top-heavy and unbalanced your composition will become! As in the case of the visual center versus the geometrical center, we are not speaking of an exact geometrical triangle, but rather of a free, nonsymmetrically shaped triangle.

The triangle is applied especially with figures and still lifes. You can see it in many of the paintings in this book. Also, look at the work of the great masters of the past — Caravaggio, Tintoretto, Michelangelo — for examples of the triangle in composition. We also find the triangle composition dominating in architecture, sculpture, and music: think of the structure of cathedrals, the composition of classical sculpture, and the lower wide base and the movement upward of the triangle in many forms of music.

Mood

The expression of different emotional moods can be emphasized through the symbolic arrangement of space, and so contribute to the visual impact of a painting. For instance, a horizontal line is associated with a peaceful mood. Long, vertical lines convey monumental stability and upward movement. Vertical lines are strongly represented in architecture, starting in ancient times in the form of columns and reaching their peak in Gothic architecture. Dynamic movement and action can be expressed in lines moving diagonally from the lower left to the upper right corner of a composition.

Perhaps you will get additional ideas of the possibilities of composition from these few examples.

Color in Composition

An equally important factor in the composition of a painting is color. Since color is the most exciting element in a painting, the painter is often inspired by a certain color relationship and creates his painting under this influence. Painters often disagree as to which element is more important: subject, composition, form, value, or color. Color, however, has a great influence on composition. In subjects such as still life and figure painting, especially, the opportunity to select and arrange the colors before beginning a painting gives the painter a great deal of flexibility in composition.

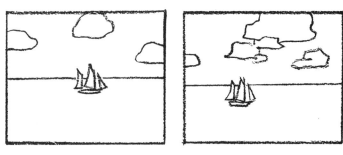

Figure 15: *The example on the left shows a poor composition: the horizon cuts the space exactly in half; the boat is in the geometrical, rather than in the visual, center; and the clouds are all alike and uninterestingly spaced. In the example on the right, these faults have been corrected: the horizon has been moved down; the boat has been taken out of the geometrical center; and the clouds have been given diversified shapes and placed in a more interesting pattern.*

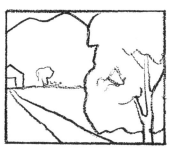

Figure 16: *Here is another example of a bad composition which has been corrected. In the example on the left, everything seems about to fall off the edge of the picture frame: the mountains graze the top edge; the house is half in, half out, of the picture; the road lacks depth; and the tree takes up exactly half of the picture space, dividing it equally. In the example on the right, the objects in the picture space have been brought down to a size more in keeping with the proportions of the picture space.*

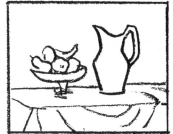

Figure 17: *In this third example of a faulty composition which has been corrected, the example on the left focuses on the uninteresting table legs and the space behind them instead of on the still life, while the actual objects of the still life seem to be crowded up against the top corner of the picture frame. In the example on the right, we have closed in on our still life, which is the center of interest.*

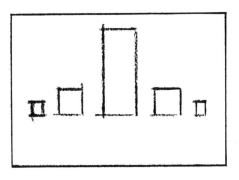
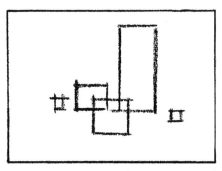

Figure 18: *Notice the lack of excitement in a symmetrical and formal arrangement of abstract blocks (above). When the same blocks are set up in a freely spaced composition, the results are much more interesting (below).*

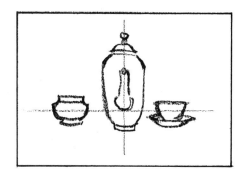
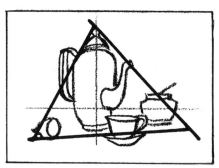

Figure 19: *In this example, objects are used in the same kind of composition as is shown in the preceding example. When the objects are shifted from their symmetrical composition (above) and placed as a group (below), the composition has a visual, rather than a geometrical, center. Notice that the composition is based on the classic device of the triangle.*

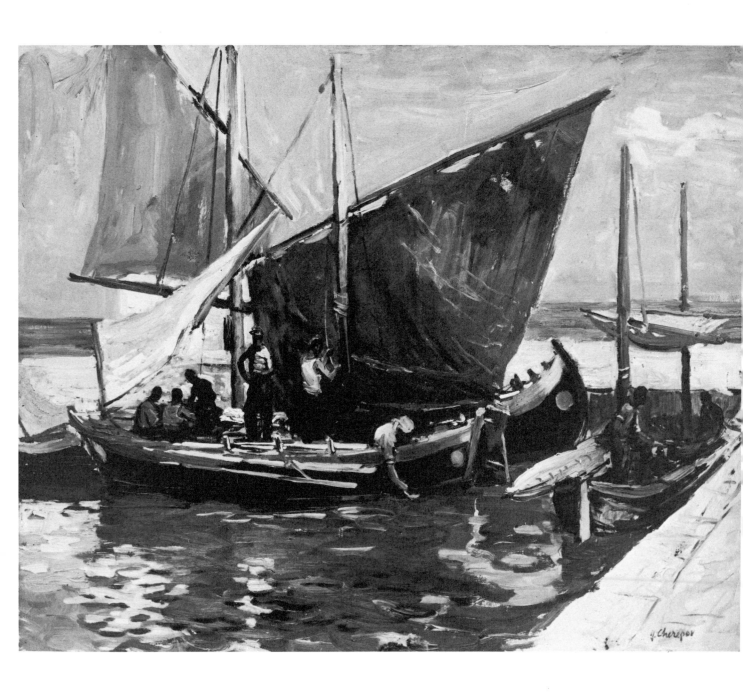

Boats in Ravenna, *28" x 34". The colorful yellow sails of these fishing boats, repaired with orange patches and highlighted by the evening sun, create a breathtaking color contrast to the blue in the sky and in the water. The sails also give a very interesting dynamic design to the space arrangement. Look at them as three differently shaped panels placed at different angles against the sky. The vertical and diagonal lines of the masts serve as the connecting link for these panels. The brightness of their color is strengthened by the dark mass of the boat.*

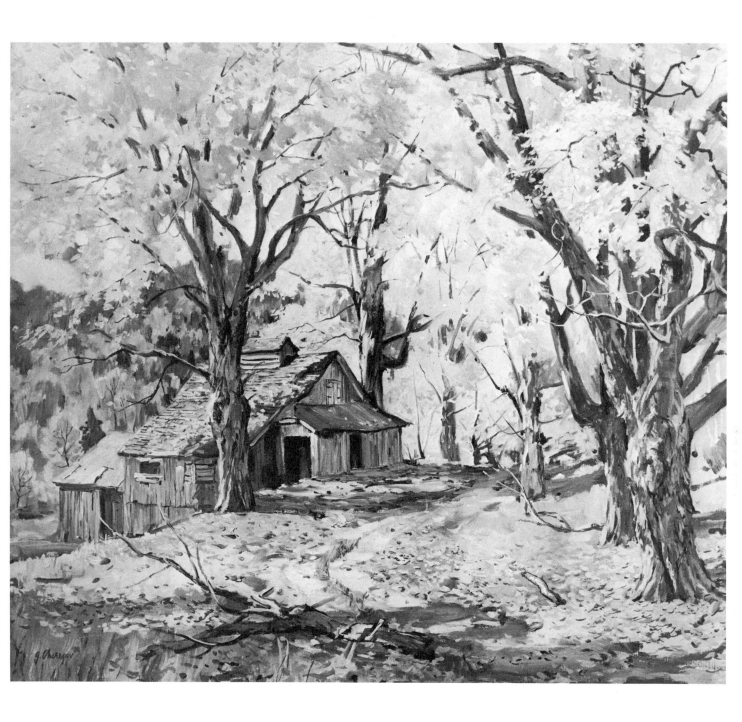

Sugar House in Vermont, *30" x 36". The peeled-off colors of the old building, with the sunlit golden yellow of the surrounding maple trees, was the theme which inspired this painting. Color also influenced the space composition. Most of the canvas is occupied by the gold of the foliage and the building; the next important object in regard to color, the road and foreground area, is placed in the visual center, yet slightly lower to expose the height of the trees, and more to the left to open a depth of vision. The road leads the eye to the building and off into the distance. The big treetrunks to the right are a vertical counterbalance to the horizontal plan of the building. Courtesy Grand Central Art Galleries, New York.*

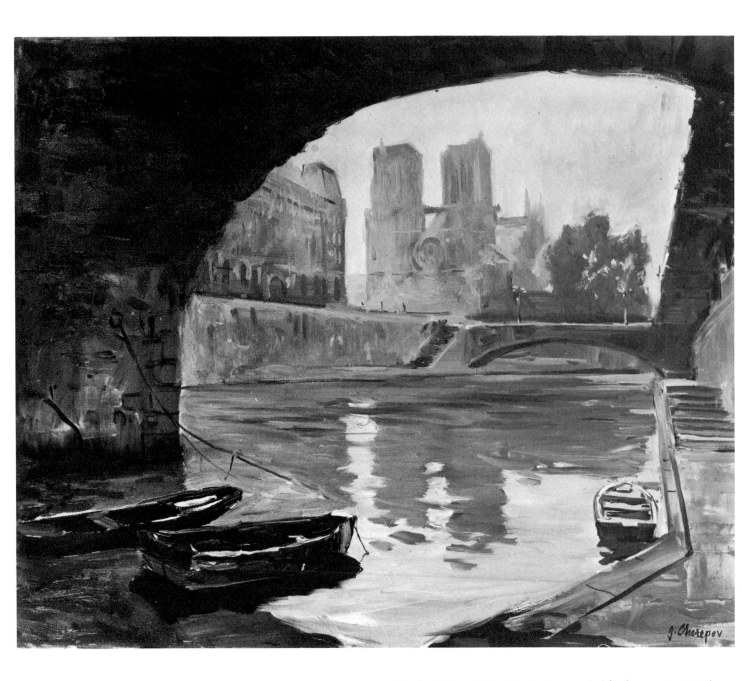

On the Seine, *24" x 30". Paris is probably the most painted city in the world. Walking in the streets, however, I did not find it easy to choose a motif which would be typical of Paris and yet not be a cliché. Notre Dame, seen from under a bridge in the early morning haze and reflected in the river, offered a composition rich in a variety of shapes. The arch of the bridge, including the reflections on the water, creates a half-circle through a third of the canvas. This half-circle is counterbalanced by the horizontal lines of the river and the verticals made by the towers of Notre Dame. The boats point diagonally toward the distant dome. The heavy mass of the bridge, with the boats in the foreground, is the first plane, while the group of buildings with the second bridge and the sky comprise the second plane. The gray colors of the second plane suggested the use of the minor tone palette. Courtesy Mobil Oil Company.*

Color Relationships

It should be emphasized here, that in color relationships, as in space-balance relationships, the presentation of two equally large areas of different colors should be avoided, because they will neutralize each other. Only one color should be dominant; use a second or third complementary color as an accent. Certainly, in many individual situations, where the subject requires a definite color, it is difficult to enforce this suggestion; but my point is that in cases where you have the opportunity to arrange the objects — in still lifes, flowers, portraits — give considerable thought to the color arrangement of your composition.

Harmonious Color Composition

There are ways to develop and refine your sense of color relationship through exercises — by painting several canvases in different color arrangements, for example.

First, try this assignment: compose several paintings in warm colors. A still life is the best subject for this purpose. Select several objects in a variety of yellows — flower pots, bottles, and different pieces of cloth or colored paper for the background, for example. Then, try a composition based on a variety of reds, grays, greens, or blues. Finally, here is a very interesting and rather difficult task: paint a subject composed of white objects only. For instance, take a breakfast table covered with a white linen tablecloth; a setting of white porcelain with silver; a glass of water; an egg in an eggcup.

Such limited color schemes have to be painted with the whole palette, using all three primary colors, without black.

This is a challenge which can be approached at a later stage, after you have acquired considerable experience handling form and value.

Complementary Color Composition

The next group of paintings can be done in complementary colors with greater contrast, where red, purple, orange, yellow, blue, green will be introduced in their whole intensity. Often these compositions may be arranged with flowers or toys and fabrics. When we include fabrics in still lifes and figure paintings, we deal very frequently with folds, using them as design elements. You should give special attention to studying how to arrange, highlight, and paint them (see "Folds and Drapery" in Chapter 10, Still Life).

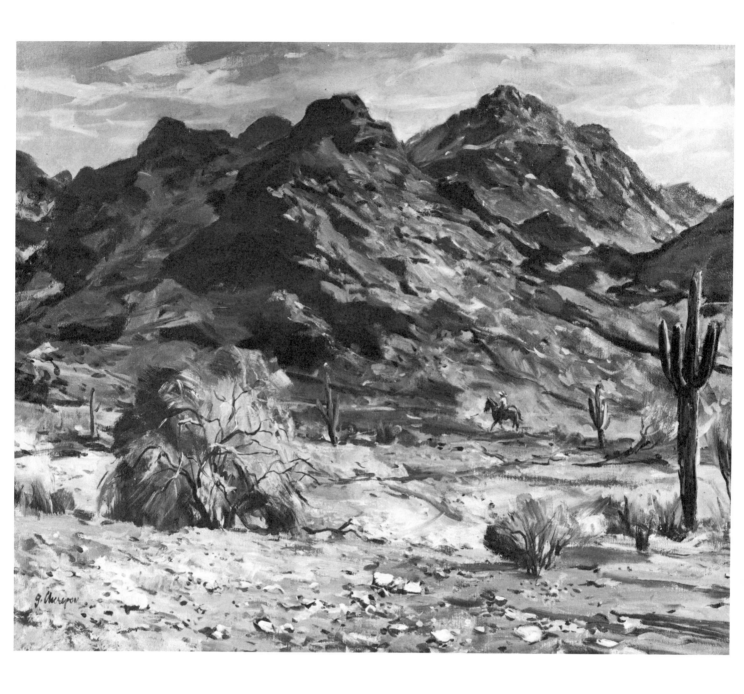

Arizona Motif, *24" x 30". In Arizona, high, snow-covered mountain ranges are just miles away from hot, sun-drenched desert areas. Camelback Range, near Phoenix, attracted my attention with its desert, dusty gray cactus, and low brush scattered between gray rocks. The mountain formations dominate the space composition. Their shapes are formed and emphasized by light and shadow. These value relationships are an important part of the expression of form and must be carefully observed. The small, lonely figure of the distant rider adds to the dimension of space and to the mood of the subject.* Courtesy Grand Central Art Galleries, New York.

6. Form

The next, not less important, element in painting is form. After the subject matter is established and the composition of large areas is laid out — when you know the exact location and size of the objects to be painted — this is the moment to be concerned with their shapes, their individual characteristics, and their relationship to depth and light. For example, if a large tree is shown in a landscape, it is essential to emphasize its specific character: that is, it should really look like an oak, maple, birch, spruce, etc. This, of course, applies to all objects, including the human figure.

Importance of Form

To express the individual character of a human head or a figure, an even more extensive study of form is required. Consequently, the art student who is looking for short cuts, who neglects the necessary study, will never experience the excitement of being able to express the beauty of a human face. Every attempt to do it will result in distorted, grotesque forms. Such a painter's only escape is in abstract or nonobjective painting.

Geometric Forms

In the following pages, I would like to suggest a very helpful method of studying form. Even though it is not new, it is, in my opinion, most constructive. If the reader is already familiar with this method, but has not spent enough time or effort for complete understanding, it would be wise to go over this material again, since it is the key to mastering form.

There are three basic geometric forms: the *cube*, the *sphere*, and the *cylinder* (Fig. 20). Most objects surrounding us are based on one of these forms. If you're able to see all objects stripped of details in terms of one of these three basic forms, you'll find it much easier to deal with perspective. A house, for

example, seen in terms of a box (a cube form) or a treetrunk seen in terms of a cylinder, become simplified forms that can be logically placed on the picture plane to indicate depth and distance.

Perspective

There are two types of perspective: *linear* and *aerial*. The latter will be examined in the step-by-step color demonstration of *Pacific Coast* (pp. 85-88) and in Chapter 11, *Landscape*. In this chapter, we are concerned with linear perspective. Take a simple box (a cube form). Place it on the floor in a three-quarter-view position and observe its relationship to depth (Fig. 21). There are two factors to consider: *the eye level* and *the vanishing point*.

Eye Level

The eye level is an imaginary horizontal line in front of your eyes. Look straight at this eye level, holding a pencil or a stick horizontally in front of your eyes, and you will see that the box is located on the floor *below* this line. Naturally, this line will move up or down in accordance with the changes in your position, standing or sitting.

Vanishing Point

The vanishing point is an imaginary point to which the parallel lines from the sides of a cube (the box) converge. As a rule, it should be remembered that the vanishing point is always located at the eye level — never below, never above. You may visualize this more easily by again looking at the box on the floor. Holding a long stick horizontally in front of your eyes. This indicates the eye level. Hold another stick parallel to the bottom edge of the side of the box. Extend this line to the eye level (indicated by the horizontal stick). Do the same with the upper edge of

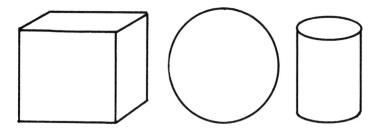

Figure 20: *The three basic geometric forms: cube, sphere, and cylinder.*

the same side of the box. Exactly where both lines join (converge) at the eye level (the horizontal stick) is the vanishing point (see Fig. 21).

Horizons

After a certain period of training, your eye will easily visualize and follow these imaginary lines without the aid of such mechanical devices as sticks. As an exercise, while out walking on the street or driving a car on the highway, observe how the lines on both sides of the road converge at one point on the horizon. The lines below the horizon (shoulders of the road, bottom of the telephone poles) point upward, the lines above the horizon (telephone or power wires and the upper parts of the poles) point downward, to the same vanishing point (Fig. 22).

Buildings

Buildings are usually based on the form of a cube. Fig. 23 (above) shows a house located below our eye level. Because we are looking at it from above, all parallel lines converge upward to the vanishing point. The same building appears different when the eye level is low (Fig. 23, below). The closer corner of a building always appears larger than the other corners which are farther away, and parallel lines point downward to the vanishing point. Any cubic form, in a position where we can see two sides, will always have two vanishing points at the eye level. After you establish the basic form of the building in its relationship to perspective, it is easy to draw all the details, windows, doors, chimneys, etc., in perspective also because they will automatically fit into the same lines and points.

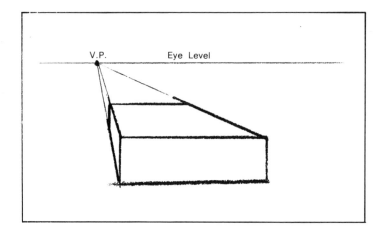

Interiors

Sketching the interior of a room is very helpful in understanding linear perspective. Note in Fig. 24 how all the lines of the room and the lines of the objects in it converge to the same vanishing point. Exceptions naturally occur in the furniture standing in different positions, not parallel to the walls. These vanishing points must be defined individually in relationship to the eye level.

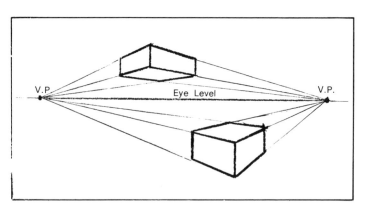

Figure 21: *A cube seen in relationship to eye level and vanishing points.*

The Sphere

Objects based on the spherical form (melon, apple, ball, etc.) differ from the cube when seen in perspective. There are no converging parallel lines, no vanishing points, and no changes related to the eye

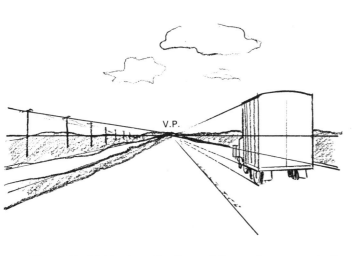

Figure 22: *Notice how the lines of the road converge to the vanishing point on the horizon.*

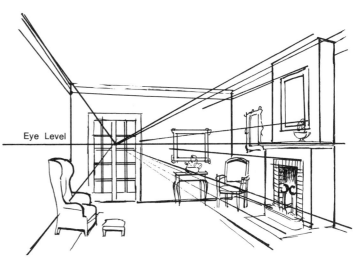

Figure 24: *Here, parallel lines converging to the vanishing point are shown in an interior.*

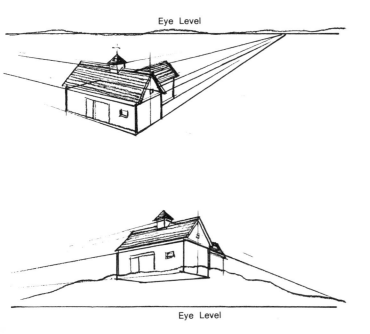

Figure 23: *Looking at a house from below our eye level, all parallel lines converge upward to the vanishing points (above). Looking at the same house from above our eye level, all parallel lines converge downward to the vanishing points (below).*

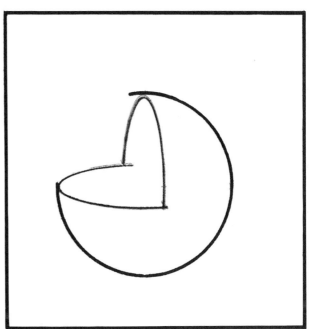

Figure 25: *This sphere with a wedge cut out of it shows us that a circle seen below our eye level in perspective takes on the appearance of an oval.*

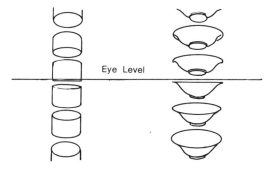

Figure 26: *The bottom of a cylindrical shape is seen as a straight line when it is viewed at our eye level. As it moves above the eye level, the bottom becomes increasingly circular; as it moves below the eye level, the top does.*

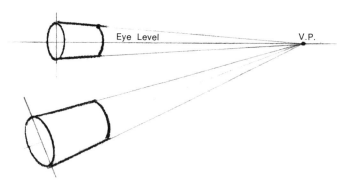

Figure 27: *We see both the front and the sides of this cylinder. In this position, the sides of the cylinder follow the same laws of perspective as a cube.*

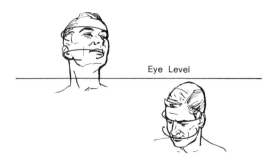

Figure 28: *The head, viewed from various angles, displays the same ovals as we see in the shapes in Fig. 26.*

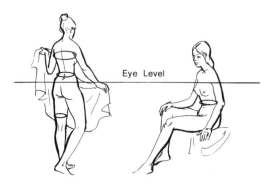

Figure 29: *The human figure can be seen in terms of cylindrical shapes to help establish correct form.*

level. No matter where and in what position we turn the sphere, the basic form remains unchanged, except where the sphere has been cut and a part removed, as in Fig. 25. Then, naturally, the circle below the eye level appears to our eye as an oval. The diameter of the oval changes according to its distance from the eye level. Incidentally, in checking the correctness of the oval, it's helpful to draw a horizontal line and a vertical line across the oval, which should divide it into four equal parts.

The Cylinder

Dealing with objects with cylindrical shapes, we frequently see ovals (the top and bottom of a cylinder seen in perspective) and their relation to the eye level. In Fig. 26, again, the oval which is viewed at the eye level appears to be a perfectly straight line. As the cylinder is moved more and more below eye level, the roundness of the oval top approaches the dimensions of a circle. The same changes will be visible in the cylinder's circular bottom if the cylinder is raised above eye level. The parallel, perpendicular lines on both sides of the cylinder remain unchanged. If we see the top and sides or the bottom and sides of the cylinder, it means that either the cylinder is tipped or that the viewer's angle of vision is above or below the cylinder. The parallel sides of a tipped cylinder converge to the vanishing point at the eye level (Fig. 27). The more open the oval, the sharper the angle of the converging lines of the sides of the cylinder will be. As you become familiar with this rather simple law of perspective, it will enable you to draw the branches on trees growing not only at both sides of the trunk, but also facing out toward you as well as those facing away from behind the trunk. In selecting objects for a still life, you will find more objects (vases, bottles, plates, etc.) are based on the cylinder than on any other basic form.

(Right) Mr. Riedmuller, *30" x 24". This portrait of Mayor Riedmuller was commissioned for the centuries-old town hall of Memmingen, West Germany. The over-all traditional surroundings of the gallery of portraits of prominent officials required a formal setting and the presence of the chain with the coat of arms of the town. The prominence of the head demanded simplicity in the whole composition. The large, strongly designed features required more attention to form than to color. For this reason, the sitter was placed close to the light, increasing the contrasts and lowering the values of the shadows to emphasize the form. The presence of the chain influenced the entire space arrangement, and, with the large dark area of the body, contributed to the stature of the sitter. Collection Town Hall, Memmingen, West Germany.*

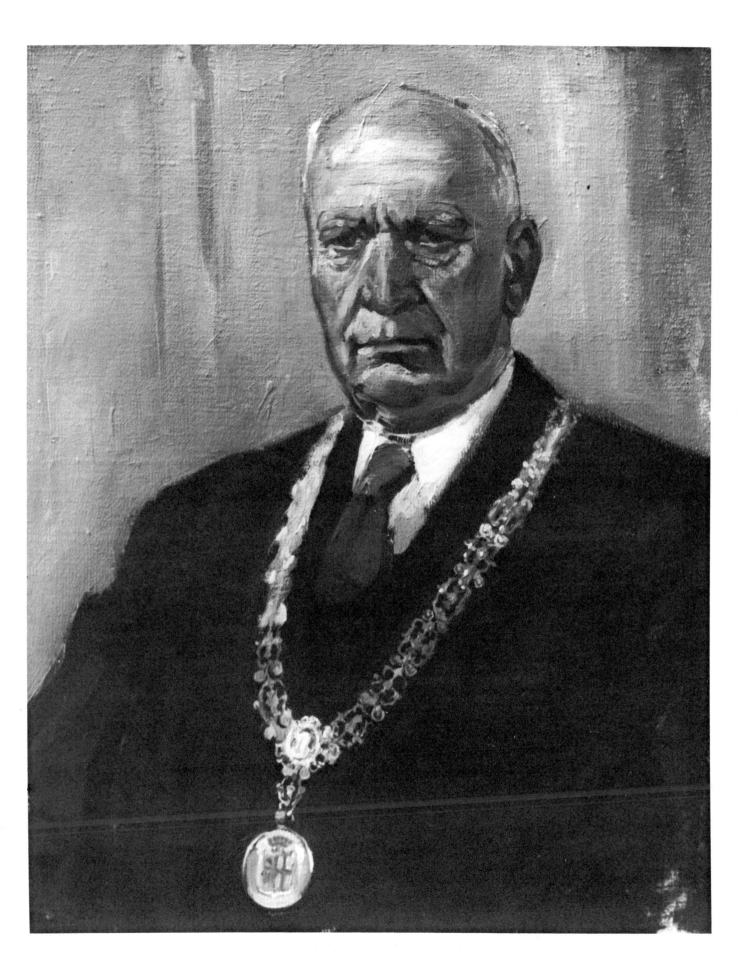

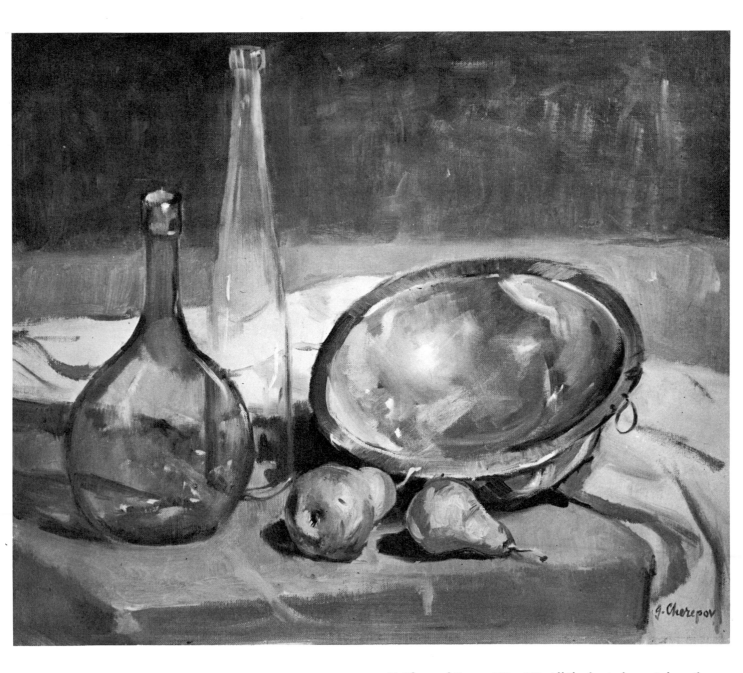

Bottles and Brass, *16" x 20". All the basic forms I described in this chapter are represented in this still life. If you reduce these objects to their basic forms, you will find that the bowl is a sphere, cut in half; the tall bottle next to the bowl is a cylinder; the other bottle is a combination of both sphere and cylinder — the bottle part has a spherical shape, but the bottleneck is cylindric — and the same can be said about the pears; the tabletop is based on a cube shown below eye level, therefore we see the two sides of the near corner directed upward toward the vanishing point on the eye level. Cylindrical forms seen below the eye level form an oval, as shown by the mouth of the shorter bottle. The oval of the bowl appears more open to our view, because it is tipped toward us. Notice the space composition. How are the objects placed? The two bottles form a group, the taller one placed toward the center and balanced by the oval of the bowl.*

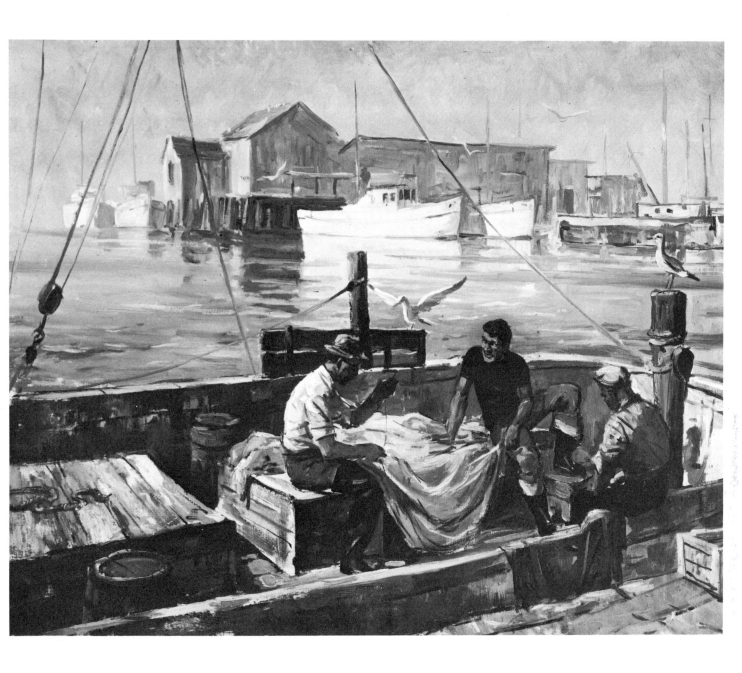

Fisherman's Wharf, *24"x 30". Notice how the basic shapes described in this chapter are illustrated here. The box to the left side of the boat is based on the cube form. Since the boat is below the horizon, the right side of the box is directed up to the vanishing point on the horizon. The barrel next to it is based on the cylinder form. The top of the barrel appears as an oval, because it too is located below the horizon. Through careful analysis of the more complex forms of the human figure, you will find the application of the rules involved in their three-dimensional presentation. Private Collection.*

The head, viewed from various angles, displays the ovals mentioned above. Fig. 28 shows the head above eye level, where you see more of the chin and nostrils, but less of the forehead. When the head is viewed from below the eye level, the forehead is dominant. If you visualize an oval around the head, it will help you check the degree of its position (looking up or looking down) and form the features of the face correctly. The human body can also be seen in simplified cylindric shapes in order to help establish this correct form (Fig. 29).

Further Study

These are the general guidelines about the right approach in seeing the form and its relationship to depth. For more detailed study of perspective, I recommend *Perspective* by Gwen White and *Perspective for Sketchers* and *How to Use Creative Perspective* by Ernest W. Watson.

Continue to train the eye in measuring space proportions of one area against another by constantly sketching everything around you; fill your sketchbooks with drawings, as shown in Fig. 30.

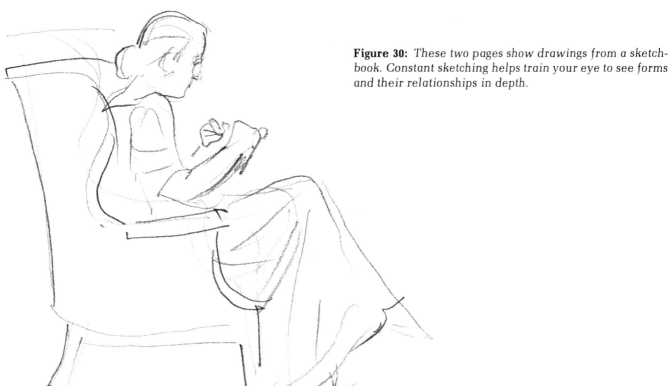

Figure 30: *These two pages show drawings from a sketchbook. Constant sketching helps train your eye to see forms and their relationships in depth.*

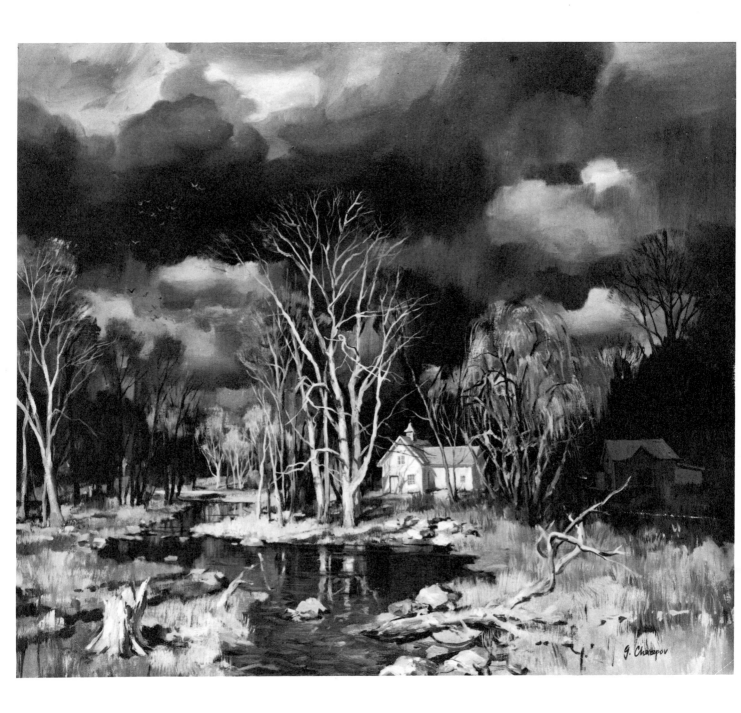

After April Shower, 34" x 40". In April, we experience dramatic changes in the weather. Sometimes all four seasons pass over us within a few hours; heavy rain or snow may suddenly end and bright sunshine may break through heavy clouds, highlighting parts of the landscape like stage reflector lights. One of these moods is expressed here. The heavy clouds, moving away after a shower, create a dark background for the group of trees and the white sunlit building. This subject is an example of strong contrasts in value relationships. The highest point of this contrast is on the light building; the deepest value is in the woods behind. Courtesy Grand Central Art Galleries, New York.

7. Value

Value refers to the degree of lightness or darkness of a tone or color. Being able to see values depends on your ability to see colors in terms of black and white and gradations of grays; an ability, really, of looking at real life as if it were a black and white movie instead of Technicolor.

To familiarize yourself with values and train your eye to see the most delicate nuances of grays, here is an exercise which may help: make a line of nine equally sized squares. With a clean brush, paint the first square on the left white. As you move to the right, add black to make darker and darker gradations of gray until you reach the ninth square, which will be pure black (Fig. 31).

High and Low Values

In speaking of values, we prefer to use the expression *higher* or *lower* value, rather than lighter or darker. You may hear the expression, "A painting is done in a high key," meaning that the light values dominate the canvas. In the same way, value measures the relationship between the colors. Brown is lower in value than yellow, for example, and red is higher in value than purple. We can obtain a higher value of blue by adding white, or a lower value of yellow by adding green, blue, or brown.

Monochrome

It is advisable to make several paintings in black and white or in monochrome (a painting done in one color) as demonstrated in *Still Life with Sculpture* (see step-by-step demonstration, pp.52 and 53). At first, painting in monochrome may not excite you because of its lack of color. But monochrome painting offers a good opportunity to practice dealing with the elements we have discussed so far: subject, composition, form, and value. It is difficult for the beginner to control all five elements simultaneously in the process of painting, and so we will temporarily eliminate color. It is usually easier to study the four elements first, and after familiarizing yourself a little more with their problems, go on to color.

Light and Shadow

The expression of light is also an important part in our study. To express light, you must also express its opposite, shadow. Light and shadow complement each other, and you cannot show the one without the other. The stronger the contrast, the sharper the line between shadow and light, the brighter the light will appear. A very weak contrast, on the other hand, will make the light appear weak as well.

Spend some time in observing shadows, how shadows appear to your eye in different light and in different surroundings. Observe white clouds in a sunny sky and highlights on white snow. Try to establish the distinction between values. See how much darker or lighter shadow on white snow is than shadow on clouds. Identify the value difference of light and shadow on black velvet.

Reflection

The essential characteristic of shadow is a presence of reflections cast from surrounding objects. It is rare for no reflections to be visible. Shadows and reflections are helpful in presenting an object in three dimensional form, as shown in the illustrations of round forms in Fig. 32. Observe the highest light gradually moving to the shadow, and on the opposite side receiving reflected light which emphasizes the roundness of the form.

Analyzing a Monochrome Still Life

Let's analyze the monochrome painting, *Still Life with Sculpture*, (see step-by-step demonstration, pp.

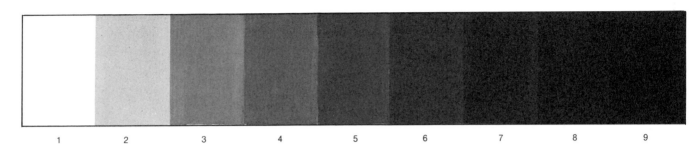

| 1 | 2 | 3 | 4 | 5 | 6 | 7 | 8 | 9 |

Figure 31: *Values, the measure of light or dark, are seen in gradations of grays. These numbered squares show gradations of value from white, through a series of grays, to black.*

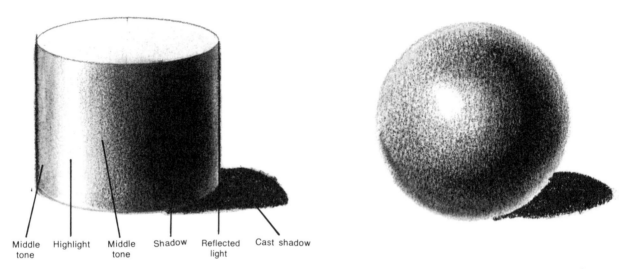

Middle tone Highlight Middle tone Shadow Reflected light Cast shadow

Figure 32: *Shadows and reflections shown on round forms emphasize their roundness.*

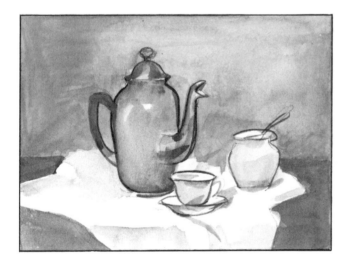
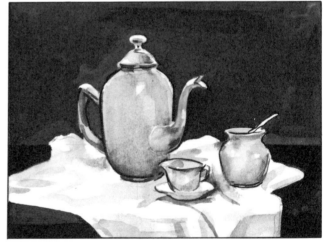

Figure 33: *The importance of studying the value relationships of a particular object is extended to planning an entire painting as well. These two examples demonstrate the same still life in two different value relationships. In the still life to the left, notice the value contrast between the light objects and the light background. In the still life to the right, because of the greater contrast between the values, the objects are emphasized much more. Naturally, this planning of values for large areas in a painting should also correspond to the color relationships between the objects. (See Chapter 5, Composition — pp. 33 and 37 — for further details on color in composition.)*

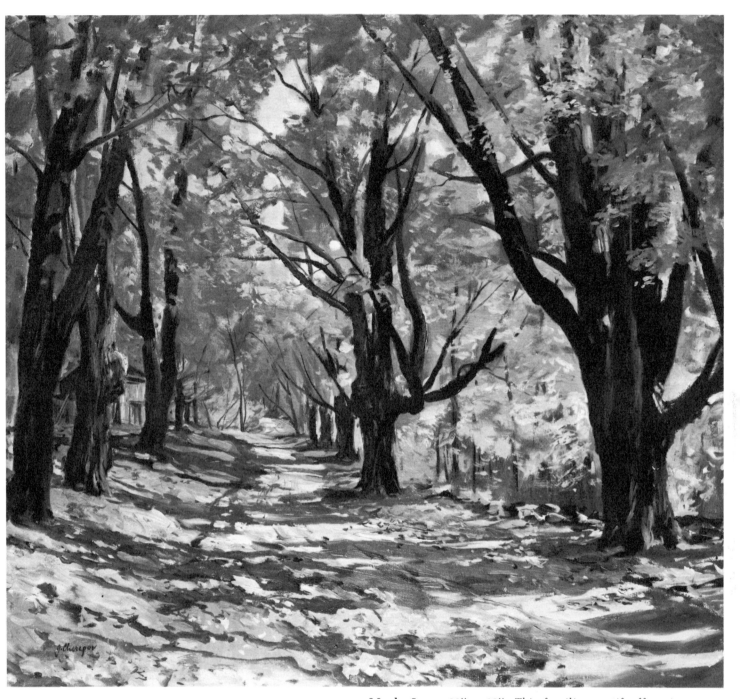

Maple Lane, *30'' x 36''. This familiar motif offers inspiration for painting in all the seasons. Although this painting was done in glorious autumn colors, you can imagine that a gray winter day, when the dark trunks of the trees stand in dramatic contrast to the white snow, would also create a very interesting mood for painting. Here is a case in which the sky appears in very few places between the branches; therefore it was not touched before the preliminary design of trunks and large masses of foliage had been distributed with a large bristle brush. The interplay of light and shadows on the road is an important part of the painting, and attention has been given to the distinct separation of the areas of grass, earth, and leaves in light and in shadow. At the same time, the unity of the gradually vanishing road has been preserved.* Collection Mr. Harlow W. Gage.

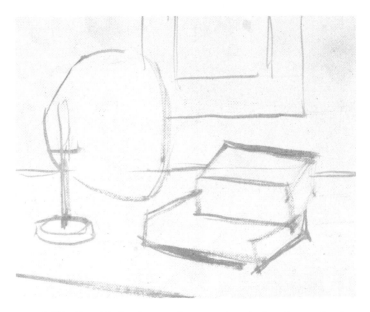

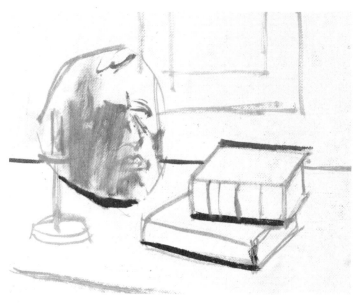

Still Life with Sculpture *(Step 1). A painting always begins with the space arrangement of the large areas. A very light gray color was used to indicate the location of the main objects in this monochrome painting. I kept a good distance from the canvas by holding the brush at the very end of the handle.*

Still Life with Sculpture *(Step 2). I corrected and defined the general form of each object with a darker tone, without removing the original lines. Also, the features of the sculpture were suggested with a few strokes of the brush.*

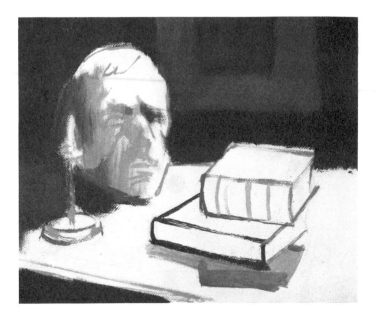

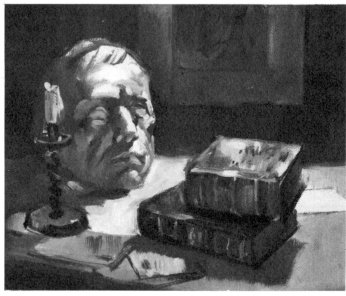

Still Life with Sculpture *(Step 3). When painting in monochrome, it is helpful to prepare a palette based on the value scale shown in Fig. 31, starting with white on the left side of the palette and ending with black on the right side. About seven different grays can be mixed and placed on the palette between the two extremes of white and black. In this step, the darkest values of the background were distributed with a large bristle brush to establish contrast.*

Still Life with Sculpture *(Step 4). In this step, the delicate distinction of tone values on all the objects received attention. These subtle nuances of values in the shadows and reflections are essential for the expression of light. Notice how the light surface of the table throws a reflected light in the area of the shadow on the sculpture, emphasizing the form.*

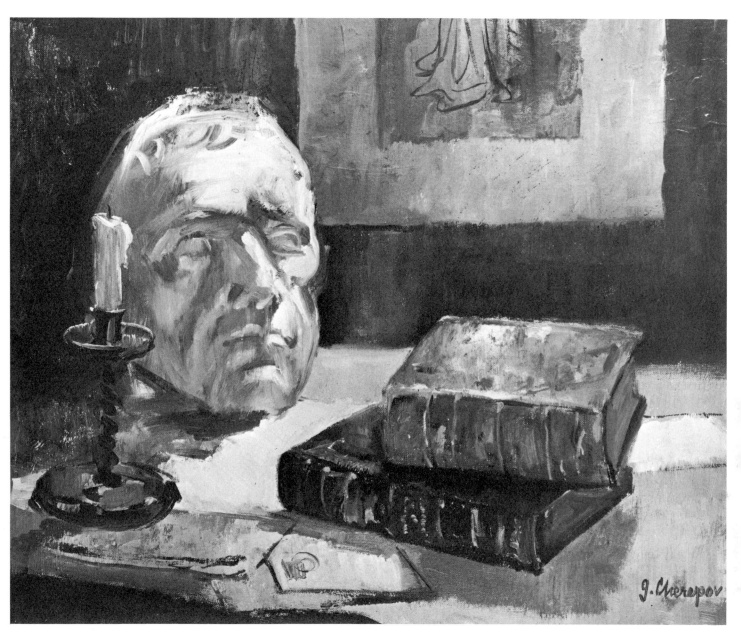

Still Life with Sculpture. *In the final painting, the finishing touches are rendered: the highlights on the candlestick and on the books; and the loosely defined calligraghy of the picture in the background, the titles of the books, and the marks on the letter paper.*

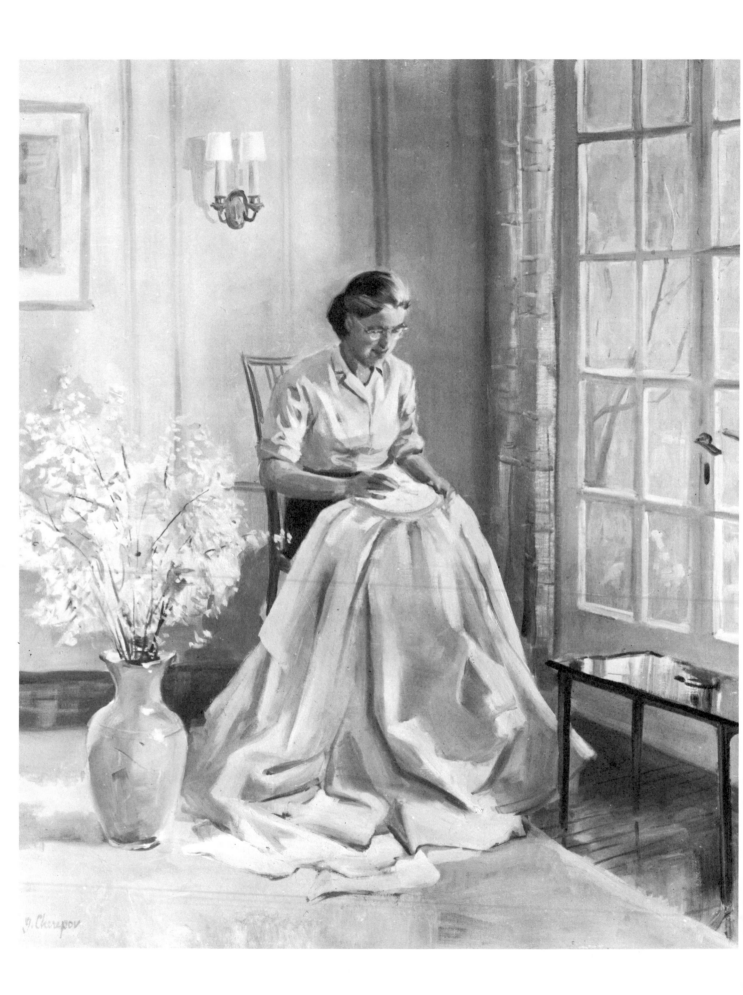

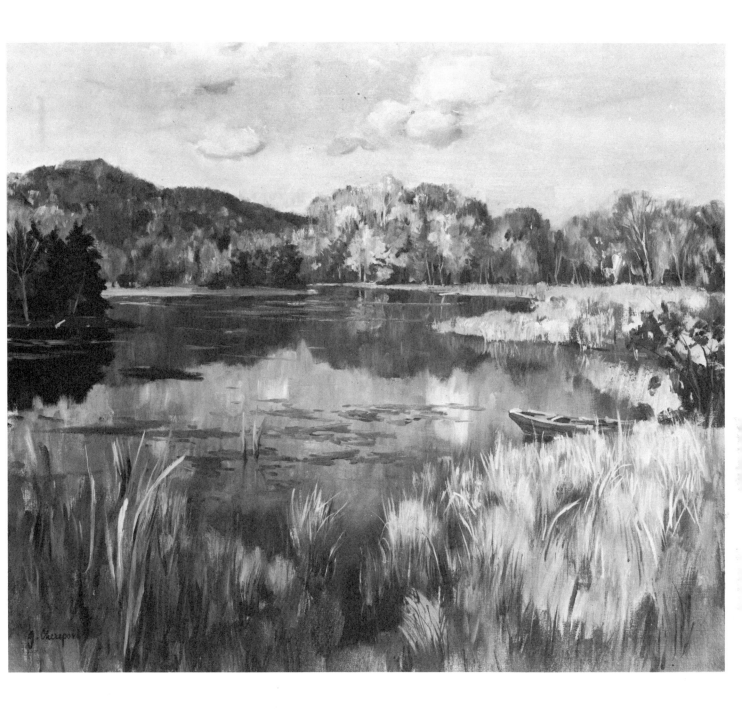

(Left) Quiet Hour, *34" x 30". My wife was embroidering a piece of white cloth on a sunny spring day. The draping of the folds created, in this contemporary setting, a design reminiscent of the elaborate attire so much admired in seventeenth and eighteenth century paintings. To appreciate this design, try to visualize the same scene without the fabric and its folds. This theme has a white wall, white rug, white vase, and white cloth, interrupted only by the yellow of the forsythia and the warm light green colors behind the door. A major tone palette was applied here. A subtle tone-value relationship in a light key was my primary concern, rather than bright contrast of pure colors.*

(Above) Serenity, *30" x 36". The tone-value relationship is important in this painting. The light reflections of the sky blend gradually to the darker value of the water. The degree of darkness has been established in reference to the darkest area of the pine woods in the shadow. To correctly establish the value of the water near the foreground, its relationship to the light area of the water and to the dark area of the pine trees must be checked. There are two reasons for the water being darker in the front: first, the clear sky is lighter near the horizon and darker at the top, and the image is reversed when it is reflected in the water; second, the area near us is seen from above, and therefore the values are influenced by the dark pond bottom. Courtesy Grand Central Art Galleries, New York.*

52 and 53) in terms of the elements we have already discussed.

The subject — still life — is composed from the objects belonging to the theme: old books, candle, sculpture (head of an ancient Roman poet), a few letters, an etching on the wall.

The composition (space arrangement) is established with a few pale outlines; the books are indicated in the visual center, and the parallel horizontal lines of the table are counterpointed by the verticals of the candle. The rectangular shape of the etching on the wall breaks the monotony of the large background area.

The form of this still life is expressed in a variety of shapes. Note that the books are based on the cube shape. Since we see the top of the books, we are aware that they are placed below the eye level. Following the lines of the edges of each book up, we define the vanishing point on the imaginary eye level line, which is above the painting. Through placing each of the books in a different position, we naturally achieve different vanishing points. In this case, the book underneath has a different vanishing point than the book on top, but both points will cross the eye level line. The candle holder and the candle are based on the cylinder form, and are below the eye level: we see their tops and bottoms as ovals.

The values in this painting are built on the principle of great contrast from high to low. The source of light is located on the upper right. Consequently, all objects are highlighted from above, and so create shadows on the opposite side. The highest value is in the visual center of the canvas, on the white sculpture, on the surface of the table, and in the highlights on the leather cover of the top book. Notice how the reflected light from the table emphasizes the characteristic structure of the face on the shadow side of the sculpture.

Applying this method of analysis to your own work will help you to find the answer to many of the problems you are faced with in this process of painting.

Summer Bouquet, *30" x 24". The lavish colors of this painting offer an example of a major tone palette setting. The subject required a great many colors in their pure hues, so cadmium yellow medium, cadmium organge, violet, and rose madder were added to the basic palette shown in Fig. 35. Color is the main compositional element of this painting and greatly influenced the space arrangement: the flowers are in the large are of the visual center, while the vase and the background are given secondary importance. To keep the values of the large areas surrounding the flowers in a high key, a light sunny terrace room with a large window facing the ocean was chosen. The flowers were arranged to form a harmony of yellos, oranges, and reds. A cool blue drapery was placed next to the bouquet to strengthen the impact of the warm colors of the flowers.*

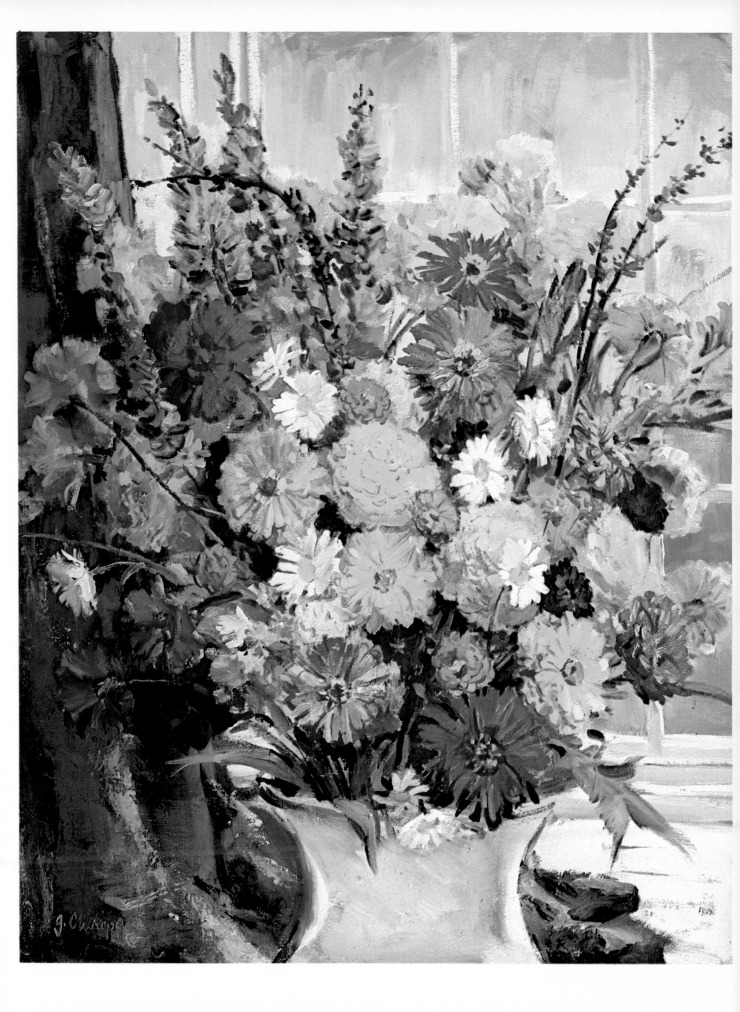

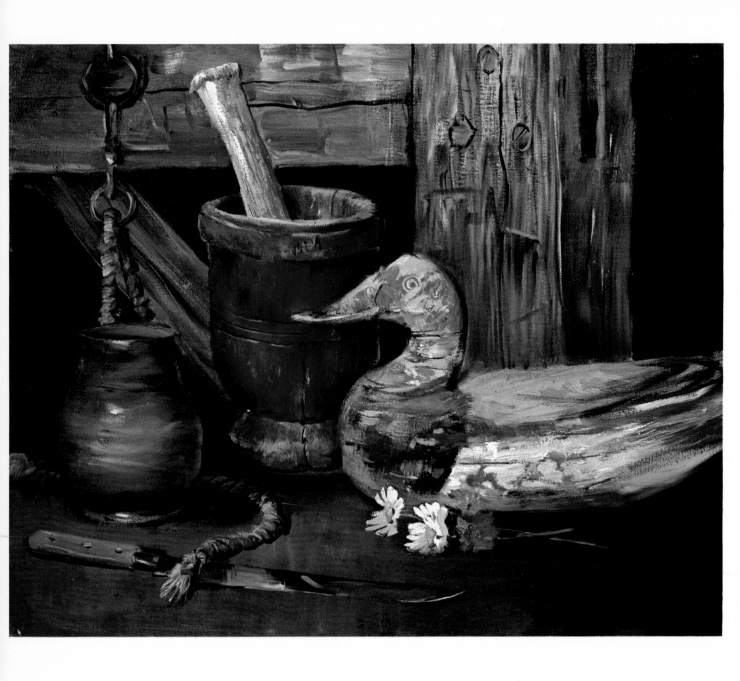

Still Life with Decoy, *16'' x 20''. This old wooden decoy, with its partly peeled-off colors, is an interesting object for a still life setup. It is placed in the visual center of the picture space. Because the decoy is basically a horizontal shape, it required a vertical balance. A light gray jug with blue decoration and a smaller pot in a dusty, cool blue color complete the triangular shaped composition.* Private Collection.

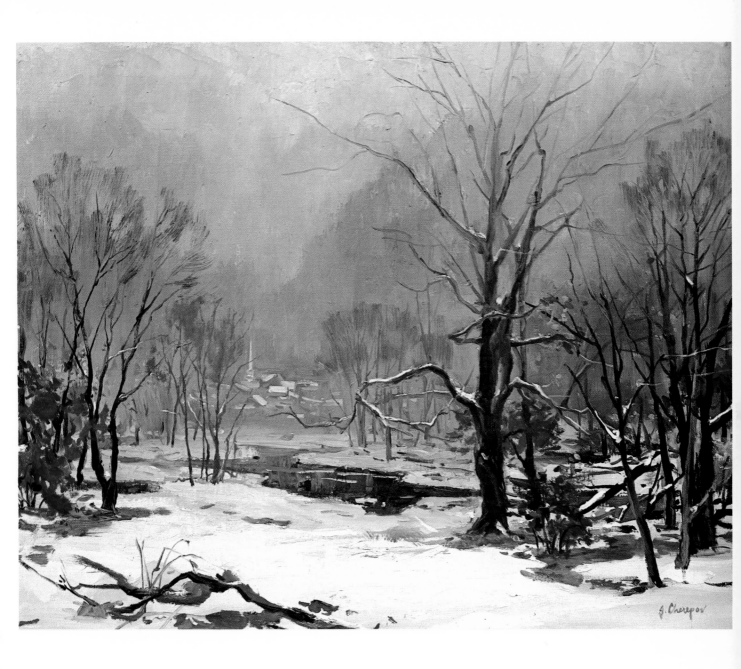

First Snow, *24" x 30". The wintry mood of this scene suggested a very narrow minor palette based on Prussian blue, Indian red, and yellow ochre pale. A touch of black was added to the trunks of the trees in the foreground. Note the density of the air as it melts the values of the mountains in the distance to very subtle nuances of grays. The maximum contrast in this painting is offered by the black silhouettes of the trees against the white snow. Private Collection.*

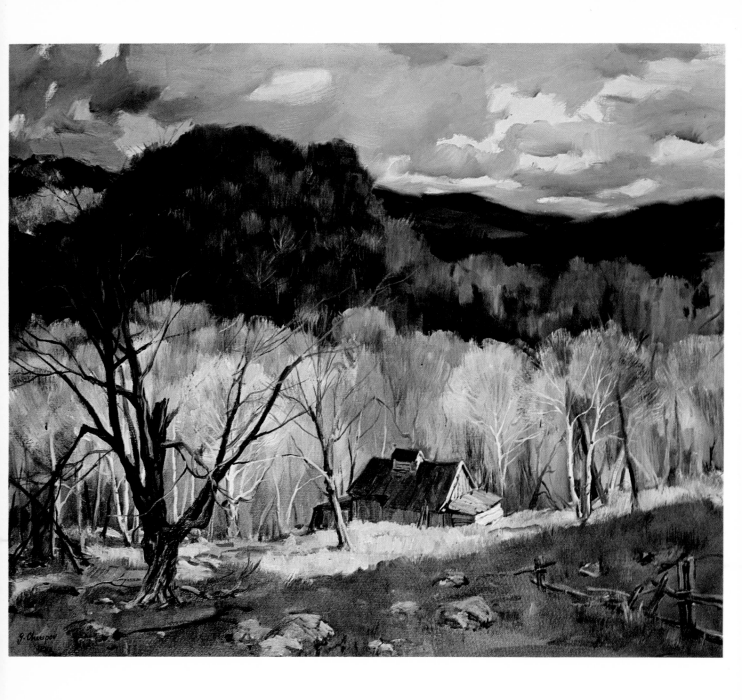

Vermont Hills, *36" x 30". This mountain scene presents a beautiful color relationship between the deep blues of the distant mountains and the light grays of the nearby trees. Sunlight, breaking through the heavy clouds, emphasizes this color relationship. This is a fine example of a painting done in the minor palette, based on Prussian blue, Indian red, and yellow ochre pale. An old maple sugar house and sugar maple tree add to the design in the foreground and give depth to the horizontally rolling hills and clouds.*

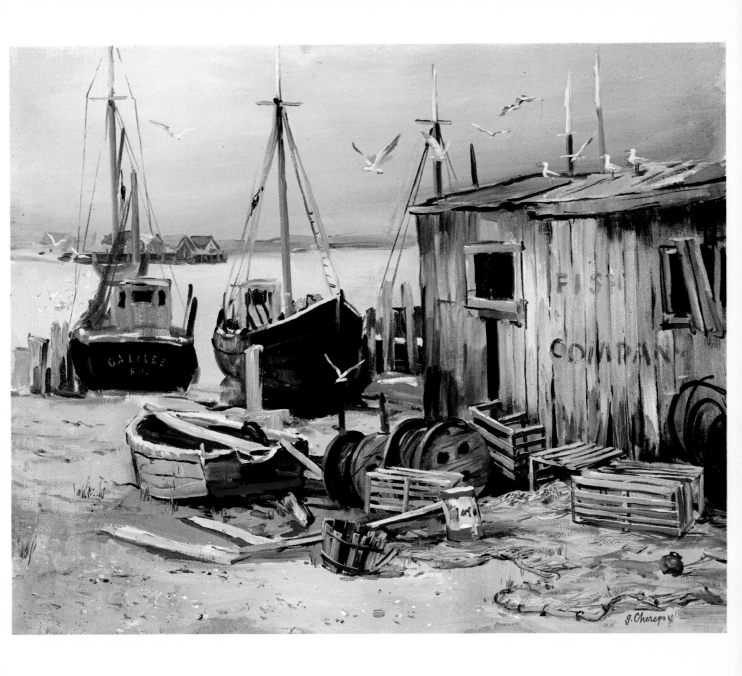

Galilee, Rhode Island, *24" x 30". The sea is often confined to the second plane of a seascape, leaving the first plane to the docks, shacks, old barrels, lobster pots, and simple rubbish that characterize a professional fisherman's backyard. The smell and lure of the sea found in such scenes attracts cats, seagulls, and, most of all, painters. Private Collection.*

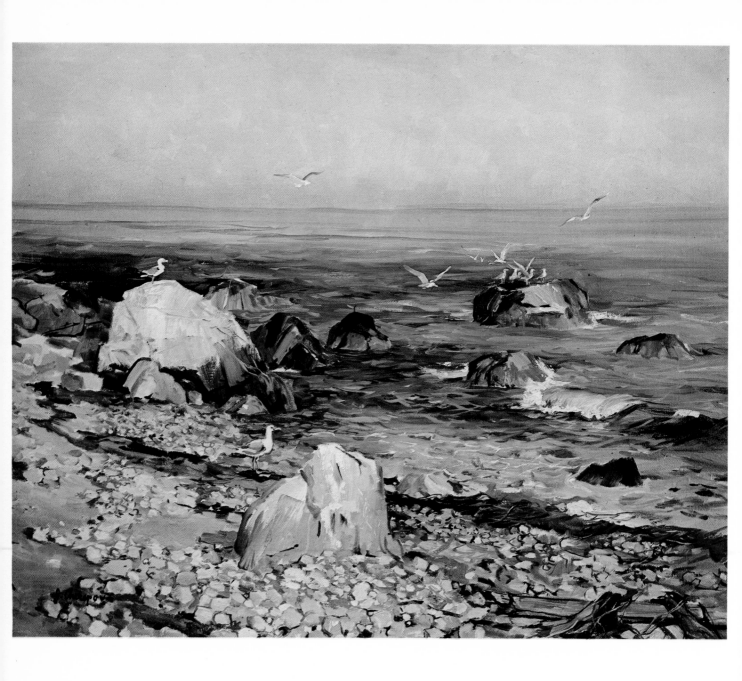

Morning on the Atlantic Shore, *24'' x 30''. Here is an example of the variety in size, shape, and color that is found in nature. Examine these rocks: the rocks beyond the reach of the tide are dry, bleached by the sun; they are lighter than those which are wet, near the water. The wet rocks, partly covered with seaweed and shells, appear orange, yellow, green, and brown. The larger rocks have different, more irregular forms and sharper edges than the smaller rocks do, as the smaller ones are ground into smooth shapes by the action of the waves. Seagulls are also part of the scene. Courtesy Walter Wallace Galleries, Palm Beach, Florida.*

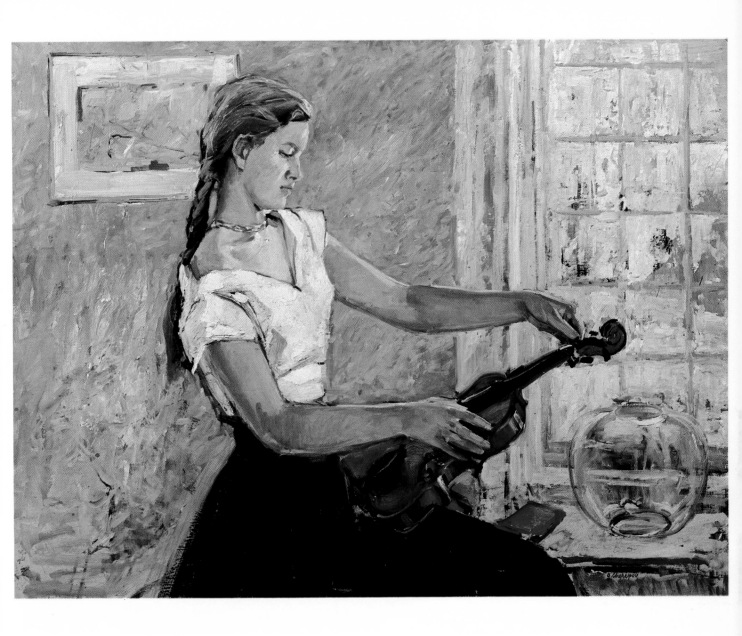

My Daughter, *32" x 38". The youthful mood of this subject suggested light values and warm colors. The wall space was painted with vibrations of the three primary colors, with a pinkish overtone. A part of the window in the background was a source of light on the model, accenting the fresh flesh colors and the white blouse. The window also provided a vertically shaped area, which was necessary to balance the long horizontal space of the wall. The painting on the wall counterbalances the hands holding the violin. Notice how the figure overlaps all the background areas — painting, wall, and window.*

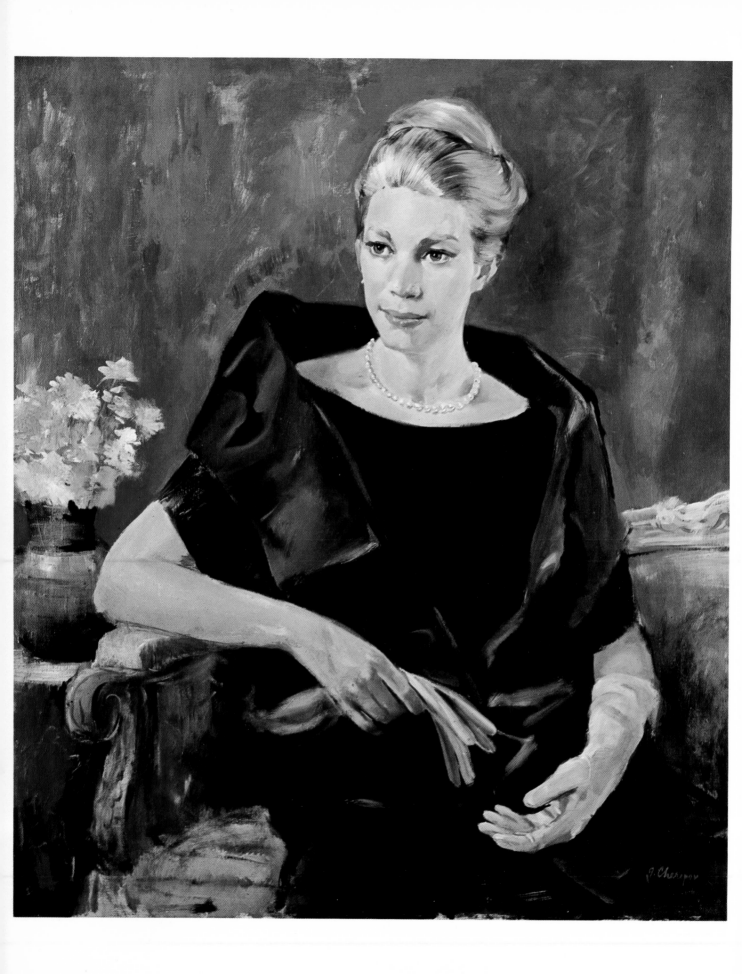

8. Color

Finally, we come to the most exciting element of painting, color. Needless to say, extensive study is necessary for its most effective use. For the beginner, it is advisable to first get acquainted with the terminology used in the description of color.

Hue

Hue is synonymous with the identity of the pigment — red, green, blue, etc. When we say, "The lemon is yellow" or "The tree is green," we talk about its hue.

Value

For every hue there is a range of values — from the light, or *high*, value at the top descending to the dark, or *low*, value at the bottom.

Intensity

The degree of intensity of the hue depends on how the color is mixed with other pigments. Through

Mrs. J. Neighbor, *34" x 30". The first concern of this portrait was with the color relationships of the three large areas: the skin and hair, the dress, and the background. The pale color of the skin and the platinum gold of the hair contrast with the black dress; the red background, modified by a touch of cobalt blue and alizarin crimson, adds a festive quality to the sitter. The grays of the antique sofa harmonize with the black dress, white gloves, and small bouquet of colorful flowers and soften the static formality of the pose. The second concern was with the design of the forms: the position of the head, shoulders, and arms and the space to be occupied by the figure. The position of the shoulders, influenced by the position of the arms and the slight turn of the head, create a natural and relaxed appearance, in keeping with the elegance of the subject. A slow painting technique, using several layers of paint, was used for this portrait. A soft sable brush was used for the fine, delicate finishing touches.*

adding another pigment, you lower the intensity, regardless of value. For example, if we speak of a painting done in black and white, or in monochrome, we can analyze only the tone value ranging from high to low in the same color. In a full color painting we talk about intensity of hues and values.

Warm and Cool Colors

Other terms used more frequently referring to colors are *warm* and *cool*. Red, orange, yellow, and brown are considered warm colors; blues and blue-greens are cool colors. But each color in itself can be graded from warm to cool, as well. For example, adding yellow to green makes it warm; adding blue to green makes it cool. As the painter becomes familiar with these color identifications, he will be able to memorize the colors while painting outdoors, where time like, "Hue — blue, value 30%, lower and somewhat cooler above, gradually warmer below" will be of great help in painting any scene — landscape or seascape — from memory in the studio.

Primary Colors

There are three primary colors: *yellow, red,* and *blue.* All other hues may be obtained by mixing these three primary colors. But none of these three primary colors can be obtained from mixing any other colors.

Secondary Colors

The mixing of equal amounts of two primary colors gives us the secondary colors: *orange* (red and yellow), *green* (yellow and blue), and *violet* (red and blue). Logically, by changing the proportion of each of the two colors, adding very little blue to yellow, a light green will be obtained. But moving closer to blue and reducing the yellow, a cool, low-value,

bluish green will result. The same changes of nuance will take place with the other colors.

Complementary colors

Complementary colors are colors which are opposite, such as red and green, blue and orange, yellow and violet. By mixing them together, one can partially neutralize their individual intensity of hue.

It is difficult to establish rules in color mixing, since this is a field in which the painter may find a way to express himself but must, at the same time, be aware of the basic principles governing color mixing.

To obtain a desired color, avoid intermixing more than two or three colors (other than white). The reason for this limitation is that by mixing an increasing number of different hues, the intensity and brilliance of the basic color is diminished and it will appear duller, and even muddy, to our eye. By using only two, or a maximum of three, colors (besides white), and by mixing them briefly directly on the canvas, their intensity and brilliance will be preserved.

The painter should not dip his brush all over the palette in the hope of accidentally achieving a desirable color combination, but should first give thought to which color and in what proportion will give the desired result.

Color Mixing

Intermixing the secondary colors produces a variety of browns and grays. But, as I stated before, extensive intermixing merely produces a duller variety of one of the secondary colors. Speaking of gray, the beginner usually attempts to achieve it by mixing black and white. Unfortunately, this produces a very cool gray which seldom harmonizes with other colors.

A variety of grays may be obtained by intermixing red and green and adding white, or by using brown with a touch of cobalt blue (or ultramarine blue) and adding white, or simply by mixing all three primary colors. White and black are not counted as colors. White will be added in any case for adjustment of values. Black is very rarely used, because it has a tendency to neutralize the intensity of the hue. Many painters avoid using it. In certain color combinations, however, mixing black and light yellow will produce a peculiar green, seen in pine trees, folds of velvet drapery, etc. But as you will see through practice in mixing the primary colors, a great variety of colors can be obtained from them which will enable you to make a painting; and when

you add browns and green to your palette, this will be sufficient for most of the study period. Bear in mind that the three primary colors can also be of different nuances, divided into the major and the minor palettes.

Major and Minor Palettes

Following are two different nuances of primary colors, with suggestions on how to use them in different paintings according to the mood suggested by the subject. Let me call them by terms synonymous to the moods in music: *major* and *minor* tones. The *major* palette is used when the subject is based on bright, intensive colors. For instance, for a bright, sunny landscape, use a palette dominated by the three primary colors, cadmium yellow light, cadmium red light, and cobalt blue (and white). The *minor* palette is used for a subject where grays dominate. A stormy mood can be expressed with the three primary colors, yellow ochre pale, Indian red or *caput mortuum*, and Prussian blue (and white).

I would not advise using both palettes together, especially because of the Prussian blue. It is a very strong color, and it is very overpowering and hard to control when mixed with cadmiums. But in combination with Indian red it produces very delicate purplish grays, and mixed with ochre it results in greens which stay in harmony with the other colors of the scheme. Experiment with these two separate palettes; explore their possibilities. Burnt sienna may be sparsely added to both major and minor palettes if necessary.

Composition with Color

In discussing composition, I have mentioned the influence that color can have. Color composition has rules similar to those of space division. Avoid introducing two complementary colors in equal size areas. This will split the view into two equal units, and therefore weaken the impact of both of them. On the contrary, introducing one color in a dominant area and the second complementary color in a subordinate space gives more impact to the composition.

In *My Daughter* (p. 63), the large area of the upper part of the painting, including the girl's figure and background is painted in warm, light colors. The cool, low-value blue of the skirt emphasizes the expression of light. Another painting, *After April Shower* (p. 48), demonstrates how the large areas of the dark, cool blue sky, including the shadow in the right part of the painting, emphasize the expression of light in the foreground. The same subject may be

arranged in many different ways by changing the relationship of space and color; we can see the influence color has on composition.

Further study and experiments with color should develop a sense of color relationships. Studies can be made by arranging different objects of the same hue (red or yellow, for example) in a still life. Select a variety of sizes, shapes, and textures in a wide range of a single color and paint them.

Flat and Broken Colors

Other terms one meets in the description of colors are: *local, flat,* and *gradated* or "broken" colors. Local color is a thoroughly mixed and uniform color. The housepainter uses this to paint walls evenly. Flat color is similar; the painter mixes a uniform color on the palette before he paints the canvas. Gradated colors are usually mixed directly on the canvas in order to introduce a great variety of light and dark and warm and cool colors, preserving the intensity of hues as much as possible. A painter may apply one color on the canvas first and then add another one, breaking into it. Here is where the expression "broken" colors originates. These separately applied colors may be worked together on the canvas in small brushstrokes, creating a vibration of colors. Close up, these small brushstrokes are clearly identifiable, but by increasing the distance between the painting and the viewer, the colors will flow together into one color, strongly expressing the light and atmospheric depth in the painting.

Don't forget that although the housepainter prepares his color by thoroughly mixing it to achieve a perfectly uniform local color on the wall, a painter, painting the same wall in a picture, sees it exposed to light and shadow and to the colors reflected from surrounding objects. He cannot paint his wall the same way that the housepainter does. To express the influence of light, he cannot use only one local hue, but must move the colors constantly, modifying them in values and intensities of warm and cool.

At the end of the last century, the impressionists experimented in this direction, putting emphasis on broken color vibration. The pointillists carried broken color to an extreme, quite mechanical method. The three-color printing process is also based on the principle of points and dots. If you examine a color print through a magnifying glass, you will notice that the print actually consists of many small points, representing each of the three primary colors separately in a variety of values. In other words, the three-color printing process achieves, with three separate plates, the same color result as the artist does in his painting.

Contrast

Many students today favor the brightest contrasts of pure hues. There certainly are themes where this approach may be justified. It is an approach which has, to a large extent, been influenced by fashionable interior decorating, where large areas are occupied by strong colors such as orange, purple, bright green, etc., and even the hostess is wearing a shocking pink gown and sitting in a green armchair. It is indeed difficult to visualize a painting of subtle nuances when looking at such a scene.

I recall an experience I had when I moved into an apartment. The landlord proudly showed the rooms with the remark, "I love colors." And he certainly did! The living room was dark green, the adjoining dining room was bright red, while the kitchen was as strong a yellow as you could find. My attempt to hang a painting on any of the walls failed completely. All that I could hang was a drawing in a white mat. Brightness of color is not always a virtue!

Color in Nature

At times, even nature does not offer the best color arrangement. While it is the painter's privilege to "correct and adjust" a landscape, please do not misunderstand this. Nature is still an excellent designer, as the amazing beauty and imagination in color relationships, in form, and in composition in birds, fishes, butterflies, flowers, rocks, etc. show. Endless inspiration for color relationships and color compositions can be drawn from nature.

The Basic Colors

The nine colors indicated in the following list are selected from the more than one hundred colors offered by manufacturers:

White (flake, zinc, or titanium)

Yellow ochre pale

Cadmium yellow pale

Cadmium red light or scarlet red

Alizarin crimson

Burnt sienna

Burnt umber

Viridian green or permanent green dark

Cobalt blue or ultramarine blue

Here is the basis for my selection. The three most important colors are yellow, red, and blue — repre-

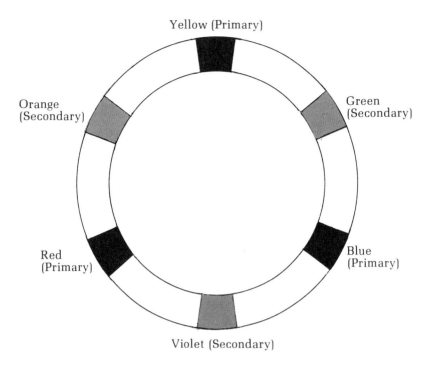

Figure 34: Color Wheel. *This color wheel shows the primary and secondary colors.*

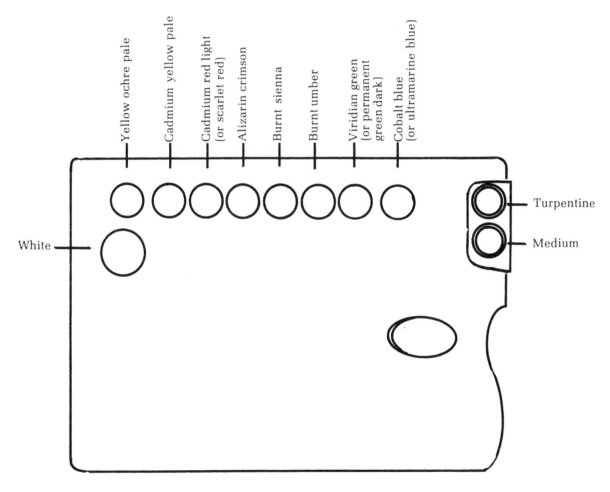

Figure 35: Basic Palette. *Here is a limited palette with the basic colors that you will need for painting any subject.*

sented on your palette as cadmium yellow pale, cadmium red light or scarlet red, and cobalt blue or ultramarine blue. None of these three colors can be obtained through mixing. They are basic. But by mixing yellow, red, and blue, a great variety of nuances in oranges, greens, purples, and browns can be achieved, as the color wheel in Fig. 34 demonstrates. By adding white to all these colors, you can modify tonal values and develop further nuances. To widen the range of these nuances, five more colors are added: yellow ochre pale, alizarin crimson, burnt sienna, burnt umber, and viridian green or permanent green dark.

This limited yet completely sufficient palette will enable you to paint any subject (Fig. 35). Naturally, the occasion will arise in which a particularly strong local color — in a flower or draperies, for example — will call for an additional special violet or green.

Experience shows that all sixty colors set on the palette do not help produce a better painting. On the contrary, painting becomes more complicated and confusing when you have to deal with sixty colors and their mixing possibilities. When you study color theory further, you will learn that mixing more than two or three colors together neutralizes the intensity of each and creates "mud." Naturally, the more colors on your palette, the greater the danger of overmixing them.

Different painters choose different colors, according to their taste and style of painting. Some artists expand their palette to include as many as sixteen colors. I would suggest you postpone making any firm decisions about your color palette until you have acquired more knowledge through study and extensive experimentation. It might well be that you will later return to the recommended nine-color palette — as happened with me.

White

It is practical to buy paints in size 14 tubes. White, which is used more often, should be purchased in the bigger, size 40 tube. Speaking of white, the question often arises as to which white to use. The opinion of painters is radically divided among flake white, zinc white, and titanium white. Titanium white, which is relatively new, has not been around long enough to test its permanence. Nevertheless, it is considered a permanent non-yellowing white. In my opinion, beginners need not be concerned about which white to use.

Quality

I would like to mention that not all colors available on the market are equally permanent. In time, some colors lose their original brilliance and darken, or they affect other colors mixed with them. All the colors recommended, however, are reasonably permanent.

Speaking in general about the quality of oil colors, when you pay a higher price, you can expect a better quality paint — one which contains more pigment and has better covering power. Low priced paints are of inferior quality.

Presenting a Painting

Paintings must be presented carefully on a wall of suitable color. For instance, a white wall as background would overpower paintings with subtle tonality and dark areas. From the distance of ten feet, such a painting would create the impression that it is a heavy dark spot on the wall.

I mention this thought in passing simply to call your attention to another aspect of color in painting: you should be aware of, and in certain instances consider, the surroundings in presenting your work. I do not mean that a painting should be created in order to match an existing decor. On the contrary, the decor should be chosen to feature the best in a particular painting.

(Left) **Dusk,** *30" x 24". The sky is the palest area in the painting. The church steeple, although white, appears darker against the sky. The melting snow is also white, but it has a different nuance of color under the influence of the reflected light from the sky. Large, very dark trees create a strong design and contribute to the distance between front and back planes. They were drawn with definite, strong brushstrokes over the already painted, but not yet dry, sky and hills. The branches were done with a small sable brush, the heavy treetrunks with a large bristle brush. The texture of the bark on the treetrunk in the foreground was produced with a palette knife. Private Collection.*

(Above) **Village in Vermont,** *16" x 12". To express the brightness on the snow and the roofs, the values of the surrounding areas were carefully adjusted. The tone value was first established near the lightest area, leaving the white canvas as the highlight. The group of houses and the church were formed by silhouetting them while painting the background with a No. 7 bristle brush. At the same time, the difference in colors was observed. For instance, the white walls of the houses, receiving the reflected light from the snow, appear warmer than the mountain behind where there is more blue. After most of the colors and the value relationships were established, details in the drawing were accentuated with a small (No. 7) round sable brush. The trunks and branches were painted with the point of this brush, applying only light pressure and moving from the ground upward, following the movement of growth. As the branches become thinner toward the end, the pressure on the brush was gradually reduced. A larger bristle brush was used to shape the treetop, and the transparent texture of the small branches was produced by holding the brush flat, in a dragging stroke, without pressure. Courtesy Deeley Gallery, Manchester, Vermont.*

PART THREE: OIL PAINTING TECHNIQUES AND DEMONSTRATIONS

The great advantage of painting in oils is that the medium is receptive to a wide variety of techniques. Oil paint can be applied in smooth, thin coats; it can be applied in thick, vigorous strokes (the impasto technique); one can paint wet-in-wet; or upon layers previously underpainted and dried. By learning the behavior of colors, you will be able to consciously plan a painting ahead of time in accordance with its individual style. Neglecting this study may lead to disappointing experiences.

9. Technique

There are a number of techniques available to the oil painter. These techniques will be discussed in this chapter, beginning with the basic direct method.

Direct Painting

Direct, or *alla prima*, painting is technically the simplest method of painting. Paint is applied over ready-primed canvas wet-in-wet (see color demonstration of *Numo* painted in the direct method, p. 96, for an example of *alla prima* painting. In exploring this method, you will find that it is preferable to use more pigment on the brush, adding a little medium for easier application. *Alla prima* painting has the important advantage of capturing the first impression briefly and spontaneously. It is the only method by which to study the finest relationships in values and colors directly from nature. However, a painter is required to have a background in draftsmanship, as well as skill in handling brushstrokes, to avoid undesirable overmixing of paints through corrections. What this all amounts to is this: the painter must be able to simultaneously control, with the same brushstroke, *form*, *value*, and *color*. For beginners, it would be easier to practice first on the simple objects of a still life (see Fig. 37). Remember not to paint over a half-dry painted surface.

If you want to continue painting on the second day, you may slow down the drying process by storing the painting in a cold, dark place. Check the surface by touching it with your finger. If it has already built up a skin, then let it dry completely in a warm, light room for several days.

Preparing a Dry Surface

If you have not succeeded in completing the painting in wet-in-wet, the dry surface should be prepared for proper binding before applying a new coat of paint. You can either rub in the medium (1/2 linseed oil, 1/2 turpentine) with a wide, flat brush or use a retouching varnish which will also refresh dull spots. I personally prefer the following method:

(1) After making sure that the previous layer of paint is completely dry, rub the surface of the canvas with a medium grain sandpaper — to prevent any damage by pressure, protect the canvas with a piece of board held against the back of the canvas (Fig. 36, above).

(2) Mix 1/3 turpentine, 1/3 alcohol, and 1/3 water in a bottle; shake this emulsion well before using it; wash it lightly over the surface with a soft cloth (Fig. 36, below).

(3) After about five minutes, rub in the medium (1/2 linseed oil, 1/2 turpentine) with a large, flat brush. Let the medium penetrate the surface for about half an hour before painting. The previous layer of oil paints will become slightly softened and receptive to the next layer, whereupon you may resume painting without the unexpected surprises of changes in intensity of color or cracking that will result from painting over an unprepared dry surface.

To avoid damage, one should be cautious in sanding where the painting is delicate and thinly painted. Ancient painters used pumice stone, actually polishing the surface. The main reason for sanding is not to

(text continued on page 97)

Still Life with Kettle (Step 1). First, the space occupied by the large and the small objects was indicated. For this, I used a small, long hair sable brush and a pale color (white with a touch of yellow, thinned heavily with turpentine).

Still Life with Kettle (Step 2). The large spaces were then subdivided into individual objects and their basic forms were sketched in roughly. My primary concern at this point was with the proportions of the objects, their relationship to each other, and with perspective. Vertical lines were drawn through the centers of the bottles to make sure that they didn't lean. The oval bottom of the light green bottle and of the kettle were referred to horizontal lines drawn through their centers. The bottom of the dark green bottle is square, therefore it must have reference to eye level and vanishing points.

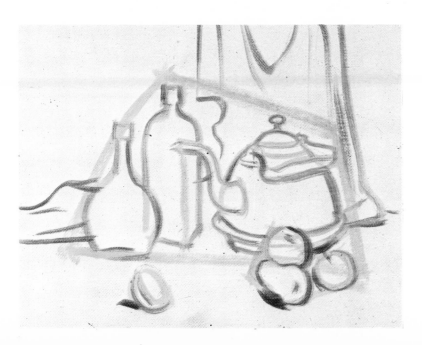

Still Life with Kettle (Step 3). After the rough sketch was completed, the outlines of the drawing were reinforced with darker color. At the same time, mistakes in the drawing were corrected. Then the essential details of the objects were drawn in.

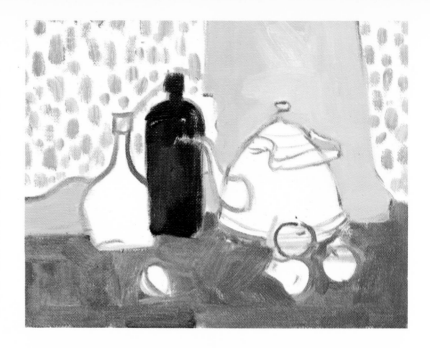

Still Life with Kettle *(Step 4). A large bristle brush was used to cover large areas of the canvas with colors which approximately matched the colors and values of the objects. No attempt was made to perfect every detail. The paint was taken from the palette with a full brush, adding some medium for smoother application. It was applied flat on the canvas with vigorous strokes, but was not rubbed in. The table was painted with yellow ochre pale, burnt sienna, white, and a touch of cobalt blue. For the dark areas of the dark green bottle, I used viridian green and burnt sienna; for the lighter, transparent areas, cadmium yellow pale was added. The drapery was painted with yellow ochre pale, cadmium yellow pale, and white.*

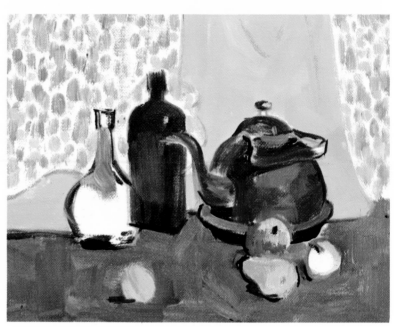

Still Life with Kettle *(Step 5). In the background, yellow ochre mixed with white was applied in separate, widely spaced brushstrokes over the entire area. Cobalt blue mixed with white was added in the gaps left between the yellow brushstrokes, and red mixed with white added to the remaining white spaces. The result is a vibration of the three primary colors. The kettle was roughly covered with burnt sienna and ochre. The fruit was painted with colors based on yellow ochre and red.*

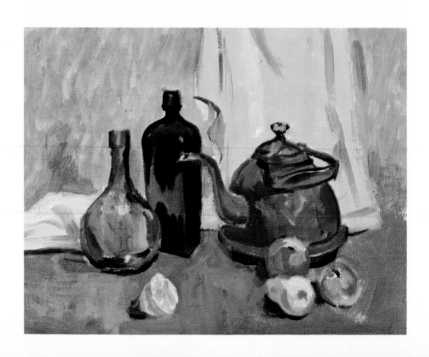

Still Life with Kettle *(Step 6). After the canvas was covered, I blended and adjusted the colors. In some places the color needed to be modified by adding another color to it, in other places the drawing needed to be modified.*

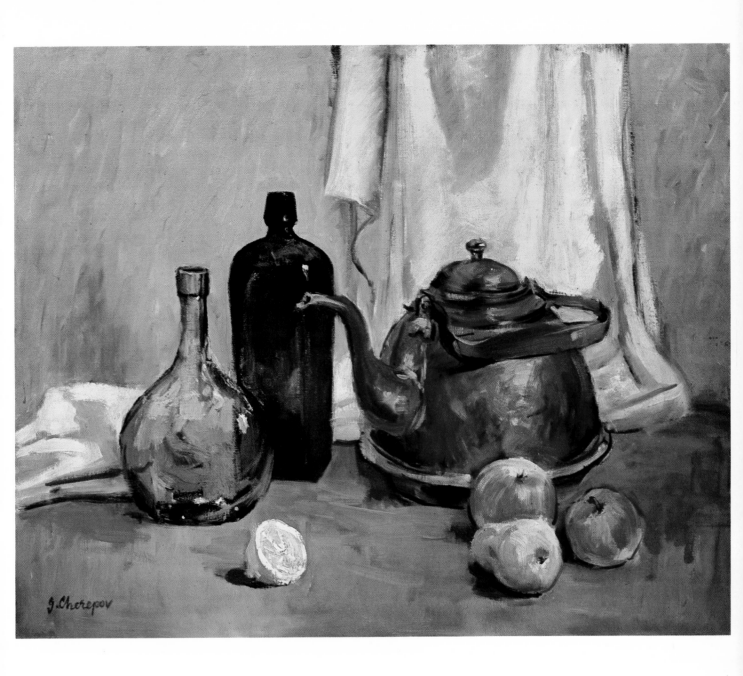

Still Life with Kettle. *In the final painting, the drawing was emphasized with a small sable brush and the finishing touches were applied with a large bristle brush in the drybrush technique. The dominant theme in this painting is the color relationship, so a general light was selected to best set off the natural colors of the objects: the warm copper color of the kettle, the dark green color of the bottle next to it, the lighter and cooler color of the smaller bottle, the bright touches of the fruit, and the warm colors of the drapery.*

Still Life with Pheasants *(Step 1). First, a very rough distribution of the large areas was made, indicating the location and size of all the objects. A touch of diluted yellow ochre was used for the drawing.*

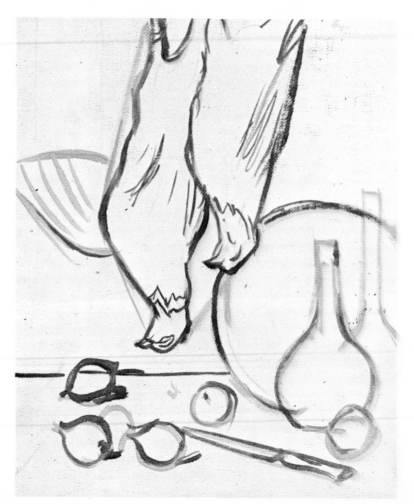

Still Life with Pheasants *(Step 2). Further adjustments of form were made and the correct lines were emphasized with a stronger tone value of burnt sienna. Any color may be used for reinforcing the lines of the drawing, except intense hues, such as Prussian blue or crimson.*

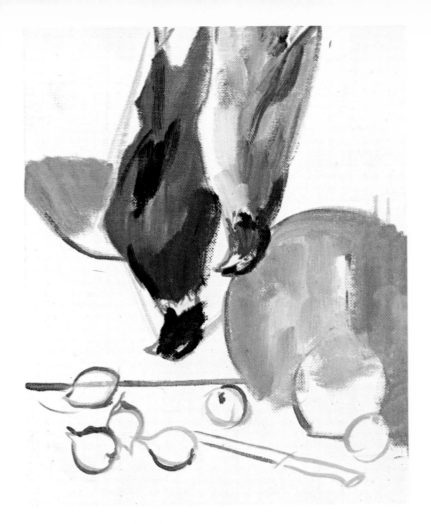

Still Life with Pheasants *(Step 3). After the drawing was established, the approximate color and value of the pheasants and the plate were painted with a large bristle brush. In this step, there was no need to attempt to achieve the exact color by long mixing on the palette. Adjustments are more easily made on the canvas, where the adjoining colors provide a better reference. The entire canvas was gradually covered with loose brushstrokes. The body of the male pheasant was painted with burnt sienna, cadmium yellow pale, and a touch of cobalt blue; the head was done with Prussian blue and Indian red. The female pheasant was painted with yellow ochre pale, burnt sienna, Indian red, and cobalt blue.*

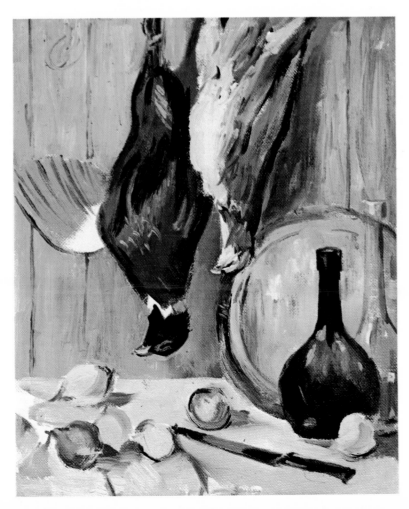

Still Life with Pheasants *(Step 4). In this step, I decided the final shape, value, and color relationships. The color of the wall is made up of burnt umber, cobalt blue, and a touch of crimson. Basically, the same colors were used for the tablecloth and the plate. The green bottle is viridian green and burnt umber, with a little cobalt blue and yellow ochre in the light areas. For the onions, burnt sienna was applied over yellow ochre and cadmium yellow pale, with a dragging, light-pressure drybrush stroke. The texture of the wooden boards was obtained by applying darker grays over the lighter background.*

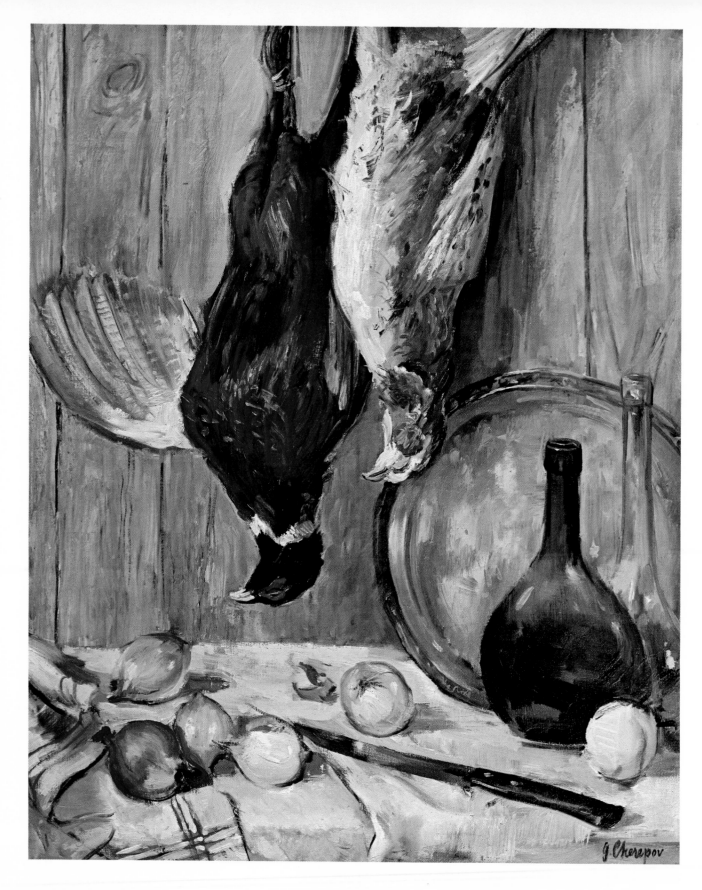

g. Cherepov

Still Life with Pheasants. In the final painting, we see a
hunter's trophy offering a magnificent color arrangement.
The green bottle was included because of its color harmo-
ny with the colors of the pheasants; the round metal plate
breaks the vertical lines of the pheasants and the bottle
and echoes the gray nuances of the background; and the
golden yellow onions and the bright cadmium yellow
lemon provide touches of bright color. The long, narrow
line of the knife completes this composition based essen-
tially on spherical forms.

Country Road *(Step 1). First, the large masses were distributed with a large brush, using very pale color (white with a touch of yellow ochre pale). Notice the freedom in the long, overlapping lines.*

Country Road *(Step 2). The large areas were subdivided into individual treetrunks and branches; details were disregarded.*

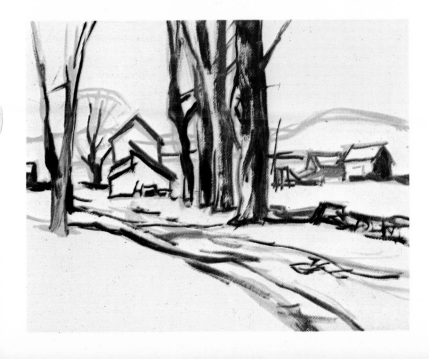

Country Road *(Step 3). The lines of the drawing were reinforced with darker color and strong shadows were indicated with a medium size brush to define the light.*

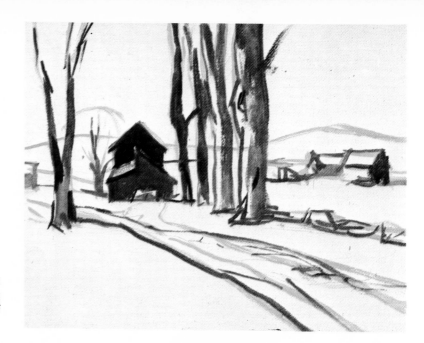

Country Road *(Step 4). The dark values were further emphasized, with the barn emerging as the darkest focal point and center of interest of the composition.*

Country Road *(Step 5). Then, using a large brush, the fields, buildings, and distant hills were painted in loosely, emphasizing the contrast in values. The shadow on the fields was done with burnt sienna and white to which yellow ochre pale was gradually added. Cobalt blue was added directly on the canvas for the cooler nuances. A great deal of white was added to the same colors for the light areas of the fields. Cobalt blue, crimson, and a touch of yellow ochre with white were used for the hills on the left side; the cobalt blue was reduced, and warm colors — crimson and yellow ochre — were added to white on the right side of the hills where the sunlight touches them.*

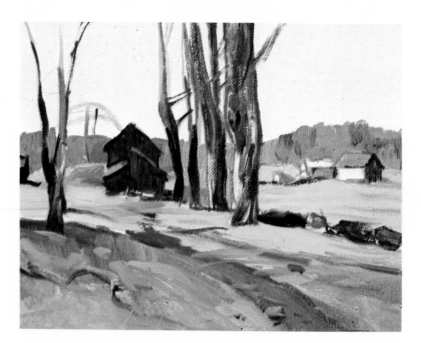

Country Road *(Step 6). The sky was added next — cobalt blue with white above, warming up with shades of yellow ochre with white as it moves toward the horizon. The trees on the distant hills were given texture, the lace-like branches of the tree behind the barn were filled in, and the bare branches of the trees were sketchily rendered. The ground, too, has taken on more detail. Note the more variegated textures and colors and the small pebbles along the road.*

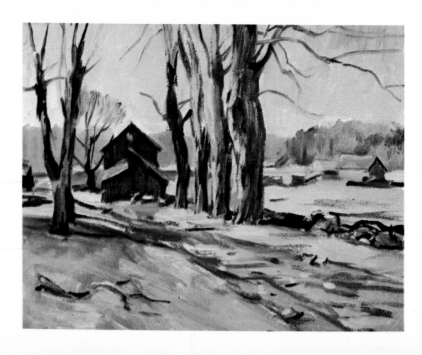

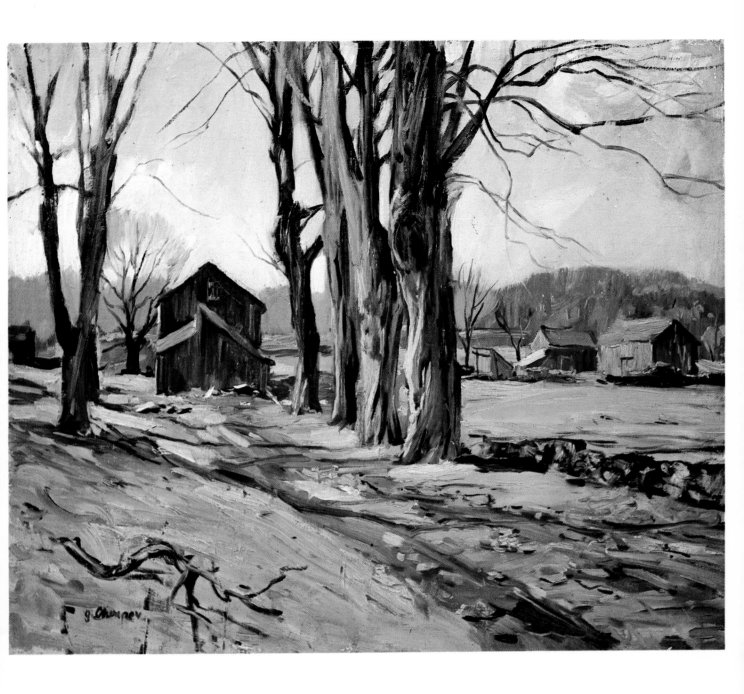

Country Road. *This painting, seen here in its final stage, was done directly on-the-spot outdoors on an afternoon in early spring. The grass is not yet green, and the season offers a harmony of warm earth colors based on yellow ochre. The still-bare treetrunks form a dynamic design in the visual center of the canvas; the sun, slightly to the left, silhouettes them against the light sky.*

Magic Autumn (Step 1). The space occupied by the pond and the trees was roughly indicated with a small sable brush and very pale color. Since speed is an important factor in on-the-spot painting, details were not included in this first roughing-out.

Magic Autumn (Step 2). I painted the lightest and brightest areas (in this case, the sunny sides of the trees) first, using a large bristle brush. The colors used were cadmium yellow pale with white, and a touch of cadmium red pale.

Magic Autumn (Step 3). Most of the large, light areas of the canvas were covered with large brushstrokes of the colors used in Step 2. Then the areas in shadow were done with viridian green and burnt sienna. The reflections in the water were painted at the same time as the objects themselves, with the same brush and the same color.

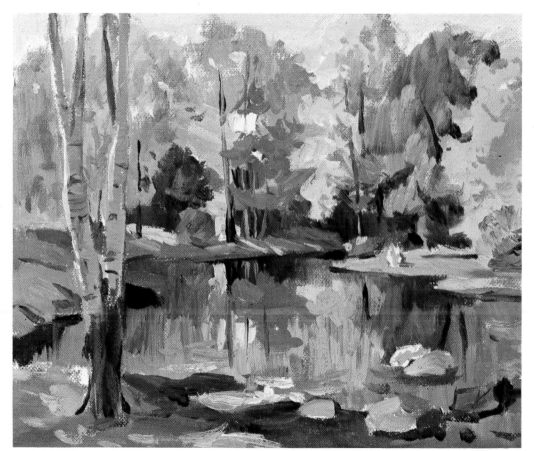

Magic Autumn (Step 4). The colors that had been roughly applied in Step 3 were then blended. Accents were emphasized and adjusted to be in harmony with the painting, and fine detail work on branches and foliage was done with a small sable brush.

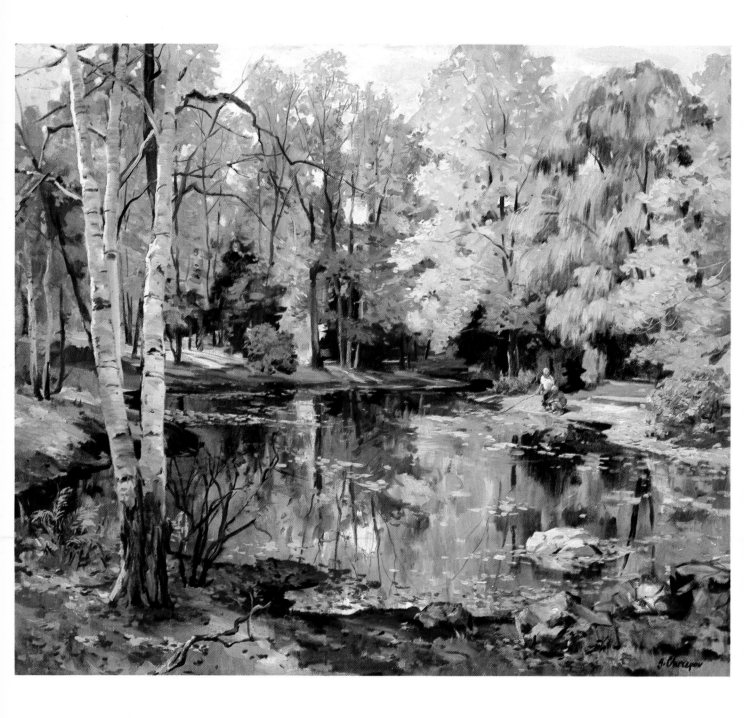

Magic Autumn. *The beauty of the motif of the final painting lies in the brilliance of its colors; it is necessary to observe and distinguish the variety of trees in their different coloring. The colors are repeated in the reflections in the water, creating a unique color harmony. Sunlight is the essential factor in amplifying the brilliance of the color relationships in this painting. Three colors were added to the basic palette shown in Fig. 35 (Chapter 8, Color): cadmium yellow medium, cadmium orange, and cadmium green pale.*

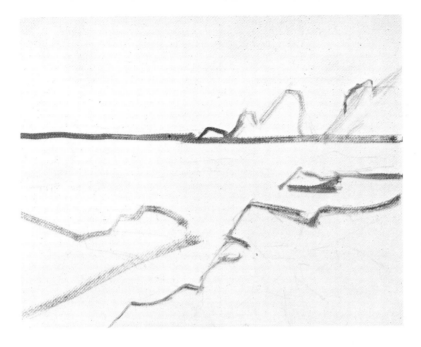

Pacific Coast (Step 1). First, the line of the horizon was established and the general outline of the large masses of rocks was indicated. For this, a small sable brush with pale color was used.

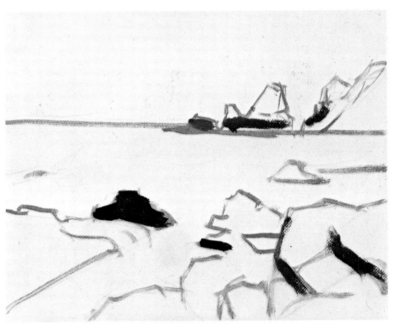

Pacific Coast (Step 2). The dominant rocks of the large rock mass were delineated with a dark color (burnt umber and cobalt blue). The darkest rock was rendered to establish the lowest value in the painting.

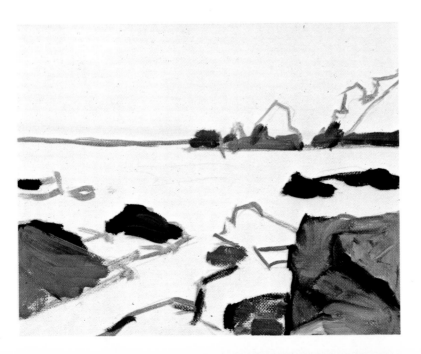

Pacific Coast (Step 3). Changing to a large bristle brush, I covered the rock on the left with burnt sienna, with a touch of cadmium yellow on the bottom and burnt umber at the top. The rocks on the right were painted with yellow ochre and burnt sienna taken from the palette without wiping the brush. To break the warm colors in certain areas, a touch of cobalt blue was added, which, seen together with the yellow ochre, results in a greenish nuance.

Technique 85

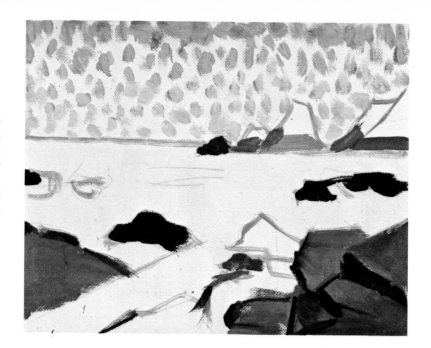

Pacific Coast (Step 4). *Before going further with the rocks, I painted the other large areas. It is easier to adjust color and value relationships referring to the areas of the sky and water instead of to the white canvas. A clean, medium size bristle brush was used to paint the sky, with the three primary colors — cobalt blue, yellow ochre pale, and alizarin crimson — plus white. Starting at the top with dark blue, short, free brushstrokes were made in horizontal rows, leaving white canvas in between. With each successive row, more and more white paint was added to the blue to heighten the value toward the horizon.*

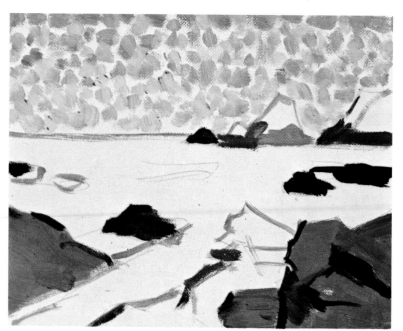

Pacific Coast (Step 5). *In the same way as in Step 4, yellow ochre pale was applied between the blue strokes, beginning with a darker hue at the top and gradually becoming lighter toward the horizon.*

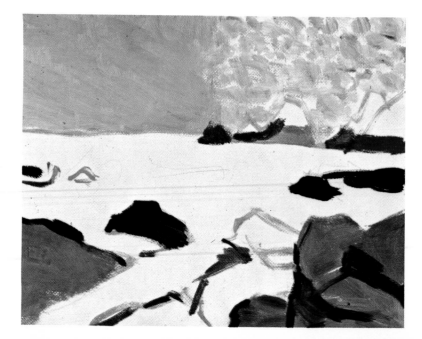

Pacific Coast (Step 6). *The last white areas left between the brushstrokes were filled in with alizarin crimson. Alizarin crimson must be used with deliberation because of its overpowering intensity; only a small amount need be added to white to create the pink color seen in this painting. For the sake of demonstration, the three colors used in this painting were blended on the left side of the sky only.*

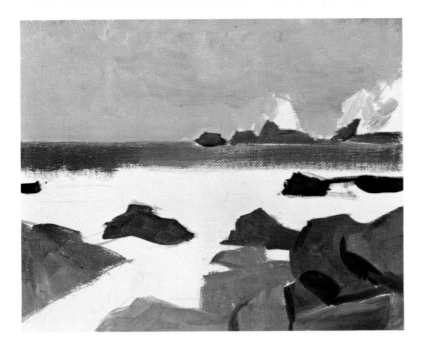

Pacific Coast *(Step 7). The degree of blending depends on the personal taste of the painter and on the style of the painting. Independent of the degree of blending in the brushstrokes, however, the gradual descent from the dark (cool) color at the top of the sky to the light (warm) color at the horizon must be maintained in order to express depth in the sky.*

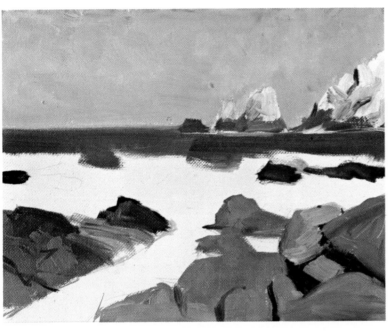

Pacific Coast *(Step 8). After the sky was done, the dark blue area of the water and the light distant rocks were painted. I used the same brush and the same three primary colors that were used for the sky.*

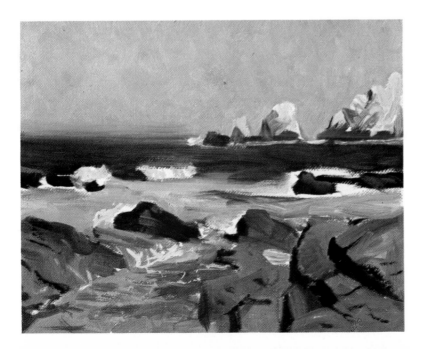

Pacific Coast *(Step 9). After the colors and the values of the surrounding areas were established, it was much easier to work on the area of light foam in the water. The transparency of the agitated water running over the sunlit rocks to the left in the foreground was one of the most complicated parts of the painting; the constantly changing design of the moving water made it difficult to identify forms and colors.*

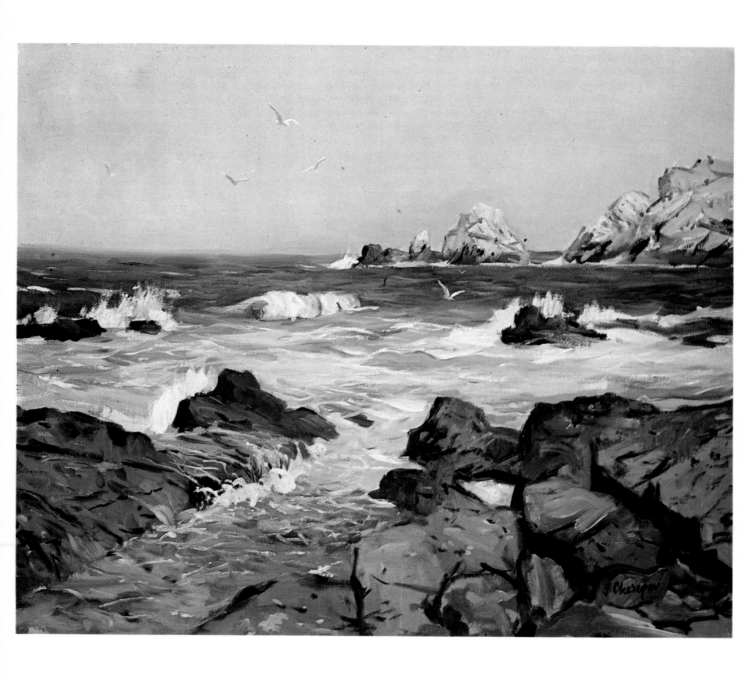

Pacific Coast. *In the final stage, the area of the sky and water was painted with the three primary colors, cobalt blue, yellow ochre pale, and alizarin crimson. Permanent green dark was added to the water in front. For the rocks in the foreground, cadmium yellow pale, burnt umber, burnt sienna, and a touch of cadmium red light were used in addition to the three primary colors. A few seagulls, done with a sable brush, complete the scene.*

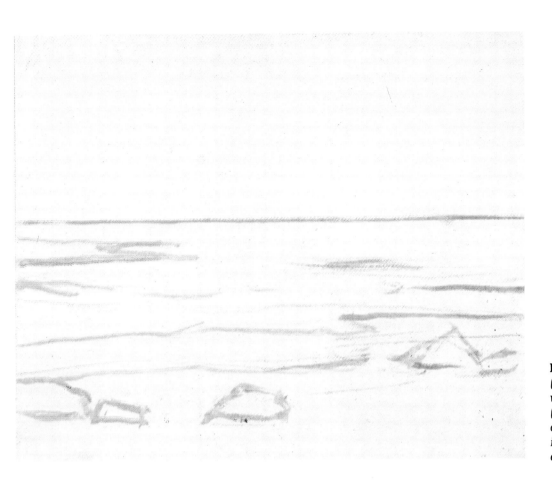

Low Tide on the Sound
(Step 1). The space division
was indicated with a small
(No. 7) long hair sable brush
and a very pale color. There
is no need for a detailed
drawing at this stage.

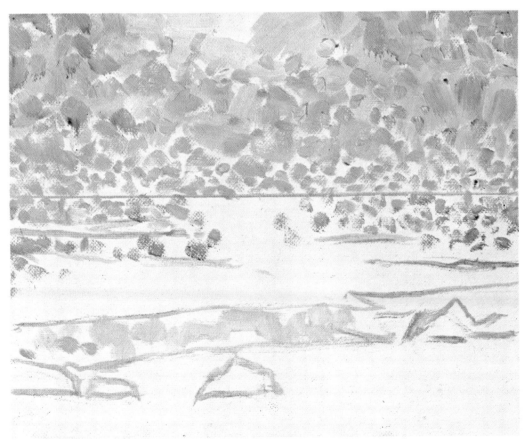

Low Tide on the Sound
(Step 2). The areas of sky,
water, and sand are vibra-
tions of the three primary
colors applied separately
and gradually mixed on the
canvas. The degree of val-
ues in each of these colors
was carefully controlled.
Since the air against the sun
is on the warm side, the first
color, yellow ochre mixed
with white, was distributed
in brief strokes with a No. 7
bristle brush. The next col-
or, cobalt blue, was mixed
with white on the palette to
the same value as the yellow
ochre and distributed in the
same manner in the gaps
left between the previous
strokes. It is important to
modify the values, adding
more blue to the darker and
cooler areas and less blue
nearer the light. There are
still white gaps left between
the brushstrokes for the
next application of color.

Low Tide on the Sound (Step 3). The next color, alizarin crimson mixed with white on the palette to the desirable light value, was distributed on the remaining white canvas. The colors are still not blended together. As in the previous two colors, the values were controlled by adding more white near the source of light and less white in the darker areas of the sky. The red color is more dominant closer to the horizon than in the upper areas of the sky.

Low Tide on the Sound (Step 4). Throughout the entire process of painting, it is helpful to frequently step back from the canvas and look at the work with half-closed eyes in order to see the relationship of values. The separate strokes of color were blended and the nuances of the colors were adjusted by adding one of the three colors where necessary. It is very important not to overmix the colors; they should be "broken" by crossing the brushstrokes over each other to preserve the flow of gradation from top to bottom and to the light.

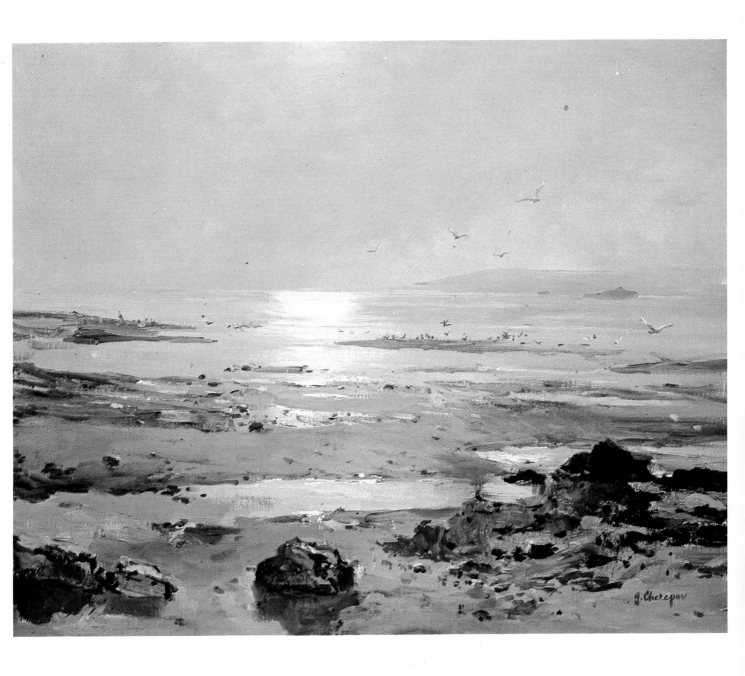

Low Tide on the Sound. *The distant island was painted after the values of the sky and water were established in this final stage. The same three primary colors were used as for the sand, but with less white and blue. The dark, wet rocks on the left, done with burnt umber mixed with white, represent the opposite tone on the value scale, and emphasize the high value of the whole painting. The fine touches in the drawing, such as the distant seagulls, and the highlights, were done with a small (No. 7), long hair, round sable brush.*

Tahitian Girl (Step 1). *The space occupied by the figure was indicated in a triangle shape, using soft vine charcoal. Then without using too much pressure, the general shape of the figure was drawn in.*

Tahitian Girl (Step 2). *After the preliminary charcoal drawing was done, the excess charcoal dust was blown off and the drawing was sprayed with a fixative. It is worthwhile to reinforce and correct the drawing at this time with a small brush and diluted paint. In this case, burnt sienna thinned with turpentine was used. The reason for reinforcing the drawing with paint is so that it will be visible when painted over.*

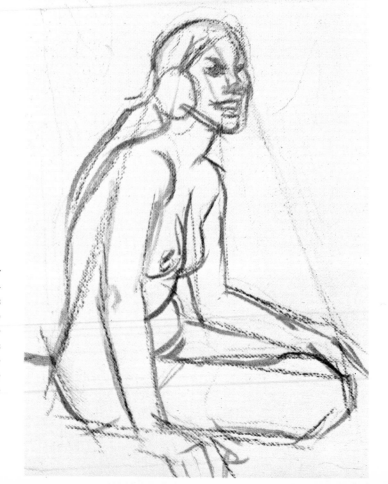

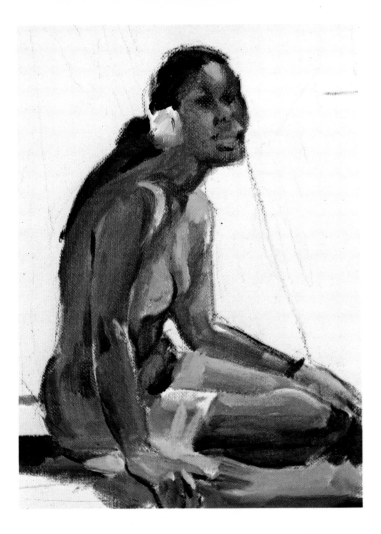

Tahitian Girl (Step 3). The palette setting did not require any colors in addition to those shown on the basic palette in Fig. 35 (Chapter 8, Color) except that cobalt blue was exchanged for ultramarine blue to obtain the darker areas of the hair and skin. The brushes used were the basic three shown in Fig. 7 (Chapter 1, Materials and Equipment). It is not important to start painting the head first; one may start with any part of the figure. The general idea is to cover the whole area of the figure with approximate colors and values. The colors are adjusted and modified through adding the necessary colors from the palette.

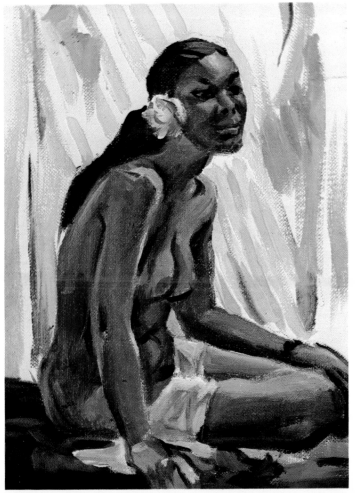

Tahitian Girl (Step 4). The colors surrounding the figure were painted with special attention to their correct relationships to each other. To increase the contrast between the dark skin and black hair of the girl and the sunny background, a yellow striped drapery was selected. This warm color is emphasized by the blue cloth on the bottom of the painting. The model obviously is of African-Oriental descent and represents an exotic beauty. The racial characteristics of her face were observed; the lower part brought forward to emphasize the mouth. The large eyes and the line of the forehead give a dynamic line to the whole face.

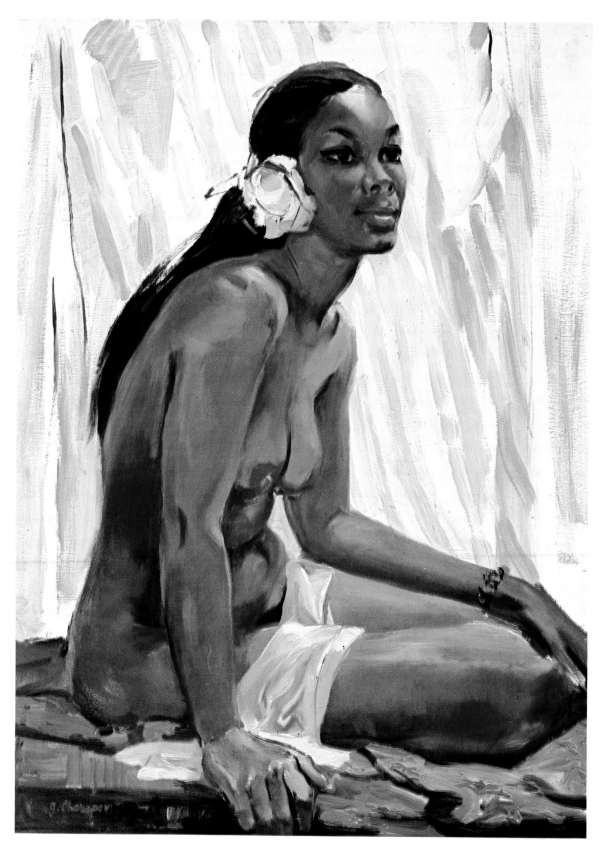

Tahitian Girl. *In the final painting, we see a composition rich in color and linear contrasts. There is movement in the dynamic thrust of the girl's body and in the bold lines of her face. There is movement, too, in the play of colors against one another and in the relationships of different linear directions, as seen in the yellow drapery, the blue cloth, and in the figure itself.*

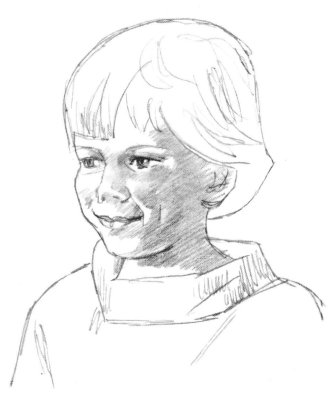

Numo (Step 1, Slow Method). First, a careful drawing was made on a piece of drawing paper, the size of the canvas (12" x 9"). This preliminary drawing may be done in charcoal or in pencil. To obtain a better image and indication of form, shadows were included.

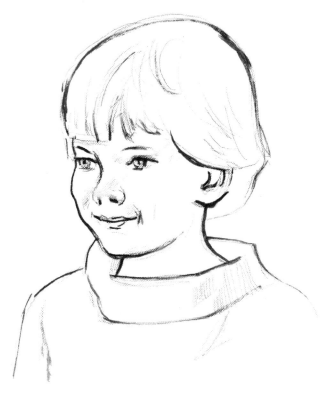

Numo (Step 2, Slow Method). The back of the drawing was covered with masking tape. With a light pressure on a pencil, the outlines of the drawing were gone over and transferred to the canvas. To protect the canvas from punctures, a piece of board may be held against the back.

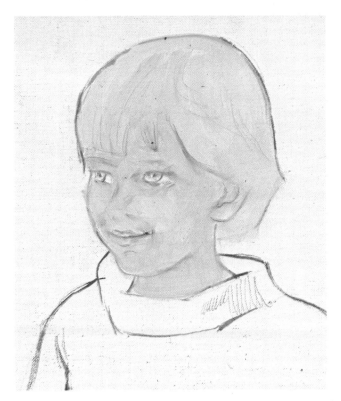

Numo (Step 3, Slow Method). I filled in the areas of the face and hair first to establish the so-called flesh color. This underpainting was applied with a medium (No. 7), flat bristle brush, using a lean medium of 1/3 linseed oil mixed with 2/3 turpentine. The hair was done in a light tone of yellow ochre and white, with the same lean medium.

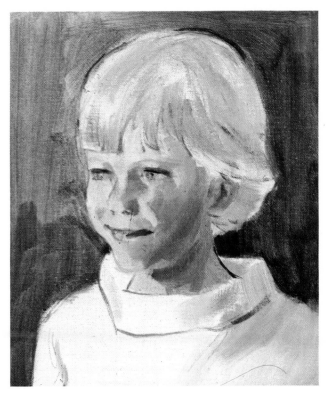

Numo (Step 4, Slow Method). In this step, the underpainting of the large areas was continued. Still using the No. 7 bristle brush and a lean medium, I painted in the background with burnt umber and cobalt blue. The face was modeled with cadmium yellow pale, yellow ochre pale, and cadmium red pale, my "flesh color." Texture was added to the hair with umber and cobalt blue.

Technique 95

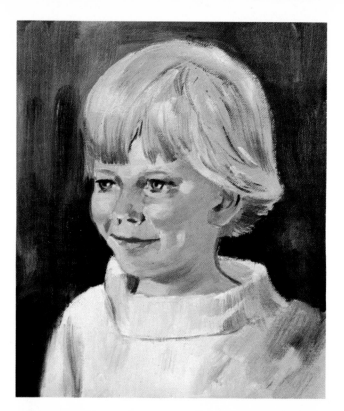

Numo *(Slow Method). For the final modeling, the warm underpainting was painted over with cooler colors, obtained by adding cobalt blue to the warm colors. To express the texture of the child's soft skin, the brushstrokes on the face were lightly blended with a flat sable brush. The texture of the hair and sweater was produced by a dragging, drybrush stroke, using a large, flat bristle brush. The fine details of the eyes, nose, and mouth were done with a small, long hair, round sable brush.*

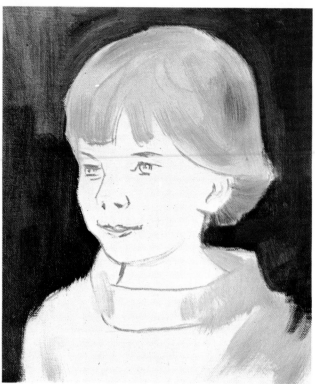

Numo *(Step 1, Alla Prima Technique). The direct, or alla prima, technique is rather easy from a technical point of view. An alla prima painting is usually completed in one or two consecutive sessions, while the painting is still wet. This method, however, requires a very sound knowledge of handling the elements of subject, composition, form, value, and color. In this first step, the space division was made with a light color. First, the general outline of the size and location of the head was indicated with a large bristle brush and the primary colors, then the features of the face were done.*

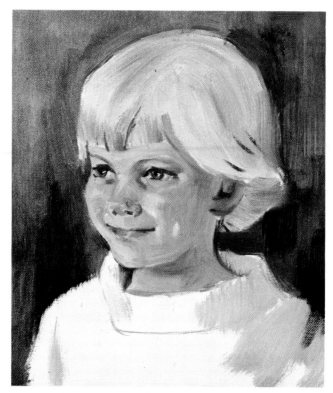

Numo *(Alla Prima Technique). In the final stage, the large area of the face, hair, and background was painted with a large bristle brush and a few primary colors. The medium was 1/2 linseed oil mixed with 1/2 turpentine. Special attention was given to the modeling of the face; observe the delicate relationship of colors and values on the forehead, cheeks, nose, mouth, and chin. The final details of the eyes, lips, nostrils, and ears were painted with a small sable brush.*

(text continued from page 72)

smooth the brushstrokes, but to slightly roughen the paint — especially where it has dried to a glossy surface. The same caution should be exercised in washing the surface with emulsion. If the canvas loosens, gently hammer in the keys on the back of the stretcher frame to tighten it again.

Actually, it is advisable to plan a painting ahead of time, selecting the technique of painting accordingly. For instance, if you are dealing with a complicated drawing with many details, and in the style of painting requiring precision, obviously the slow method, rather then the *alla prima* method, will be preferred. Let me go with you, step by step, through the whole process of this slow technique (also, see step-by-step demonstration of *Numo*, painted with the slow technique, pp. 95 and 96).

Imprimatura (Step 1)

You may find it easier to work over a toned canvas rather than over a white surface. The thin coat of paint applied to give a tone to the painting is called the *imprimatura*. It can be applied with a large, flat bristle brush or with a trowel-type palette knife, using a paint medium or turpentine and copal. This imprimatura dries quickly, and the next day you can paint over it. For this purpose, it is usually preferable to use light and pale colors rather than strong, intensive hues. A pinkish gray or greenish gray, unevenly applied and making one area slightly lighter or darker, will give texture to this first step.

Plan the Composition (Step 2)

Make a few brief pencil sketches on paper in the same proportion as the planned painting, primarily to define the composition which establishes the best relationship between the large areas.

Drawing on the Canvas (Step 3)

Distribute the forms and the spacing on the canvas after the imprimatura has dried, using, without pressure, a soft vine charcoal stick. Do not use an eraser to correct mistakes; rather, wipe gently with a soft, clean cloth. After the drawing is done, spray it with charcoal fixative or reinforce the lines with thin paint applied with a small brush.

To achieve maximum precision, the drawing can be done on a piece of paper the same size as canvas, then transferred onto the canvas by rubbing the back of the paper with charcoal or with white chalk, and pressing gently with a pencil to transmit the lines onto the canvas. After that, reinforce the lines again with paint or with ink.

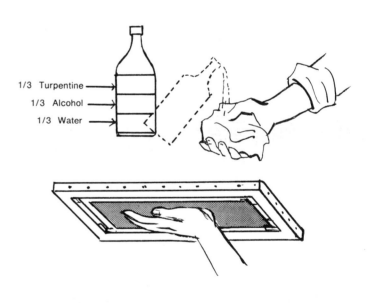

1/3 Turpentine
1/3 Alcohol
1/3 Water

Figure 36: Preparing a Dry Surface. *To prepare a painted, dry surface for painting over, rub it with a medium rough sandpaper. Protect the canvas by holding a piece of board underneath it, supporting the back of the area you are sanding (above). Then mix equal parts of turpentine, alcohol, and water in a bottle. Shake this emulsion well before using, and wash it lightly over the surface with a soft cloth (below).*

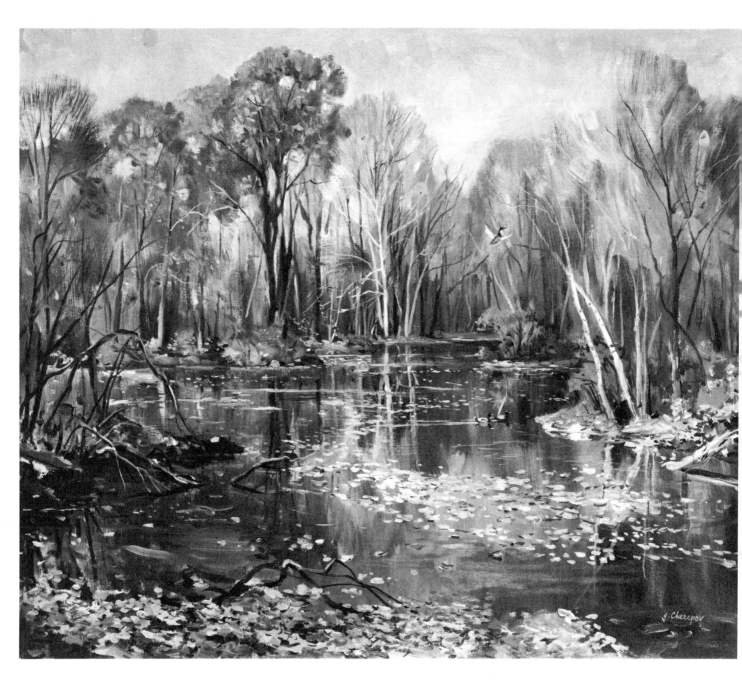

Sanctuary, *30" x 36". A sunny day in autumn offers a brilliant harmony of variations in gold and yellow. The trees in the distance were painted with a large bristle brush; the essential character of a large number of the branches was expressed with drybrush strokes, leaving bits of sky between the branches. To avoid hard edges and to create a soft haziness, these drybrush strokes were applied while the paint of the sky was still wet. The reflections in the water were painted with the same brush and the same colors, using mostly vertical strokes. Afterward, the more detailed drawing of the treetrunks and branches was superimposed with a small (No. 7) sable brush, using long, upward strokes with only a little pressure and releasing the pressure gradually at the end of the strokes. The same brushstrokes were repeated in the reflections, only in reverse. Private Collection.*

Applying the Paint (Step 4)

After imprimatura, composition, and drawing are completed, begin your painting. Observe the value relationships in addition to the color relationships. The imprimatura has already set the middle tone value, so indicate the darker and lighter areas. This will give you the feeling of three-dimensional depth and light. In painting the first layer, avoid heavy impasto strokes in order to provide a smooth surface for the next layer. In this first layer, use a lean medium: 1/3 linseed oil, 2/3 turpentine. In the second layer 1/2 linseed oil, 1/2 turpentine, with a few added drops of copal. In each subsequent layer, proportionately reduce the turpentine, working from lean to fat. If you work over a dry surface of paint, use the method described in "Preparing a Dry Surface" in the beginning of this chapter for proper binding between each layer of paint.

Glazing

The glazing technique is similar to imprimatura. A glaze is a thin coat of transparent color applied over an already underpainted painting to modify the color to a cooler or warmer hue. In planning to glaze, you should paint in lighter values, and then glaze with complementary colors, because a coat of glaze should always be darker. For instance, a green underpainted with light yellow, which, after drying, is glazed with Prussian blue, has an entirely different quality than a green of yellow and blue mixed on the palette. The medium for glazing is mixed from 1/2 turpentine, 1/2 mastic varnish, with a small part of sun-thickened linseed oil. This medium dries rapidly and requires quick application (see Fig. 38).

The glazing technique is seldom used anymore. Nevertheless, I feel it is useful to describe it, since it may inspire you to explore the possibilities more deeply, and eventually find it useful in your own way.

Palette Knife Technique

More popular today than the glazing technique is the application of paint on the canvas with a palette knife. A variety of effects can be achieved by the skillful handling of a palette knife. The brightest intensity of a hue is presented by a flat application of impasto pigment; the finest sharp line is made with the edge of a blade; and interesting rough textures can be achieved by scraping the paint. For instance, old driftwood, bark on trees, or the rough texture of rocks can all be done very effectively with a palette knife (see Fig. 39).

Figure 37: Alla Prima Technique. *This still life with a jug was painted with a bristle brush in the alla prima technique. The paint was applied impasto, with vigorous strokes, to express the roughness of the texture of the jug. The mixing was done right on the canvas.*

Figure 38: Glazing Technique. *In this still life with a violin, a greater degree of precision drawing was required, and the painting took longer to do. It was painted in the glazing technique: the canvas is first toned with thin paint; after this coat has dried and the drawing been completed, the painting is continued in a slightly lighter key and a smoother coat of paint is applied; when this coat is dry, the painting is glazed with a transparent glaze.*

Figure 39: Palette Knife Technique. *The palette knife technique was used here to capture the textures of old, weatherbeaten wood. A variety of effects is possible with the palette knife, from thick impasto to fine lines.*

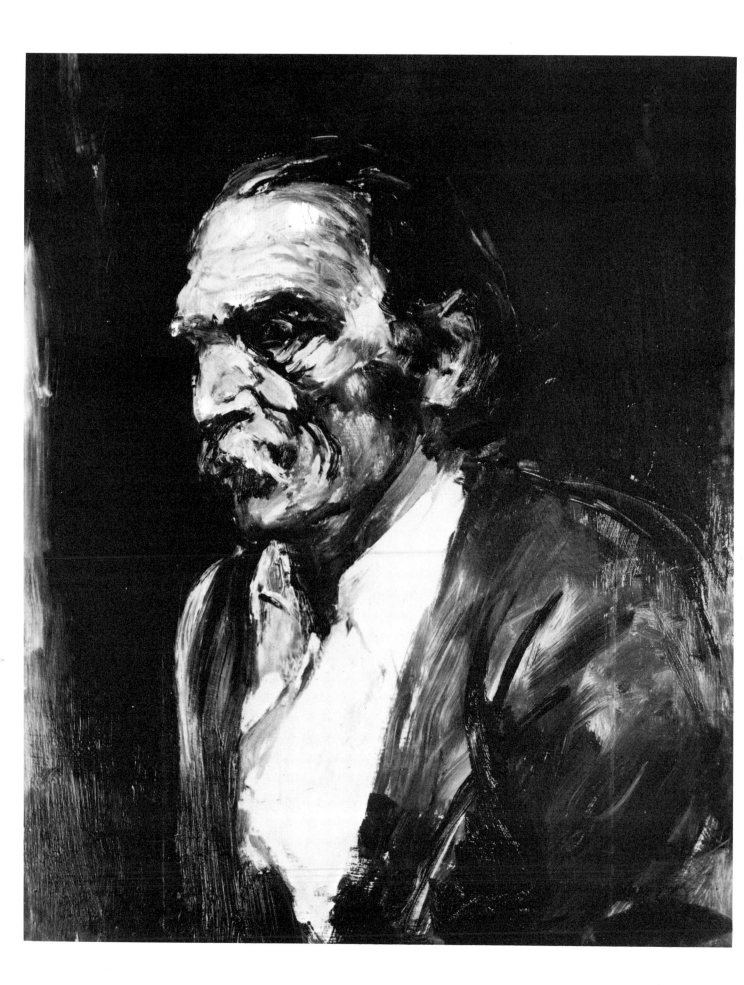

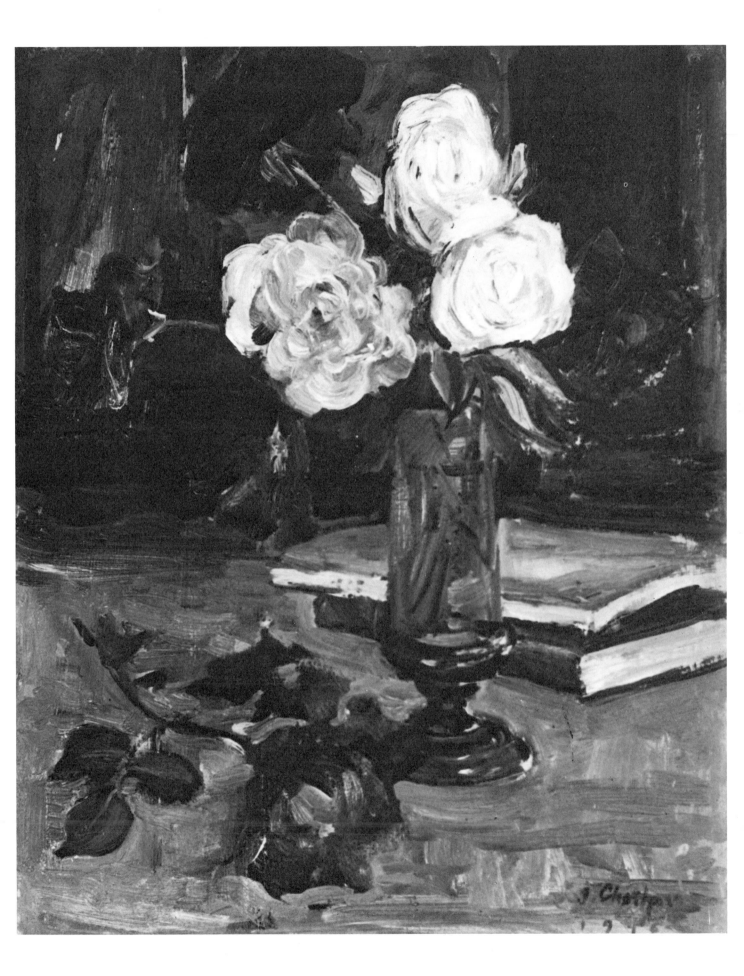

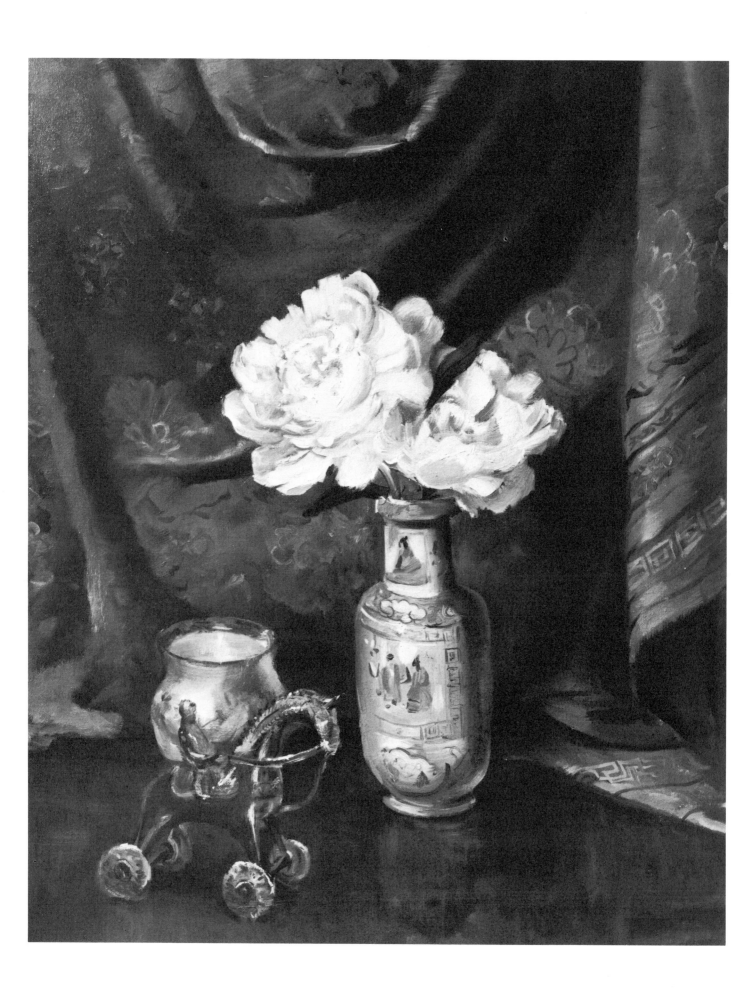

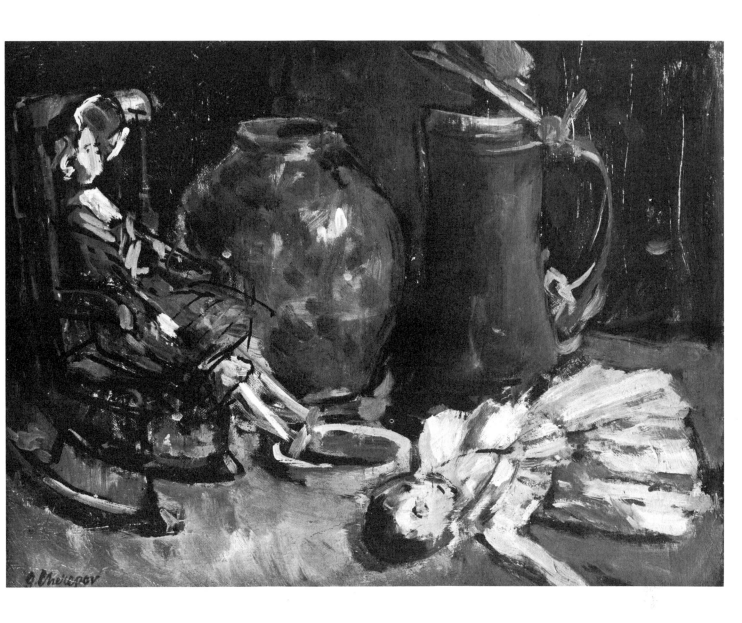

(Left) Oriental Still Life with Peonies, *30" x 24". Here is a group of objects which have a very close relationship as far as style is concerned. The old Chinese porcelain, by its color and design, complements the Chinese silk of the drapery. This drapery emphasizes the white peonies. The repeated design in the drapery follows the folds and catches lights and shadows.* Collection Mrs. E. Wallace.

(Above) Still Life with Dolls, *12" x 16". The colors and textures of these dusty old dolls from an antique collector's shelf suggested a painting expressing the nostalgic mood of forgotten toys. A very narrow minor key palette was used for this still life. The doll in white, lying limply, head down, emphasizes the loneliness of abandoned toys.* Collection Mr. F. Oppenheimer.

not to be tempted to "copy" the arrangement, that one should capture the "impression." This makes sense primarily as an exercise for developing visual memory, and the ability to memorize moments in which time for long and careful study is not available. In the study of a still life, however, it is advisable to look back and forth from the subject to the canvas, constantly checking the subtle nuances of color, value, and form.

Stand at arm's length from the canvas. Hold the brush at the very end of the handle, loosely, with three fingers. Holding the brush in this way, it is easy to change its position in all directions. This gives you flexibility in painting and a full view of the large areas of the canvas.

Painting a Still Life

Let's take a typical still life, *Still Life with Kettle* again, and see how it was painted. To begin with, the space for the whole group of objects was roughly indicated with a small brush, using very thin, light color (for example, white with a little ochre or blue), as shown in Step 1. Next, this space was subdivided into individual objects and their basic forms were sketched in (Step 2). More attention was given to their proportion, their relationships to each other, and to the law of perspective, than to small details.

At this point, it helps to visualize horizontal and vertical lines on the canvas and to refer the objects to them. This will prevent the appearance of leaning in the bottles and the kettle. Notice that the bottom of the green bottle is square, therefore it has reference to the eye level and vanishing points.

After the rough sketch was completed, the outlines were reinforced with darker color (Step 3). At the same time, mistakes were corrected where necessary. There is no need to remove incorrect lines; their presence can help you to find the correct form.

Naturally, the same space indication and detailed drawing could be done with soft vine charcoal, which is sprayed with fixative before beginning to paint. However, in my opinion, there is an advantage in starting at once with brush and paint. To make this clear, we should note the difference of the role of drawing in black and white as opposed to its role in painting. In drawing or etching, the line and

tone value are the only means, and therefore the essential elements, of expression. In painting, the dominant elements are composition and color. Carefully drawn lines will be overpainted and an effort to preserve them will interfere with the process of painting. A person who has worked hard on the details of a charcoal drawing may become so tied to the existing lines that he hesitates to cover them with solid paint and begins to tint the drawing with thin color, so that the result appears like a colored sketch, rather than painting.

A large (No. 10) bristle brush was used to cover the large areas of the canvas with colors approximately matching the colors and values of the objects (Step 4). Again, there was no attempt to be perfect in every detail. These can be filled in later. It is more important to paint with a full brush, adding some medium for smoother application. It is difficult to say what proportion of medium and paint to use. This has to be found through practice. As a guideline, keep in mind that the more the paint is thinned, the more the color intensity is weakened, bringing the method close to the watercolor technique called "wash." On the other hand, if the paint is too dry, it has to be rubbed into the canvas in order to cover it, which causes an overmixing of colors. Also, application of heavy impasto complicates the continuation of the painting later, when the paint is dry. For example, a rough surface may make the working out of fine details very difficult, if not impossible. You will probably find that a moderate proportion of medium and paint and a minimum of mixing the paints is desirable.

As described in Chapter 8, *Color*, the mixing of the colors should be done more on canvas than on the palette. On the canvas, we see the colors in their relationship to each other, therefore we can judge better what other colors to add in order to achieve the desired result. The development of the background in *Still Life with Kettle* (Steps 5 and 6) demonstrates this method of color mixing.

From the beginning, emphasize the color and value relationships in stronger contrast than you finally want them, as if you were painting a poster, and adjust and modify them later where necessary. It is more difficult to start with gray, overmixed halftones and to work up to more intense hues later.

Autumn Foliage, 34" x 30". The extraordinary pure intensity of the colors of autumn foliage inspired this still life arrangement. Carefully selected branches in a variety of autumn shades were arranged in a gray pewter pitcher. Several pieces of fruit, in suitable color harmony with the leaves, were placed on the light tablecloth to enrich the color and the design. Private Collection.

Brushstroke and Texture

A few words should be said about the brushstroke and its use in the expression of texture. Handling a brush is not just an incidental, uncontrolled phenomenon; it is a subject of study, a constantly

controlled, individual, characteristic "handwriting" in the work of a painter.

In painting a still life, you should pay particular attention to the different textures of the objects; you are repeatedly dealing with a great variety of objects representing distinct textures, such as metal, glass, pieces of fruit, ceramic, wood, draperies, etc.

Examining this aspect of *Still Life with Kettle*, we find that the copper of the kettle was painted first with a large bristle brush, with vigorous strokes and firm pressure on the canvas. Light and shadows were applied unevenly in accordance with the texture of aged metal. A small sable brush was used to emphasize the drawing of details such as spout, handle, and lid. Then a large brush was again used, but without much pressure, for blending where necessary. For the finishing strokes, a big bristle brush was used in a drybrush technique.

Drybrush Technique

The drybrush technique permits the application of color without mixing it with the underlying layers, and yet allows the underlying hues to appear between the bristles of the rough stroke, creating a richer interplay of colors. To apply the pigment, take a good amount of paint on the end of a large bristle brush. Let the flat side of the brush touch the canvas only lightly, and drag it without pressure across the surface, so that no blending results between the newly applied and the underlying colors.

It is advisable to experiment with this technique on a separate canvas, exploring its possibilities. It's possible to express various textures by learning to give the stroke form and direction with slight motions of the wrist.

Folds and Drapery

Draperies are often used as an essential part of the composition of a painting, especially in such subjects as still lifes, flower paintings, figures, and portraits. Draperies give the painter the chance, through arranging the folds, to add other shapes to the cubes, spheres, and cylinders in his painting, and to enrich the design and soften any stiffness.

Regardless of the current fashion in clothing, a painter can always find a way to include folds in his composition; fabric can be thrown down under the objects of a still life, it can be hung as a backdrop, or it can be included as an integral part of the painting, as in *Quiet Hour* (p. 54).

I would like to call attention to the characteristics of draperies to the student who finds painting folds difficult. Consider the differences in texture of fabrics: some are soft, some brittle; some dull, some of high luster. The crisper the material and the higher the luster, the sharper the folds will break and the stronger the contrast between light and shadow will be. Basically, the process of painting draperies is not different from that of painting any other object. After the general forms are drawn, the dark and light areas are painted to indicate the shape of the folds. Next, the values are carefully adjusted to show the reflections on the shadow side. A large flat bristle brush is often used in brushstrokes which move across the folds to emphasize their three-dimensional, round quality.

Naturally, one of the greatest challenges in painting fabric is working with one which has a repetitious pattern, a design which follows the undulations of the folds (see the Chinese silk in *Oriental Still Life with Peonies*, p.106). The pattern is carefully drawn on the folds and the values adjusted to follow their roundness. This requires a slow technique of painting. If the pattern is very finely woven or printed, it is best to paint the folds in their basic color first, with light and shadow. After this is dry, then apply the drawing of the pattern and paint the changing values of the fold-following design with a small sable brush.

Highlights

Finally, as the last touch on a painting, the highlights are applied. They are usually brighter and smaller on shiny glass than on aged metal or pieces of fruit. Generally, I like to suggest that the student not overdo the highlights in a painting. Too many small white dots may distract the eye from the more important color composition and have a cheapening effect on the painting. In saying this, I have in mind still lifes which the reader also may remember seeing: crowded, highly polished glass, metal plates, and grapes against a very dark background; white dots as highlights painted sharply on each grape, and on the silver plates.

If the subject calls for highlights, observe the differences in value and color between their appearance on glass, metal, fruit, and so forth. Also, note the difference between the edges of the highlights on differently textured surfaces. In some cases, they are sharp and well-defined, in others, they are soft and blend into the color of the surface.

Analysis of Color in a Still Life

In working more with still lifes, you will always discover additional interesting subjects which are suitable for painting. A hunter's trophy, as shown in

Still Life with Wooden Horse, *12" x 16". An antique wooden horse, set against a group of ceramic pots, is the main object in this nostalgic still life. The color relationship is dominated by a variety of very subtle color nuances in the ceramic ware, and is enriched by the dull, Venetian red color of the horse and the yellowish green of the apples.*

Still Life with Pheasants (see step-by-step color demonstration, pp. 76-78), for example, offers a magnificent color arrangement. Nature often amazes with its stunning color harmony and richness of imagination in design, as in the male pheasant in this painting. Look at his deep Prussian blue head and neck, with the pure white line separating these colors from his iridescent, reddish brown body; and at the graphically perfect red trim around his eye. I am not a hunter, and probably never would have the desire to kill such beautiful birds; but as a painter I cannot resist the temptation to paint them when I get the chance.

Analyzing the composition, I should mention that, first, observing the birds suspended, a decision had to be made about how much of them was to be shown. By displaying more of the legs and tails, the most decorative part of the colors on head and chest would have been reduced in importance.

The second immediate problem concerned the choice of color for the especially large surrounding area of the background. Considering the alternative possibilities of light or dark, bright or neutral, I rejected dark values because, with them, the contrast between background and the colors of head and body would have been lost. For the same reason, a bright, intensive color was rejected. Raw, weather-washed, gray boards seemed to have the most suitable color and texture.

The next question was: is it enough to have the birds, or is there a need for other objects to balance the space; and how strong should they be? The green bottle was selected for its color harmony with the colors of the pheasants. However, the vertical shapes needed to be broken by a different form, and a link had to be provided between the two groups of objects. The round metal plate seemed to solve this, adding at the same time new nuances of gray colors to the background.

The bottle and plate certainly should be resting on some sort of table or box. A dark table would have unnecessarily divided the painting, so to achieve more freedom in form, a piece of light-colored drapery was thrown onto the table. The empty light area on the table needed still more form and color,

however. Small, golden-yellow onions seemed appropriate, and a cadmium yellow lemon added a fine touch against the green bottle. Since all these objects are based on the spherical form, the long, narrow line of a knife was chosen to complete this arrangement.

Still Lifes with Flowers

There are painters who specialize in flower painting only. The important difference between flower painting and other forms of still life is that color is the chief element which attracts the painter. Flower painting requires, first and foremost, a finely developed sense of color relationships. This quality is more essential than a botanically faithful representation of each individual flower. Obviously, the decorative element dominates this subject.

The variety and strong intensity of local colors calls for an enlargement of the basic palette given in Fig. 35 (Chapter 8, *Color*). You might want to add pigments like Mars violet, cerulean blue, cadmium orange, etc., because you may not be able to achieve the desirable hue in its full intensity by mixing the colors of your palette. These additional colors will be used in their pure state without intermixing them with others.

Eventually, through observation and some experimentation, you will be able to identify which colors could be added to the existing set without much difficulty, *Summer Bouquet* (p. 58), is a floral theme, an arrangement of warm colors in their full intensity. The white vase, white wall, and the blue drapery were selected on purpose to emphasize these colors.

Still Lifes with Antiques

Antiques provide endless material for still life arrangements. In *Still Life with Decoy* (p. 58), an old wooden decoy, with its partly peeled off colors, is an interesting object with which to start such a setup. Placed in the visual center, it requires a companion object that provides taller, vertical, spacing. A light gray jug with a blue decoration and a smaller pot in a dusty, cool blue color complete the composition.

Antiques usually suggest a subdued narrow color harmony, based more on a richness of tonal values than on bright contrasts of pure pigments. A very dark, close to black, background offers a desirable harmony in this case. This type of background is often seen in eighteenth-century Flemish and Dutch paintings. Usually, a painting in which the dominant areas are very dark also requires rather smooth brushstrokes; and, finally, a coat of finishing varnish to preserve the freshness of the color nuances.

Still Life with Flowers and Silver, *16" x 12". The objects chosen for this arrangement are in harmony as far as their style is concerned, but they differ in texture. Glass, flower petals, silver, porcelain, and napkin contrast well against one another. The silver of the milk pitcher is emphasized by the dark color of the leaves in the vase. The white porcelain cup and saucer balance the space and at the same time represent another surface texture. All the objects were selected for their subtle relationship with one another and to harmonize with the roses' pale color.*

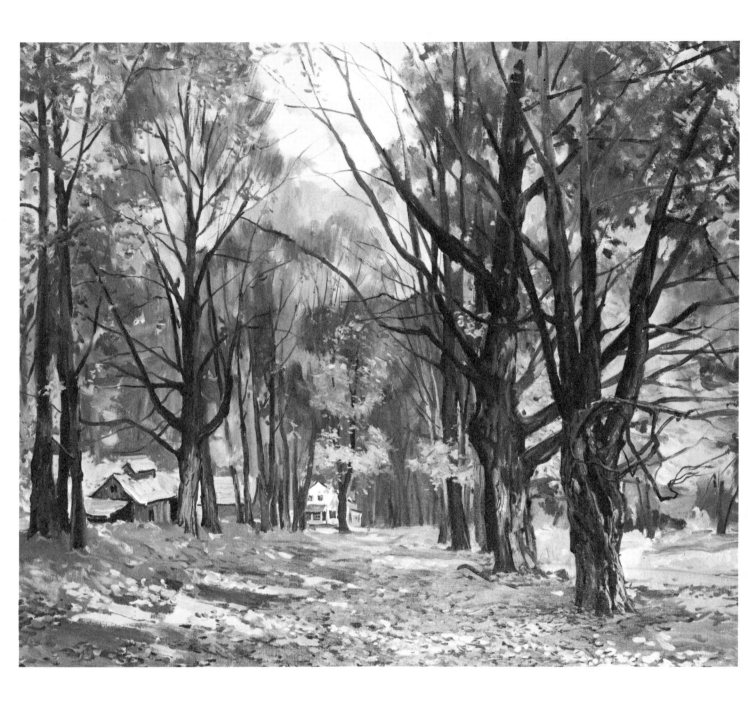

Vermont Sugar Maples, *30" x 36". The knotty, irregular, twisted trunks of the sugar maples are always a very attractive subject for painting or drawing. The majestic maple grove which lines this road creates a spectacular autumn view. To express the full height of the trees, the space composition required a low horizon. Most of the foliage has fallen to the ground, and a number of branches are bare, which partly opens the view on a hazy background of distant mountains. Trees and background were painted simultaneously. In the same manner, the large trunks and the masses of the foliage were painted together. The smaller branches were painted in last with a small sable brush. Courtesy Deeley Gallery, Manchester, Vermont.*

11. Landscape

When painting a still life, we arrange the objects before starting to paint. In landscape painting, however, the situation is different. The mountains, streams, and trees are already there, prearranged and immovable. It is up to the painter to visualize any changes he wishes to make. To begin with, do not let paintings that you have previously seen influence you to chose large panoramic views or complicated subjects to paint. Select a simple motif; frequently, you may locate one in your immediate environment. When painting outdoors, it is difficult for an inexperienced person to extract the essential pictorial elements from many confusing details; sometimes, he may spend hours walking or driving around, only to return with the disappointed remark, "There's nothing around to paint!" A simple device like a view-finder may help you visualize possibilities for painting; it may help you discover new and interesting material in your backyard, which in the beginning may have escaped your attention.

View-Finder

It is easy to make the view-finder shown in Fig. 44 yourself. A view-finder is merely a firm black or neutral gray cardboard, approximately 5 3/4" x 4 3/4", with a cut out opening, or window, 2" x 2 3/4" in size.

Hold the view-finder in front of your eyes. By moving it closer or further away, judge how much of the view to include in the composition. Also, move the view-finder higher or lower to determine the height of the horizon and the amount of foreground and sky. After these decisions are made, hold the view-finder in a fixed position and check the relationship of the objects to the edges of the frame.

To sketch the scene on the canvas, visualize vertical and horizontal lines through the center of the opening and refer the dominant objects to them. If you find it difficult to visualize these lines, you may find it helpful to stretch two thin threads exactly through the center of the view-finder, taping their ends to the board. This divides the opening into four equal areas and makes it easier to distribute the large masses correctly. Later, in the process of painting, if you find it difficult to establish value relationships, looking through a narrow slit cut out on the side of the board may help you (see Fig. 44).

Sketching

If you have doubts as to which composition will make a better painting, make a few preliminary pencil sketches in a small sketchbook (Figs. 45, 46, and 47). It is wise to have such a sketchbook always in your pocket and to make brief sketches of anything which attracts your attention as material that might be used for a painting. Even if some of these sketches will never be used for any purpose, there is a great advantage in making them as frequently as possible: they develop an ability to observe as well as a sense of composition. Do not attempt to make an exact, detailed copy of the motif seen.

Paradoxical as it may sound, nature is our greatest teacher and source of inspiration, yet it very rarely offers a completely perfect arrangement for painting. A camera will take care of the documentary record of the motif. The painter, however, equipped with knowledge and skill, has the freedom to make changes to achieve the most desirable composition. Therefore, if you think that a tree, with its particular shape, does not belong in a certain place, feel free to move it or take it out. If a hill is too low, or the line of the horizon is too straight, make the adjustment in your sketches until the composition is solved to your satisfaction, then paint it on the canvas.

Frequently, when I analyze a student's work, I hear the remark, "It was there; I saw it exactly this way." This is said in self-defense, but there is no reason to paint a scene *exactly* as you see it.

Figure 44: *A view-finder is a helpful tool for composing pictures.*

Figure 45: *This page from a sketchbook is the preliminary sketch for a building. Such preliminary sketches are excellent practice.*

Mood in Landscape

One of the most important elements in a landscape is the *mood.* In no other subject, with the exception of seascape, is the expression of a mood as important as in landscape. In my opinion, the impressions we associate with a landscape are connected more with a certain mood than with design. For example, try to form a mental picture of these moods: "Early dawn in winter" — the silhouettes of a house and trees against a pale light sky, with the snow appearing darker than the sky; "Late autumn day" — gray muted colors with hazy distant woods turning to purple-blue; "After a spring shower" — dark trunks of trees as a contrast to the subtle greens reflecting in a wet street.

There are endless varieties of moods, which, unfortunately, are very little observed by a person who does not paint. To capture the fine nuances of these moods of nature in your painting, and to communicate them, considerable study has to be made of all the objects that repeatedly appear in landscapes: trees, rocks, clouds, reflections in water, buildings, animals, people, birds, and so forth. Observe and sketch these constantly in different relationships to the light. Try to see and capture the most characteristic form of every object in your sketch; bring out the differences that distinguish each object from other objects. This is especially important when sketching trees, as I mentioned earlier; although their basic structure is the same — roots, trunk, branches, leaves — their shapes are very different. Everybody is familiar with the shape of a spruce or a birch, but to distinguish between a maple, an elm, and an oak may cause difficulty for many. To those who doubt the importance of such specific study for a painter, the answer is that one cannot express the character of an object without knowledge of its basic form.

Planes of Aerial Perspective

In the expression of depth in landscape it is necessary to observe various planes of aerial perspective. Aerial perspective is the decrease of color and value differences within planes of increasing distance from the observer. It is caused by the refraction of sunlight in tiny water droplets in the air (humidity) into its constituent rainbow colors. A similar effect is produced by the scattering of light on dust and smoke particles in the air. It is seen as a more or less dense haze that lies between the observer and the thing observed.

To express this effect with pigments on canvas, only the three primary colors (plus white) are

needed. For the major palette, they are cobalt blue, alizarin crimson, and yellow ochre pale; for the minor palette they are Prussian blue, Indian red, and yellow ochre pale.

The two landscapes in the step-by-step color demonstrations, pp. 79-84, are examples of the use of aerial perspective. Try to analyze them from this point of view. A particularly good example of aerial perspective can be seen in *Country Road* (pp. 79-81). Here, with the exception of the trees in front and a few accents in the fields and on barns, only three colors — cobalt blue, alizarin crimson, and yellow ochre pale — were used. This painting consists of three planes: (1) trees in the front and barn in the middle; (2) barns in the background and sunny hill to the right; (3) far hills on the left and the sky.

Note: when you observe a cloudless sky, with the sun at your back, the sky changes color as you look first at the zenith and then at regions lower and nearer the horizon. It has its darkest (of lowest value) blue directly above and becomes lighter (of higher value) and warmer, containing more red and ochre and less blue, in the regions closer to the horizon. The technique for achieving this aerial perspective of the sky is shown in the step-by-step color demonstration for *Pacific Coast*, (pp. 85-88).

If the subject is seen against the light, on the other hand, the situation is completely different. The sky will then appear as a more or less light area, as shown in *Countryside* (p. 26), *On the Seine* (p. 36), and *Winter in the Berkshires* (p. 120).

When you study the examples mentioned above, you may note that the choice of planes is to some extent arbitrary. Yet, to achieve a three-dimensional effect on canvas, it is important to see or visualize the subject from this point of view. Train your eye to see these divisions (close the eyes halfway to wipe out distracting details), so that you can plan the color and value relationships for the whole painting.

Preparations for Outdoor Painting

There are two ways to study the outdoors: one is to make a sketch from which a painting is done later in the studio (Fig. 48), the other is to paint directly onto the canvas (Fig. 49). When you decide to work outdoors, be sure to take the necessary equipment: portable field easel, paintbox with paints, brushes, medium, turpentine, cups for medium and turpentine, rag, palette knife, canvas, and folding stool. Place yourself so that the sunlight does not hit the canvas or blind your eyes. Preferably, wear dark clothes to prevent a reflected light on the painting.

Although the shapes in a landscape usually do not change, the light certainly does; and this must be

Figure 46: *Here is another preliminary sketch taken from a sketchbook, this time with trees worked in with light and shade.*

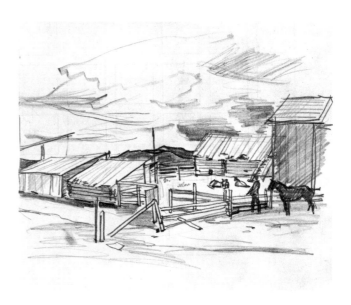

Figure 47: *This sketch of farm buildings under a sweeping sky was also taken from a sketchbook. These brief sketches help develop an eye for composition and should be done as frequently as possible.*

Figure 48: *A typical setup for painting in the studio.*

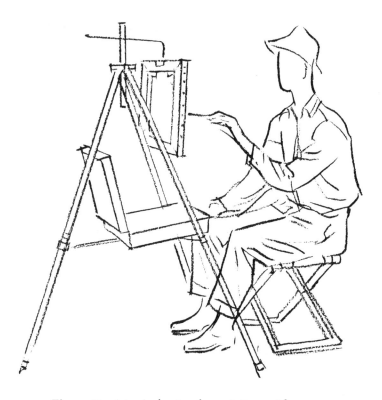

Figure 49: *A typical setup for painting outdoors.*

kept in mind. In the beginning, it is easier to work on a gray day, when there are no shadows that change quickly as the sun moves on. Do not rush to start the painting until you have a clear image in your mind of what you are going to paint. Otherwise, the palette setting (see Fig. 35, Chapter 8, *Color*) and the general approach are very much the same as for painting a still life.

Autumn Landscape

In my choice of themes, an inclination for autumn scenes is evident. One of the reasons is the warm color harmony dominating these motifs. Having lived in New England for many years, I must admit I share the enthusiasm of the public crowding the roads in autumn. I follow the urge to capture the spell-binding color beauty of autumn moods.

The beauty of the autumn landscape lies in the brilliance of its colors. We have to observe and distinguish the variety of trees in their different coloring. The colors, repeated in reflections in the water, create a unique harmony. Sunlight amplifies the brilliance of the color relationships of autumn. Unfortunately, the light is not permanent; it constantly changes its position, affecting the areas of shadows and the colors, including reflections in the water.

How to approach the task of capturing and expressing at least a part of this beauty? Most painters of the traditional school suggest making a quick drawing and notes of the colors; or painting a small sketch to try to establish the most dominant color relationship. But most painters also advise memorizing as much as possible. This is certainly a sound, and in regard to the time limitation for painting outdoors, a logical, solution. The power of the impression and the excitement which a painter experiences from his immediate contact with nature is, unfortunately, later apt to diminish. It is difficult, after a day or two, to reconstruct the impact of the first impression in the studio from memory, or even with the help of a sketch or photograph.

Direct Painting Outdoors

Direct, *alla prima*, painting gives the painter the chance to capture the fine nuances in color relationships suggested by nature, giving the painting great vitality. I personally enjoy working on a large canvas right on the spot. It is a great challenge, and at the same time gives great satisfaction. Naturally, one has to work extremely fast; decisions about space arrangements and changes in position of objects have to be made immediately.

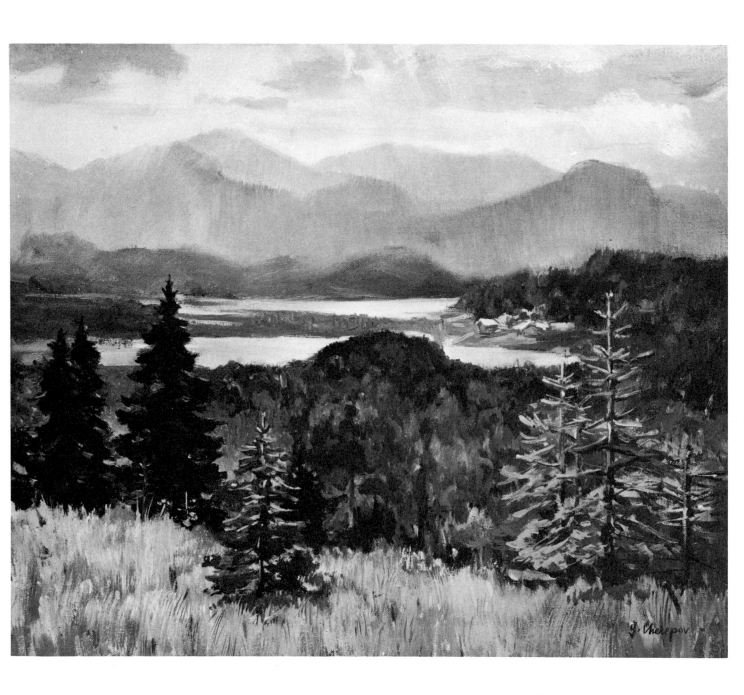

Evening at Lake Whitingham, *16" x 20". This panoramic scene demonstrates a use of aerial perspective in the value relationship between the dark spruce trees in the foreground and the same trees, much lighter, in the woods on the distant mountains. The highest tone value is on the water, which reflects the sunlight. The trees appear as silhouettes against the setting sun, receiving light only on the edges of their branches. Courtesy Grand Central Art Galleries, New York.*

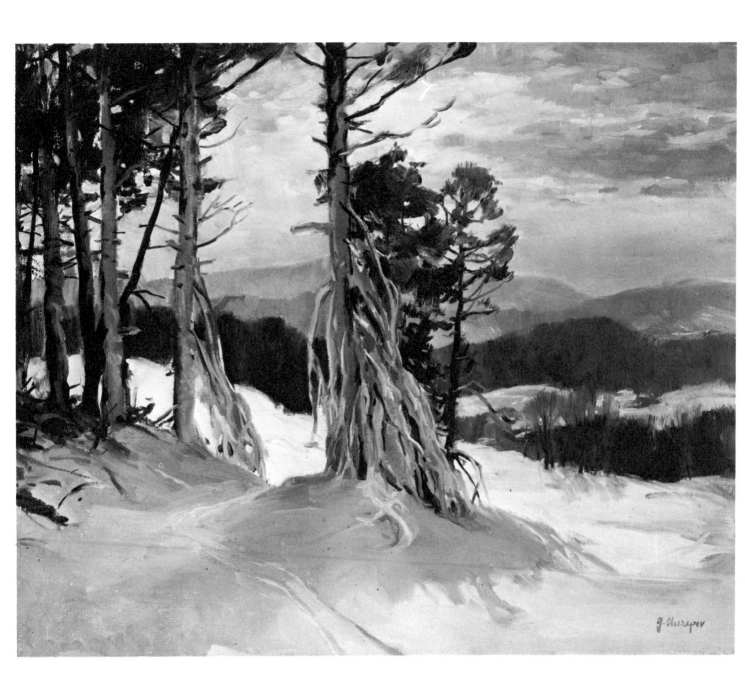

Winter in the Berkshires, *24" x 30". In order to make this study, I felt the need to work directly from nature, in spite of the cold weather. Working very fast because of the rapidly changing light, I used mostly a large bristle brush. In winter, when one is dealing with large areas of white snow and light skies, particular attention must be given to close tone-value relationships, especially if the landscape is viewed against the sun. Again and again I examined and compared the colors and values of sky, mountains, and snow. Where the tone-value difference was not notice- able, the color difference had to be defined (warmer or cooler). The fine gray colors called for a minor key palette. Details of the trees in the foreground were finished in the studio.*

Direct painting outdoors requires a high level of skill and great experience in handling the media, since there is no time for preliminary sketching or underpainting or for detailed drawing on the canvas. At the same time, if the light conditions do not change, you may continue to paint the next day. But we cannot rely on this possibility and must try to accomplish as much as possible in one session. Naturally, on-the-spot work is not always successful. There is often disappointment when a sudden change in weather conditions makes it impossible to finish the work, but the benefit of observing and studying nature is still of great importance.

Reflections in Landscape

Most people associate water with blue color, and in the beginning amateurs will paint blue sky, green trees, and blue water. One must forget this formula. Observe the color of the water in each individual case. As a guideline, note that when the surface of the water is quiet it reflects the objects on the opposite side of the viewer. When the wind agitates the surface, the reflections will disappear and the color of the water will be influenced by the color of the sky. In a small pond, surrounded by woods, the surface remains motionless and reflects the color of the trees, rather than the sky.

In painting reflections, notice that the values are slightly darker than the actual object and the color is less intensive; also, edges are more softly blended.

Analysis of a Landscape

In *Magic Autumn* (see step-by-step color demonstration, pp. 82-84), three colors were added to the basic palette shown in Fig. 35 (Chapter 8, *Color*), cadmium yellow medium, cadmium orange, and cadmium green pale. The large areas were indicated with a small brush and very pale color, just enough to indicate the areas of different colors (Step 1). Since speed was an important factor in this case, unimportant details were not considered. This subject, done on-the-spot, was a very complicated task. The difficulty lies in the complicated, interwoven design of trees and bushes, every one of them individually colored and differently exposed to light and shadow; and all of them reflecting in the water. The painting gives the impression of constant color vibration.

After a rough indication of the space occupied by the pond and the variety of trees, I changed to a large (No. 10 or No. 12) bristle brush. As long as your brush is completely clean, it is practical to start painting the lightest and brightest areas first. In this case, these were the sunny side of the trees (Step 2). Cadmium yellow pale with white was applied first. A touch of cadmium red pale was added, and the next tree was painted. Most of the large, light areas were painted in this manner, without changing or cleaning the brush. By taking a sufficient amount of paint from the palette, thinned slightly with a touch of medium without mixing much on the palette, the canvas was covered with large brushstrokes (Step 3).

To achieve the desired nuances and values, it was necessary to modify the color on the canvas by adding a touch of another color. Where the water is motionless, all the trees and the bushes on the opposite shore reflect in the pond as they would in a mirror. It saves time to paint the reflections of each tree in the same color and with the same value as the actual tree. The slight difference in value and color of the reflections will be adjusted later. The edges of the reflections will also have to be softened.

It is important to cover the white surface of the canvas as soon as possible, in order to establish the right relationship between the colors and the values. Large white areas interfere with the color relationship and mislead your judgment. After the bright and light colors were roughly distributed, the dark areas of the shadows under the trees were painted. This emphasizes the expression of light. The darkest values are seen in the shadow of the evergreens, where viridian green with burnt sienna was used. Again, the same colors were used immediately to paint the reflections in the water.

In the final step of any painting (in this case, *Magic Autumn*), we are most concerned with the adjustment of form, values, and colors (Step 4). Throughout most of the painting process, it is necessary to look at the whole subject while working on a particular part of the canvas and to avoid getting involved with only one particular detail. The whole painting must be seen as a unit. It will help if you train yourself to look at the subject with half-closed eyes and frequently step back from the canvas. By squeezing the eyes, the contours of the subject get softer and it becomes easier to make the right accent judgment. Accents must be in harmony with the whole painting. Finally, any fine, detail work (branches and foliage) is done with a small sable brush.

Before Season, *24" x 30". The space composition of this peaceful gray day at the seashore is expressed in horizontally oriented areas: sky, water, and sand. I purposely rejected all objects except the two small figures, which emphasize the loneliness of the beach and give a sense of dimension. The close range of high-key values required a very precise, delicate arrangement. The whole painting is kept on the edge of white, with the three primary colors neutralized through intermixing with tones of gray. The only touch of pure white is introduced on a small area of white on the figures.*

12. Seascape

The sea has always been a source of inspiration for painters, musicians, and poets. Some painters are so impressed and enchanted by the beauty and richness of its constantly changing color combinations that they devote their lives to studying, enjoying, and painting the sea.

The study of the basic elements of oil painting, subject, composition, form, value, and color, are as necessary in painting a seascape as in painting any other subject. The palette setting is not much different either (see Fig. 35, Chapter 8, Color). Occasionally, as an additional color, a special blue or green may be added for a nuance of color in the water. Every painter develops his personal method of painting, favoring a special color or brush. This could be influenced by his art school or by tastes acquired through individual experimentation. It is interesting to learn about these different methods and to check them against your own conceptions; but the student should not hunt for a particular "secret," a short cut to success, which is supposed to do the trick.

Observe

The truth is that the "secret" lies in careful observation and study of the sea. Expand your ability to see more colors than just blue in the sky, dark blue in the water, and brown on the rocks. Take a particular rock and find the difference in tone value between the dark (wet) and the light (dry) parts as they appear in the shadow and in the sunlit areas. Also observe the color variety on the same rock from brown (in the wet areas) to gray (in the dry areas), the yellowish-green seaweed, and the bluish reflection from the sky on the wet parts, etc.

After this careful study of one rock, extend your observation to several rocks as a group and note especially the differences between their individual local colors.

Observe the changes of color and design of the waves from the shore to the horizon. The shallow water in the foreground shows the golden-yellow colors of the small, sunlit rocks underneath; a lace-like design of foam spreads over the surface of the water. The water in the shadow of the first wave rolling to the shore turns to deep purplish blue. Near the rocks, it breaks, foaming white. Light blue reflections from the sky interplay with the dark colors of the waves. This creates a design which, with increasing distance from the shore, becomes gradually less distinct and finally blends into a single unit of color.

Sky and Water

The two chief elements of a seascape are, of course, sky and water; and they are indivisible. The color of the sea is influenced by the reflections of the sky, therefore the sky is even more important here than in landscape.

The endlessly changing moods of the sea may be sketched quickly and simply on a small canvas board (the size of your paintbox) with a large bristle brush or a palette knife. Lay in large masses of sky and water, watching the differences in colors and values. To see these differences more clearly, half close your eyes to eliminate the details. Sketch in the constant companions of the sea — rocks, boats, seagulls, fishermen's shacks, lobster pots, etc. (Figs. 50 to 52).

Impressions

Why are painters more interested in old weather-beaten boats or barns than in new, polished yachts or modern villas? The answer, it seems to me, is that the patina of old, broken, and partly peeled-off colors, exposing other colors underneath, together with the irregular shapes of aged wood and rusty anchors, harmonize with the elements of nature —

Figure 50: *These lobster pots, the barrel, and the buoy from the pages of a sketchbook are just a few of the constant companions of the sea.*

Figure 51: *By far the most prevalent of the sea's constant companions are seagulls. This page from a sketchbook shows seagulls in flight, from several different angles.*

Figure 52: *Your sketches of the sea should include boats — all sizes and kinds of boats — such as these taken from the pages of a sketchbook.*

sand, rocks, and water, or old trees on lonely country roads — often creating a nostalgic mood. Certainly the sharp, mechanical lines of a modern steel-and-glass construction or the luxurious, streamlined look of a modern yacht cannot offer such inspiration for painting.

These captured impressions are the most precious moments in your study of the sea, because they express your personal experience, which, later, will reflect in your painting as a new and fresh approach. Avoid following clichés, such as glamorous seascapes with a big wave breaking against rocks in the foreground.

To the question, "May photographs be used as a reference for painting?" my answer is, "Yes, but with reservation." There are different ways of using photography. The wrong way, which will tempt the beginner, is to copy the photograph as closely as possible.

An advanced student, who has already made the kind of personal study described above, will use a photograph only as a suggestion open to his own interpretation, or he will use it as an aid in drawing a particular detail. He knows, from his own observations, that in photography shadows are sometimes too black or the colors are too cool (containing too much blue) and he will try to visualize the picture in accordance with his own experience.

In indoor classes, students are often forced to use photos, slides, or prints, because they cannot always refer to nature itself in still life or figure painting. Of course, it is much better if you have your own sketches in color and in pencil, rather than photographs, to use as auxiliary material.

With time, you will acquire enough experience to paint larger canvases directly on the spot, outdoors.

On-the-Spot Seascapes

Pacific Coast and *Low Tide on the Sound* demonstrate the painting of an on-the-spot seascape (see step-by-step color demonstrations, pp. 85-91). In the case of *Pacific Coast* (pp. 85-88), I had arrived in Carmel one morning with my paintbox, and to my great disappointment a heavy fog lay over the sea. Suddenly, the fog lifted like a stage curtain and a magnificent, sunny, colorful scene opened up before my eyes. The warm colors on the rocks in front, emphasized by the cool blue and white of the water, first caught my attention. This established the space composition: rocks and blue and white water comprise the first plane and receive more than the lower half of the canvas; the rocks in the distance, which are generally of lighter value and therefore in closer relation to the sky, together with the distant water

and the sky, constitute the second plane. A method of achieving aerial perspective of the sky by mixing the three primary colors — yellow ochre pale, alizarin crimson, and cobalt blue — is shown in detail in the step-by-step demonstration of this painting. You are already familiar with this method of mixing separately applied colors on canvas from the demonstration of *Still Life with Kettle* (pp. 73-75).

To capture the mood of the old fishing harbor in *Galilee, Rhode Island* (p. 61), I felt the need to paint directly on the spot. Strong impressions experienced in certain environments unfortunately fade away after several days in different surroundings. It is not easy to restore them again afterwards in the studio. Naturally, it would not be wise to suggest such a complicated task to the beginner. If he is eager to try such a subject anyway, I would like to make the following suggestions: simplify the subject by eliminating certain objects and areas, and try to make a sketch indicating the basic color and value relationships. A more detailed drawing of the objects may be made with a pencil in a sketchpad. Later on, at home, the whole scene may be assembled on a new canvas.

Analysis of a Seascape

In *Low Tide on the Sound* (see color demonstration, pp. 89-91), there are no trees or buildings or any other objects requiring linear perspective. A few horizontal lines, indicating the areas of the sky, water, and the shoreline completed the drawing. The challenge here is in the control of values and colors, because this seascape was painted against the sun. With the exception of a few rocks, the whole motif is in a very light key of values, with the lightest areas in the reflection of sunlight on the surface of the water. To emphasize this strong light, the rest of the painting was kept in darker values. The brightness of the sun itself cannot really be shown, but its power is amplified by showing its light on the water. This painting was done on the spot in the direct, *alla prima*, method. The setting of the palette was based on the three primary colors: yellow, red, and blue. They are presented as yellow ochre pale, alizarin crimson, and cobalt blue. The whole painting was done with this palette, and toward the completion of the painting, burnt umber and cadmium yellow light were added for the dark rocks and the seaweed on the shore.

The choice of brushes was also limited. A No. 10, long hair, flat bristle brush was used for most of the painting; to outline the areas in the beginning and for the final touches I used a No. 7 long hair, round

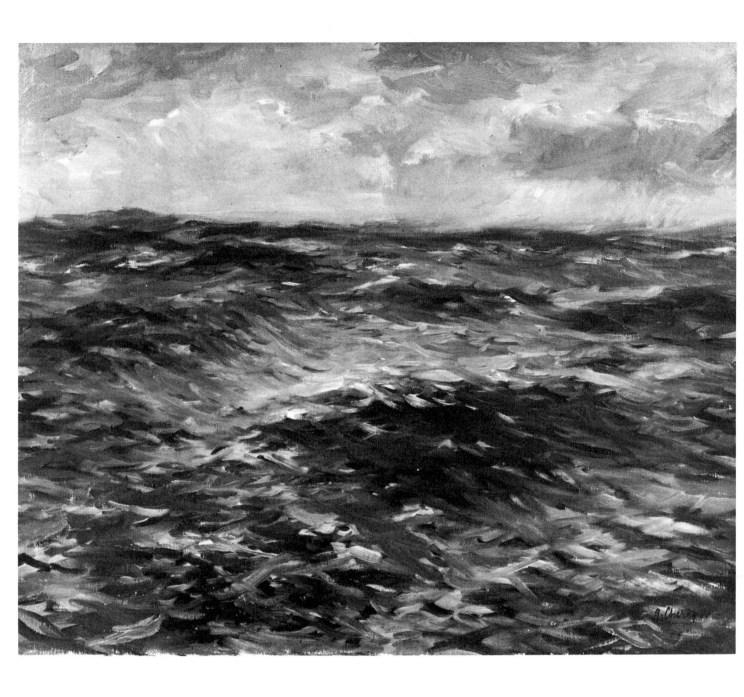

Mid Ocean, *24" x 30". I experienced the ocean in this mood on the northern route to Europe. There was nothing to relieve the monotony of the endless water — not even a bird. The cold gray sky, reflecting like lead on the surface of the deep ocean, moved me to place my field easel near the porthole of my cabin and make this study. There was hardly a need for a preliminary drawing. After indicating a horizon line, I worked with a large bristle brush right away, covering the two areas of sky and water with basically the same colors. The palette was a very narrow one, in a minor tone. It was important to express the vast, lonely atmosphere of the ocean through shaping the design of the waves.*

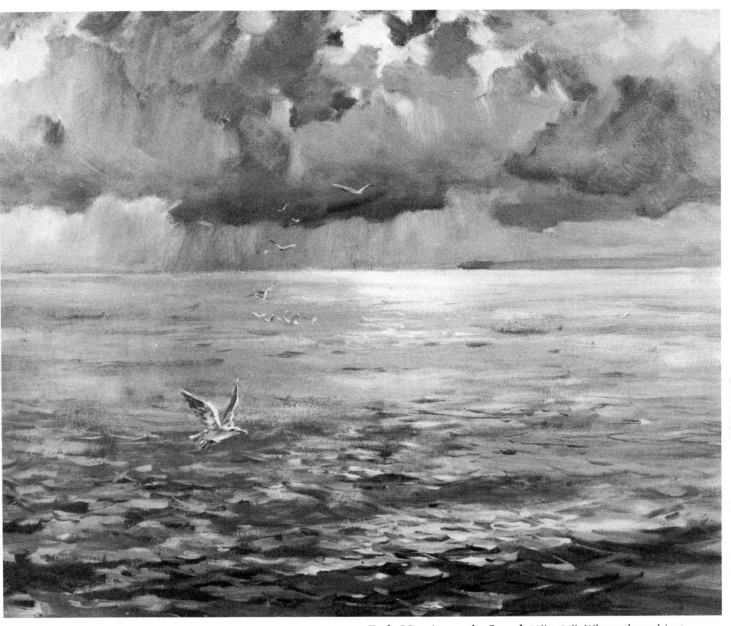

Early Morning on the Sound, *20" x 24". Where the subject consists of only two areas of water and sky, the composition is very simple. Try to determine what moved you to paint and give it the most dominant space in the painting. In this case, the reflections from the sky on the calm surface of the water created such a unity between sea and sky that the dividing line of the horizon was hardly noticeable. The shapes of the clouds and their reflections on the waves must be observed very carefully and formed by brushstrokes simultaneously with the application of colors and values. The preliminary drawing was limited to just a few brief lines, indicating the horizon and the areas of light. Large brushes were used from the beginning. Distribution of the values requires great attention, and it is the most important element next to color in this painting. The beauty of the silver gray colors, in their very subtle relationships, was expressed in an alla prima technique. Courtesy Walter Wallace Galleries, Palm Beach, Florida.*

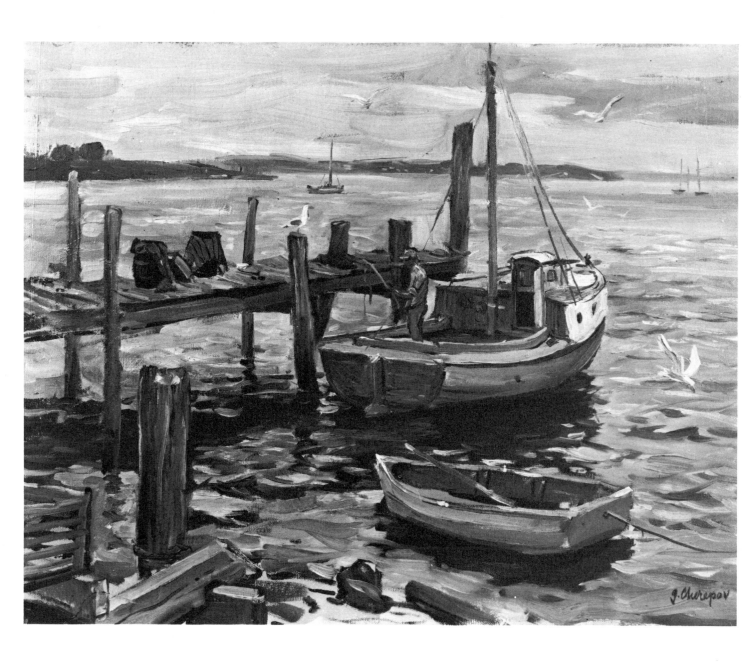

On Fisher's Island, *24" x 30". This lobsterman's place always attracts my students. One summer, I remarked to the owner that his place looked more crowded than ever. He answered, "I don't dare clean it up, the artists would give me hell!" I did not include even a part of the rubbish in this painting, because my attention was occupied more with the silver-gray light from the sky on the water and with the variety of grays on the boats and on the weather-beaten wooden posts. The irregular heights, shapes, and textures of the posts of the old dock are in harmony with the whole atmosphere of this theme. Notice that the space composition is almost horizontal, and the slightly upward-going line of the dock leads the eye to the large boat with the figure in the visual center. In order to balance these large masses another boat was placed below. Also, notice the motion on the surface of the water. Gradually, the size and pattern of the waves diminishes in the distance and become paler (aerial perspective). Private Collection.*

sable. No additional colors or brushes are required to express the subtle nuances of colors and values. The time available to paint this subject was extremely short, and I did not waste time with unnecessary equipment. As the sun lowered toward the horizon, the whole color relationship changed noticeably every fifteen minutes. Naturally, it is impossible to follow all the changes which take place in nature on the canvas. Knowing from experience and observation that these color changes move toward a warmer scale, it is wise to decide on the general tone of the painting at the beginning and stay with it throughout the whole painting, modifying it slightly with suggestions from nature. This is not the easiest task and should be approached at a more advanced stage rather than in the beginning of study.

The space division of *Low Tide on the Sound* was indicated with a small (No. 7), long hair sable brush and a very pale color (Step 1). There was no need for a precise, detailed drawing. The areas of sky, water, and sand are a vibration of the three primary colors applied separately and gradually mixed on the canvas (Step 2). The important point is to control the degree of values in each color. Since the air against the sun is rather on the warm side, the first color, yellow ochre pale mixed with white on the palette, was distributed in brief strokes with a No. 10 bristle brush. The next color was cobalt blue mixed with white on the palette to the same value as the ochre, and distributed in the same manner in the areas left between the previous strokes. It is important to modify the values while painting by adding more blue to the darker and cooler areas and less blue nearer the light.

There was still white canvas left between the strokes for the next application of red (Step 3). A touch of alizarin crimson mixed with white produced the desirable light value. The color was distributed on the available white canvas, but still not blended together. As with the previous color, the values must be controlled by adding more white near the source of light and less in the darker areas of the sky. The color red is usually more dominant closer to the horizon than in the upper areas.

Throughout the whole process of painting, in order to see the relationship of values, it is helpful to frequently step back from the canvas and look at the work with half-closed eyes. The main orientation is concentrated toward the light reflection on the water, and the white canvas was left to be painted last (Step 4). By this step, there was enough paint on the canvas to gradually blend the separate strokes. Only occasionally one of the three primary colors was added to modify an area either to a cooler or a warmer nuance. It is very important not to overmix the colors; "Break" them instead by crossing the brushstrokes over each other. It is important to preserve the flow of gradation from top to bottom and to the light.

The distant island was painted after the values for sky and water were established. The same primary colors as for the sand were used, but with less white and blue. The dark, wet rocks on the left, representing the opposite tone on the value scale and emphasizing the high value of the whole subject, were painted with burnt umber mixed with blue. The fine touches in the drawing, such as distant seagulls and highlights, were done with a small (No. 7), round, long hair sable brush.

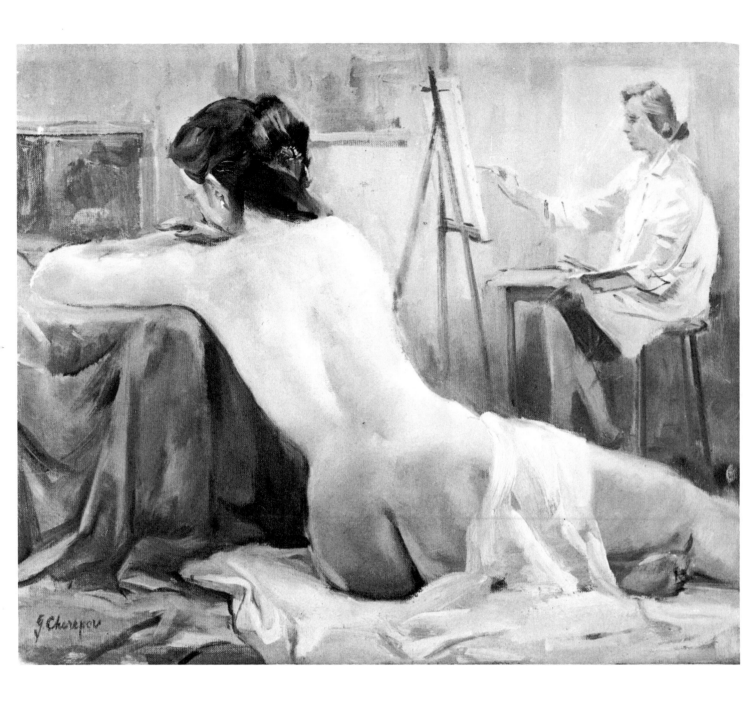

In the Studio, *16" x 20". While students in my class made a study from the model, it came to my attention that the colors and space composition of this studio scene would make a good painting. The red hair and fair complexion of the model suggested warm colors and a major palette. The folds offered a design which complemented the soft shapes of the model. The straight vertical lines of the easel and the stool, as well as the square forms of the paintings in the background, contrasted with, and therefore emphasized, the diagonally placed curves of the model.*

13. Figure and Portrait

Before starting to paint a portrait or a figure, it is wise to work in one color (or in black and white) for a certain period of time. By temporarily eliminating the difficult element of color, it is easier to acquire a knowledge of the form and values of the human body. For the study of the anatomic structure of the body I would like to refer you to *Drawing Lessons from the Great Masters* by Robert B. Hale and *Dynamic Anatomy* and *Dynamic Figure Drawing* by Burne Hogarth. It should be mentioned, however, that for the painter's purpose it is sufficient to be acquainted with the structure of those bones, joints, and muscles which determine the visible forms. They are the basic framework on which the peculiarities of the individual are superimposed.

First, familiarize yourself with the proportional relationships of the main parts of the body. Study various poses and movements from different directions and under different light conditions, with a special emphasis on a detailed study of the head and hands. If you work from a live model, it is useful to make black and white drawings in two different methods, the quick sketch and the tone drawing.

Quick Sketch

One method of drawing the human figure is the quick sketch (Figs. 54-58). The model should keep a pose not longer than two or three minutes. Take a good look at the over-all position of the figure, then draw with definite lines and free arm movement. In this short period of time you should not try to make any corrections; if the drawing does not satisfy you, take a new sheet of paper and start again.

There is no need to use fancy material for these quick sketches. A cheap newsprint paper, a piece of charcoal, and a can of fixative spray are all you need. Spray all the drawings, regardless of quality, to prevent the charcoal from smearing. Try also to use materials other than charcoal, such as Conté

crayons, felt pen, ink, brush, etc. (Figs. 59 and 60).

As soon as you are better acquainted with the human form, you might be interested in experimenting with combinations of different techniques of drawing. For instance, use a bristle brush to blend Conté crayons or use a bristle brush with black tempera or acrylic paint for the whole drawing, applying the paint both solid and with a dry-brush effect. Using a brush for black and white studies provides an intermediate step that brings you closer to the process of painting. It is not always necessary to handle a drawing as the outline of a form; covering areas of shadow and indicating a few edges of the figure are sufficient. There is no limit to the variety of lines and textures you can produce.

Tone Drawings

Another method of figure drawing is the thorough study of the figure in three-dimensional form, including a full range of tone values from white to black, as described in Chapter 7, *Value*. Examples of portrait heads done in tone are shown in Figs. 62 and 63. Such drawings, which should be larger than a sketch, may require several sessions. You will need a full-size sheet of charcoal paper (with a fine tooth), a stick of soft vine charcoal, a can of fixative spray, a piece of soft chamois leather, a kneaded eraser, sandpaper, absorbent cotton, and a soft rag.

Try a simple pose in the beginning, so the model will be able to keep the same pose longer. Mark a few points on the stand with chalk, so the model will be able to return to exactly the same position after a rest or at the next session. In the same way, mark the position of your easel to maintain your distance relationship to the model.

To start, draw very pale lines (applying no pressure), indicating the general distribution of large areas, such as the proportional relationship from

Figure 53: *A study of a human skull. Before you can define the features of the face, it is necessary to understand the underlying bone structure. (See the same skull in a painted study, p. 135).*

Figure 54: *Quick, life drawing sketches (done on newsprint with charcoal) are the best way to learn about the human form.*

head to toe, then subdivide these areas into legs, arms, and torso. If the first lines are wrong, do not try to correct them by erasing. Simply dust them off with a rag and make new ones with the same light pressure. When the general proportions are established, spray the lines lightly with fixative. During the whole process of the work, avoid rubbing the paper with greasy or wet hands.

Next, take a piece of charcoal and rub it to powder with sandpaper. Taking up this powder with a ball of absorbent cotton, apply a light gray tone over the whole figure (in Fig. 63, this light gray tone has been applied to the head).

Determine the location of the highlights, and pick up the charcoal powder with the kneaded eraser, leaving clean white paper in these areas. The eraser should be kneaded with your fingers to form it into the desired shape. In an area where the highlight is small and has sharp edges, knead the eraser into a point. For light areas on muscles, shoulders, or knees make a larger round form and pick up the powder by simply pressing the eraser to the surface. Do not rub.

If the first picking-up does not remove all the charcoal, knead the eraser again to form a clean spot and repeat. It is imperative to preserve the purity of white paper in these highlight areas, because it cannot be restored after spraying with fixative.

Getting Values

Now take a piece of vine charcoal (about 2'' or 3'' long) and use the long, flat side to apply light pressure, covering the areas of shadow. Experiment with the various possibilities of strokes of different pressures on a separate sheet of paper. By applying pressure only at one end of the stick, you can produce value differences in your stroke.

At the same time, using the flat side of your charcoal produces a point for drawing the details. In drawing the shadows, do not attempt to produce the extreme darks at once, but build up the greater value differences gradually by applying several layers of charcoal, each of which must be sprayed with fixative before the application of the next.

It is important that before each spraying you check the highlights and, with the eraser, pick up any charcoal dust that may have collected there. With increasing experience, you will know how many layers of charcoal are needed to produce deeper values.

Sketching is Important

Both methods of black and white drawing, the quick sketch and the tone drawing, are equally important

Figure 55: *A life drawing sketch done on newsprint with charcoal. The pose was held no longer than two or three minutes.*

Figure 56: *Another life drawing sketch done on newsprint with charcoal. These quick sketches are good for developing a sense of spontaneity in your drawing.*

Figure 57: *In this life drawing sketch done on newsprint with charcoal, you can see how the fullness of the figure has been suggested through the weight (the darkness or lightness) of the outline rather than through shading.*

Figure 58: *This is also a quick, life drawing sketch, but here, a bit of shading was used to indicate the forms within the contour of the body.*

Figure 59: *This page was taken from a sketchbook of on-the-spot studies for Market near Oxaxa (p. 28). It was done with pencil and felt-tipped pen in broken shading.*

Figure 60: *Here is another study for Market near Oxaxa (p. 28). This sketch was done with pencil and shaded with solid masses of watercolor wash.*

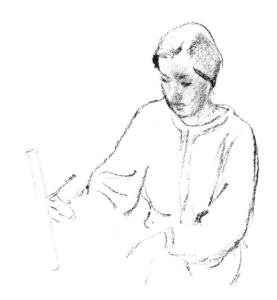

Figure 61: *A portrait done in tone on soft-tooth charcoal paper with vine charcoal.*

Figure 62: *Portrait of Walter de la Mare. This portrait was done on soft-tooth charcoal paper with vine charcoal. The highlights in this case were not rubbed off; they derive from the untouched surface of the paper.*

Figure 63: *A light gray base tone has been applied to the head: highlights will be rubbed off with a kneaded eraser.*

Skull. *To present the human figure realistically, a thorough study of the construction of the bones and main muscles is necessary — especially in portrait painting, where the personal characteristics of the face largely depend on the individual skull formation. Knowledge of the skull will help you distinguish these characteristics and to express them in a convincing way.*

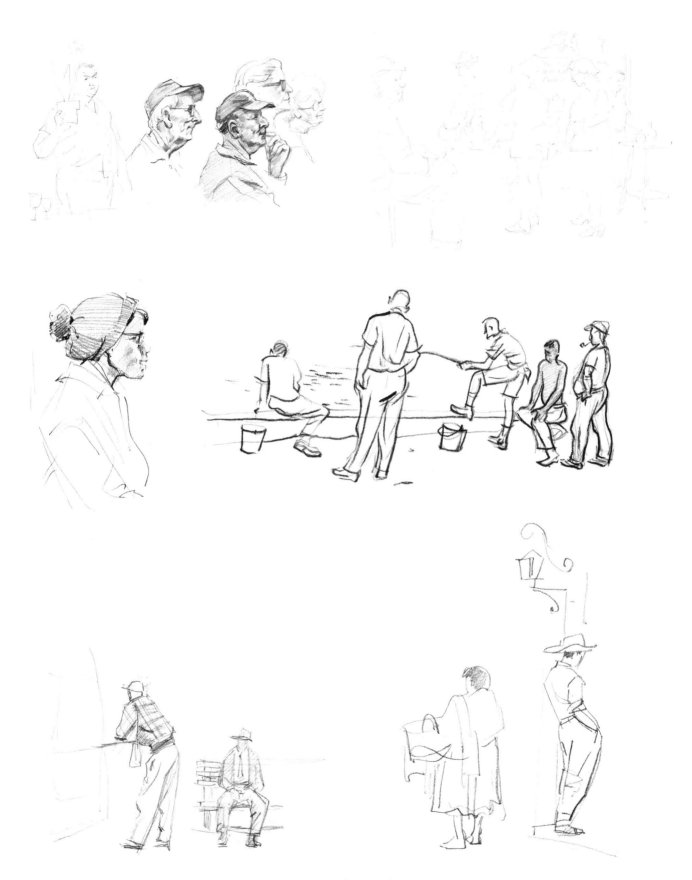

Figure 64: *These pages from a sketchbook show a series of both quick line sketches and tone drawings. As I have indicated before, sketching should be a constant occupation for the painter, and a sketchbook should accompany him everywhere.*

and should be practiced as frequently as possible. While the first frees the hand and trains the eye and mind to quick emotional response, the second provides disciplined control over form and values.

If the reader has no opportunity to draw a professional model, take one, or even three, big mirrors and model for yourself. Also, quick sketches (done with a soft Conté pencil in a small sketchbook) of people in various poses on the beach in the summer are very useful. A few sketches of this type from my sketchbook are shown in Fig. 64.

Painting in the Studio

Now let us discuss painting the figure or portrait in the studio. A small painting of the head can actually be done in any room in which a sufficient amount of light is available. However, if you are dealing with a figure painting or a larger portrait, it is helpful to have special sources of light (Fig. 65). Light and shadow can emphasize, but they can also destroy, the characteristic features of a subject. A skylight, facing north, is regarded as the best solution.

If a skylight is not available, use one large dominant window as a main source of light for the model. This window should be located higher than a standard window and it should face north, so that the effects of changing sunlight are eliminated. By covering the lower part of a standard window, a more concentrated upper light may be obtained. Logically, if you are painting a larger portrait, you have to stay at a distance of about 6' to 8' from the model.

Also bear in mind that the light on your canvas must come from over your left shoulder. If the main window is not large enough to supply sufficient light for both model and canvas, a second window is needed to provide light for canvas and palette (Fig. 66).

When painting a portrait, place the model so that the face is at your eye level. This means that if the model is posing in a chair, you must work from a sitting position (Fig. 67). If you prefer to paint standing up, the model must be seated higher. Placing the seated model on a platform roughly 15" high will solve the problem.

There is a great advantage to painting in a standing position because it gives you freedom to step back from your canvas frequently, and such a change in distance gives you better control over the progress of your work (Fig. 68).

The Figure

In approaching the human figure, the student should, as always, be primarily concerned with

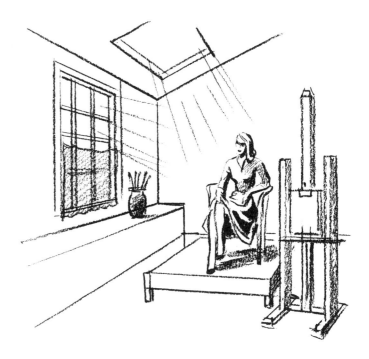

Figure 65: *The most desirable light source for a figure or portrait painting done in the studio is a skylight, facing north. If this is not possible, a large window, higher than a standard window and also facing north, should be used. A more concentrated light can be obtained through such a window if the lower half is covered.*

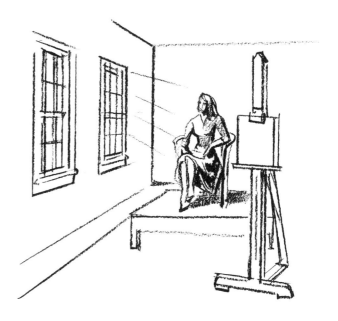

Figure 66: *If you have neither a skylight nor a large window, you should have two windows to provide enough light for both model and canvas. These, like the skylight or the large window, should ideally face north.*

Figure 67: *If the model is seated, then you must also be seated in order to keep her at your eye level.*

Figure 68: *If you prefer to work standing up, raise the model to your eye level by placing her on a platform roughly 15" high.*

composition, form, value, and color. It might be of interest to take a look at the history of art and to familiarize yourself with the human figure in the work of great masters of different centuries and different civilizations.

In ancient Egypt, for instance, the human figure was presented in static, stylized form. The Greeks chose the perfect human form to represent their gods. In the Renaissance, the glamorization of the human body continued, culminating in Michelangelo's paintings in the Sistine Chapel. In your own time, a search for new and different shapes, detached from a realistic presentation of form, is in evidence. Figures are frequently rendered as narrow, elongated shapes; or presented as abstract design. However, I believe the student should first obtain some knowledge of human anatomy and proportion before taking liberties with it.

In *Tahitian Girl* (see step-by-step color demonstration, pp. 92-94), the model obviously is of African-Oriental descent and represents an exotic beauty. Her dark skin and black hair suggested a contrast in color and value, and a very light background was chosen for that purpose. To increase this contrast and to suggest a sunny environment, yellow striped drapery was selected. Warm colors dominate the painting, and to emphasize them, a blue cloth was chosen for the bottom of the painting.

After preliminary sketches were made to establish the composition, the actual painting process began. Because this subject does not impose a time pressure, one can work at a relaxed pace and carry the painting over several sittings.

After about twenty minutes of posing, the model should be allowed to rest for five minutes. No matter how experienced the model may be, there are always slight changes in the position after every rest period. In the beginning, the student might be irritated by this, as he tries to bring every detail back to exactly the same position after each rest. Later on, as he becomes more familiar with the human form, he will be able to make his changes and decisions on the canvas, using the model as a suggestion for certain areas of his painting, rather than as a subject for exact copy.

(Right) Standing Nude Study. *This monochrome sketch, and the two which follow, was done by using a large bristle brush with burnt umber and white. For faster drying, the paint was thinned with turpentine. This sketch was made in about fifteen minutes. Attention was given to the distribution of weight, which is indicated primarily in the position of the hips. Because the model rests on the left leg, the right leg is relaxed.*

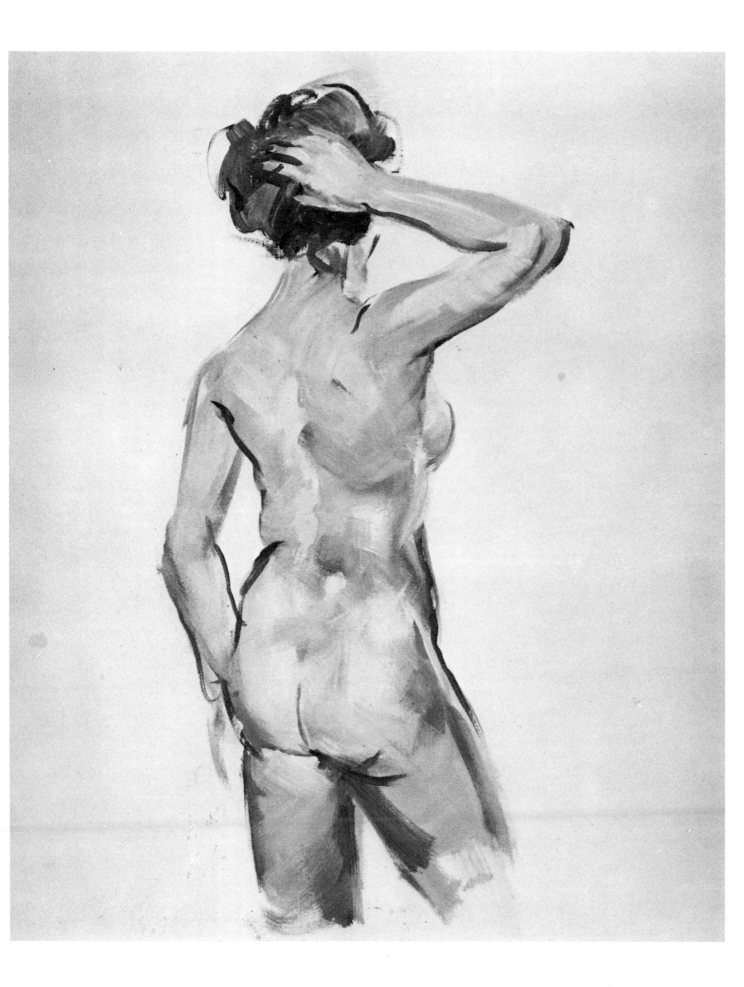

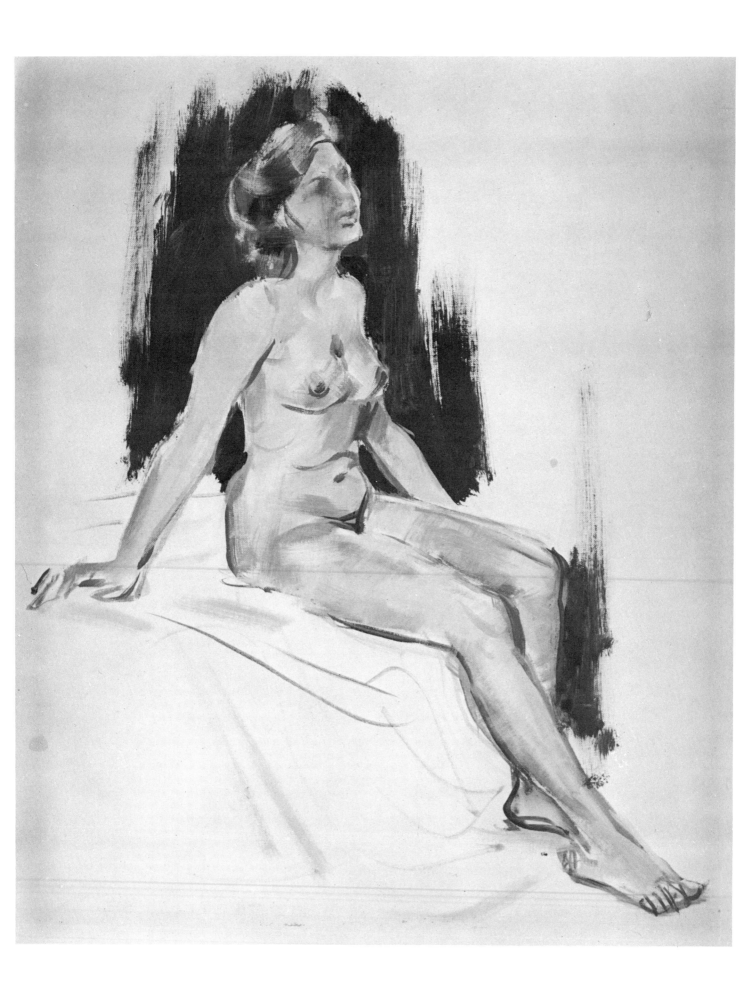

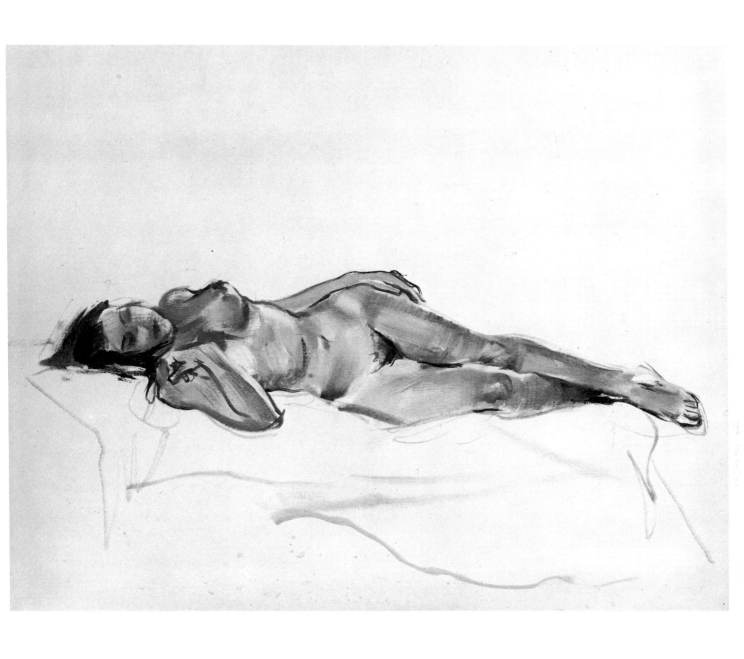

(Left) Seated Nude Study. *The round forms in this sketch were expressed by a crossing brushstroke, using a wide bristle brush. A small sable brush was used for the outlines.*

(Above) Reclining Nude Study. *In the reclining position of the body here, notice how most of the lines flow down under the influence of the law of gravity.*

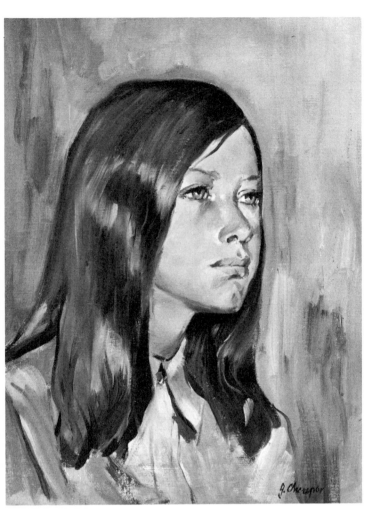

Analysis of a Figure Painting

In *Tahitian Girl*, I used soft vine charcoal with straight lines to indicate the space occupied by the figure. Then, without pressure, the general shape of the figure was drawn in light lines (Step 1). Again, the dynamic of the distribution of the large masses at this point is far more important than the fine details of the features. After this preliminary drawing in charcoal was done, the excess charcoal dust was blown away and the drawing was sprayed with fixative.

It is worthwhile at this moment to reinforce and correct the drawing with a small brush and paint (Step 2). In this case, burnt sienna thinned with turpentine was used. The purpose of this is obvious: the drawing will be still visible even if painted over.

The palette setting did not require any color in addition to those already shown in Fig. 35 (Chapter 8, *Color*), except that cobalt blue was exchanged for ultramarine blue to obtain the darker areas on the hair and skin. Also, the selection of brushes did not require any change from the previously mentioned three brushes.

Dealing with the human figure, except in a portrait, it is not important to start painting the head first; one may start with any part of the figure. The general idea is to cover the whole area of the figure with the approximate colors and values. Gradually, they are adjusted and modified through adding the necessary colors (Step 3).

For the final adjustment, all the colors surrounding the figure must be painted. Because the influence of the colors on each other is rather strong, one has to give as much attention to their correct relationship as to the precise drawing of mouth and eyes. *Note:* When the painting is not completed in the wet-in-wet method, the surface must be completely dry and prepared as described on p. 00. Working on the face, the lower part was brought forward to emphasize the mouth, and the big eyes and the line of the forehead give it a dynamic line.

The Portrait

I share the opinion of painters who say that the portrait is one of the most difficult areas of painting. In addition to composition, form, value, and color, the painter is faced with the problem of expressing the individual character, the "likeness" of the subject.

In a landscape or seascape, a painter may use his freedom to move certain areas around or change the shapes for better composition, but in a human face such changes obviously would create distortions of

Marianne, *16" x 12". The melancholy expression in this young girl's face moved me to paint her. During the whole session she hardly spoke a word or made a move. The simplicity of background and of her clothes emphasizes the expression of the eyes and the general mood of the painting.*

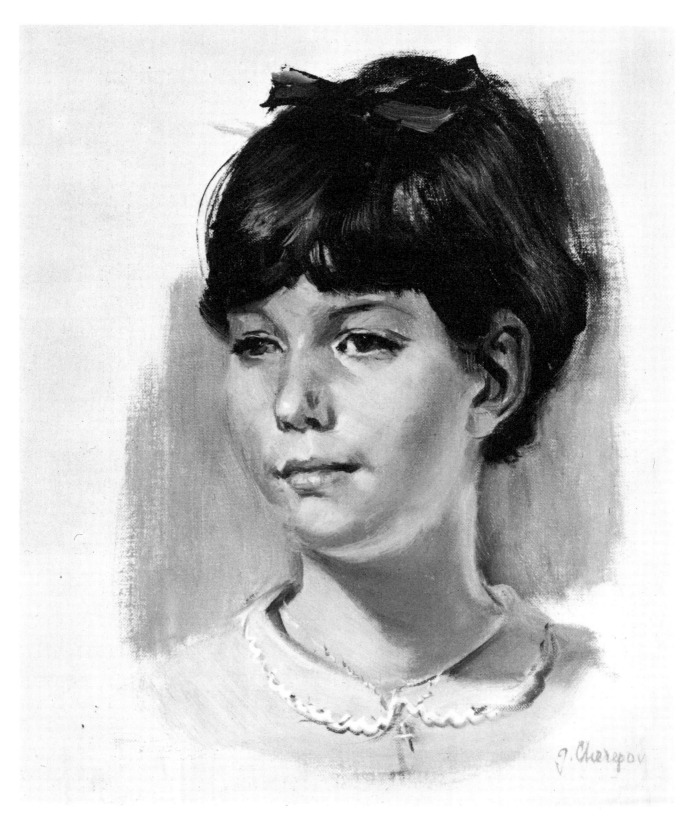

Lynn, 16" x 12". *Here is the head of a young girl, similar to Numo (see step-by-step color demonstrations of Numo, pp. 95 and 96). One of the differences between this portrait and Numo, however, lies in the relationship of values. While Numo's blond hair, fair face, and white sweater were emphasized by a dark background, Lynn's dark hair and softly lit face were complemented by a light background and a suggestion of light pink in the dress. Another difference is the painting method: Lynn was painted alla prima in two sittings, while Numo was painted in the slow technique (there is also a version of Numo painted alla prima, demonstrated p. 96).*

Figure and Portrait 143

the kind found in caricature. A painter who is not capable of mastering the medium should not try to escape behind the statement, "This is the way I see you." In the same manner, a painter who consciously flatters his model (similar to a photo retoucher) sacrifices the quality of his painting. It is so easy, in painting portraits, to get sidetracked in one of these ways. To prevent this, it is a good idea to frequently visit museums and analyze the work of the great portrait painters.

When painting a portrait, your first concern should be the esthetic quality of the painting from the point of view of composition, form, value, and color. Secondly, it has to represent the most characteristic qualities of the person whose portrait you are painting. Therefore, it is wise not to rush into the painting before you get to know the personality of your model.

Observe your model in a variety of situations and note the facial expressions. Watch him or her at work and at leisure. Visualize suitable surroundings and clothing. A good idea is to make one or more preliminary sketches in which the following questions should be considered: How large should the painting be? Should the whole figure be shown, only the upper half with the hands, or just head and shoulders? Should the model be standing or seated, and in which pose? What color and value should the person's clothing be? In what space design and color should the background be composed? Where should the lights come from and in what strengths should they be adjusted? Is a horizontal or a vertical canvas more appropriate for the composition?

For a better understanding of the meaning and importance of these problems, I would like to refer you to some of the paintings shown in this book to give you an idea of how they could be handled. For instance, in the portraits of Numo (see step-by-step color demonstrations, pp. 95-96) and Lynn (p. 143), the expression and the subtle nuances of color of the child's face impressed me the most; therefore, only the head and shoulders were painted.

The painting My Daughter (p. 63) suggested a more elaborate composition. The graceful movement of the young girl tuning her violin called for a large, horizontally spread canvas. At the same time, it opened large spaces for the background, which, in accordance with the mood of the subject, required a light key value. A part of a large window behind became a source of light for the model, accenting the fresh flesh-colors and the white blouse. The rest of the wall space was painted in vibrations of warm, pinkish colors to complete the youthful, optimistic mood of the theme.

In a similar subject, Miss Susy Richards (p. 150), the expression of the carefree personality of the young girl is enhanced by her vibrant, colorful dress and the brilliance of a sunny day outdoors. This painting also required a large canvas.

The portrait of The Honorable Mr. John S.P. Castle (p. 146) represents a retired executive, whose life was spent mostly in public work. Sparks of humor (during most of the sitting he was telling jokes) were an inherent part of his personality. Usually, he wore dark suits; to these large dark areas an even darker background was chosen to underline the most important part of the painting, his face. This portrait is done in the traditional style of portrait painting.

The portrait of Mr. B. Hwoschinsky (p. 149) also reflects the life pattern of the sitter. Having retired to his country home after many active years in the banking business, he enjoys reading near the fireplace. The large canvas (34" x 40") includes a comfortable chair, a part of a fireplace with bookshelves behind it, and a constant companion, his dog.

Work in Unchanging Light

The few examples listed above should call your attention to the various problems a portrait painter has to face and the wide variety of possibilities he has in solving the composition. Certainly, I would not suggest that you start with the most difficult task of painting a large canvas outdoors, where the model is exposed to fast-changing light, as in the case of Miss Susy Richards.

To begin with, take a small canvas (12" x 14" or 9" x 12"), and concentrate on the head and shoulders. Examine the model carefully from different sides in different light possibilities. Avoid equal strengths of light from two sources, because this splits the attention and distorts the important features of the face (Fig. 69). Use a soft general light from a large window and position the model at approximately a 45° angle to this source.

Now the position of the head must be chosen. Should it be in profile? In three-quarter view? Full face? Numo (p. 96) shows the head in a three-quarter position, with a soft light falling on the face from the left at an angle of about 45°. Notice the shadows on the cheek and nose, which bring out the characteristics of the head.

The beginner is inclined to select the direct frontal view in the hope of making the task easier. He will be disappointed to find it more difficult to form the nose and individual shapes of the face in a front

view. By taking the head in three-quarter view, he will be able to see the features more distinctly and at the same time avoid the monotony of a symmetrical composition.

Composing the Portrait

The next problem is to design the space of the three dominant areas of a portrait — face, shoulders, and background — in proper relationship to each other on the canvas. Here I have to refer back to Chapter 5, *Composition*, and to the principle of dynamic, asymmetrical space balance. In addition, the six different spacing possibilities shown in Fig. 70 should help you solve the problem. Example *A* demonstrates the disadvantage of placing the head to the left. It lacks space in front of the face, emphasizing the background behind the head. In *B*, the opposite extreme is shown; the opening of a large area in front of the face creates an unbalanced impression. *C* shows that locating the head too high divides the canvas into two equal areas (head and shoulders) which lessens the importance of the face. A similar weakness occurs if the head is placed too low, as in *D*. In *E*, the large background certainly overpowers the importance of the person. The solution given in *F* seems to be the most satisfactory. It maintains the dominance of the head while leaving enough space around it as background.

Painting a Portrait, Step-by-Step

Now let us follow the step-by-step demonstration of painting a portrait of this type. In Chapter 9, *Techniques*, different methods of painting are described. An experienced portrait painter may be able to use the *alla prima* method, working fast, wet-in-wet. He will probably achieve the best results because of the soft blending of the delicate value and color relationships of light and dark areas in the face that this method makes possible. Naturally, a beginner who has to struggle through adjusting the drawing, values, and colors and who, through these constant corrections, overmixes the paint, will be very discouraged with the result. Therefore, I suggest that, to start with, a slow method of painting is best (see step-by-step demonstration of *Numo* painted with the slow method, pp. 95 and 96).

(1) First of all, a careful drawing should be made on a sheet of paper of the same size as the canvas.

(2) The back of the paper is then blackened with charcoal and the drawing is attached to the canvas with masking tape. The outlines may now be transferred to the canvas without puncturing it with a

Figure 69: *Avoid equal sources of light from two sources (left), as this splits the attention of the viewer and distorts the features of the face. A single light source (right) shows the face in its true proportions and emphasizes the three-dimensional quality expressed in the modeling.*

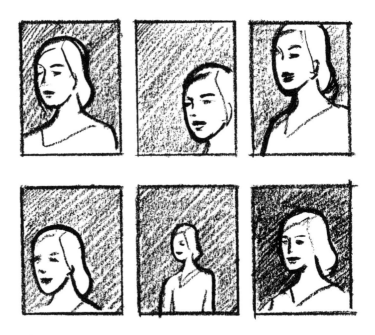

Figure 70: *How do you place the portrait head in the picture space? Here are six possible solutions, but only one of them works. In example A, the head is too far to the left; it seems to be going out of the picture. In example B, the head is too low and too far to the right; it hasn't come into the picture yet. In example C, the head and shoulders are too big for the picture space. In example D, the head is too low and too small for the picture space. In example E, too much of the body is shown and the figure is too small and too exactly centered in the geometrical center of the picture space. Example F shows the classic arrangement of a portrait head; the relationship of head and shoulders to background is perfectly balanced.*

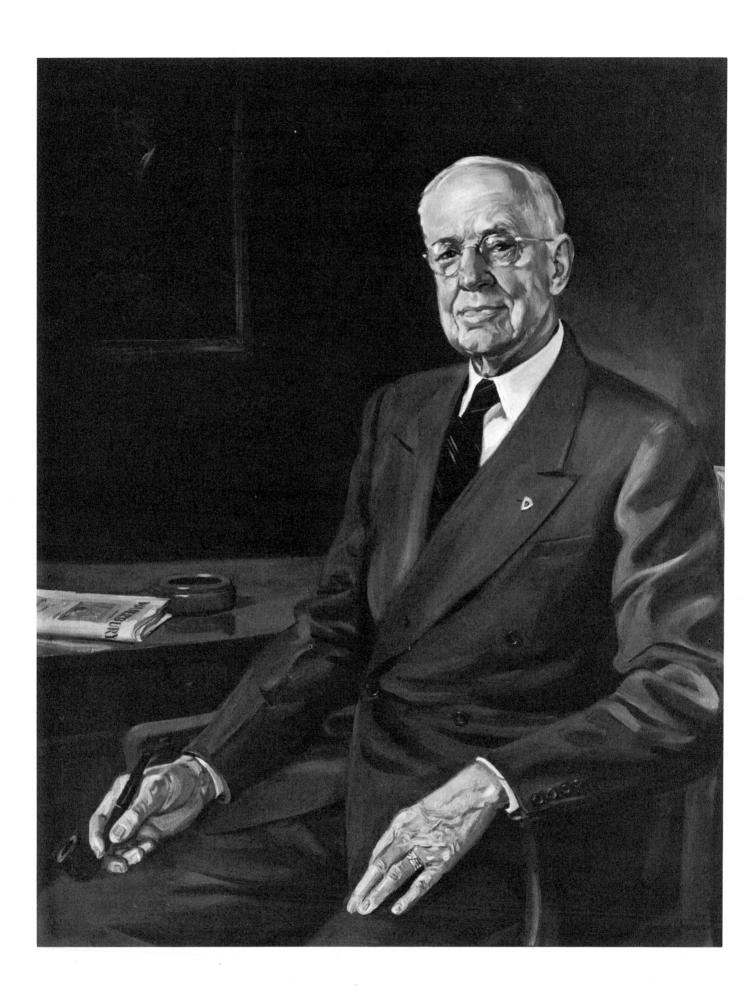

(Left) The Honorable Mr. John S.P. Castle, *36" x 30".
Characteristic of the expression of this retired executive
were the sparks of humor which played around his eyes
and mouth. I had no difficulty in entertaining him. On the
contrary, he kept my spirits high by telling jokes. Since he
usually wore dark suits, I felt that the large dark areas
occupied by the suit, together with an even darker back-
ground, would most effectively underline the most im-
portant part of the painting, his face. This type of formal
setting does not offer much in the way of color; its prime
emphasis is on value relationships.* Courtesy Ancient
Accepted Scottish Rite, Waterbury, Connecticut.

(Above) Evening, *24" x 18". Sitting comfortably in her
favorite armchair, surrounded by the comforts of her
home, this lady is reading. All the objects surrounding her
were selected to express the quiet evening of her life. A
great variety of patterns and color nuances is offered by
the upholstery of the chair and by her dress, accentuated
by the lamplight.* Courtesy Portraits, Inc., New York.

light pressure of a pencil. If you are using a stretched canvas rather than a canvas board, use very light pressure or support the canvas with a board held against the back. Instead of applying charcoal to the back of the drawing, a pencil carbon paper may be used. In the next step, the outlines on the canvas should be reinforced in a darker color, using a small brush.

(3) The underpainting of the large areas can now begin. Lean medium (consisting of 2/3 turpentine, 1/3 linseed oil) should be used. In painting *Numo*, the background was covered with burnt umber and cobalt blue. Next, the area of the hair was painted in a light tone, using yellow ochre pale with white.

(4) When the areas surrounding the face are under-painted, it is easier to define the so-called "flesh color." The first layer of the face color was applied with a flat bristle brush, using the same lean medium that was used for the background. For this first underpainting, rather warm colors were used: yellow ochre, cadmium yellow pale, cadmium red light, plus white. Basically, the light and dark areas of the face were established right in the beginning to define the shape of the nose and cheeks. The subtle tone value differences around the mouth express the soft smile so essential to this child.

(5) Developing the painting further, a cooler color in the form of light cobalt blue was added in the areas of the chin, hair in shadow, eyes, and sweater. For the final modeling, the brushstrokes on the face were lightly blended with a flat sable brush to express the softness of the child's skin. The texture of hair and sweater was achieved with a dragging, drybrush stroke, using a large, flat bristle brush. The fine details of eyes, nose, and mouth were designed with a small (No. 7), longhaired, round sable brush.

Flesh Tones

In my opinion, no exact prescription can be given for getting flesh tone. Each person has individual skin, hair, and eye colors, which have to be considered in relation to the whole color composition. Furthermore, in the three-dimensional presentation of the face, the color is not uniform; it changes every fraction of an inch in value and hue as determined by light and shadow. Ready-mixed flesh tone color, purchased from the art supply dealer, gives the effect of a flat pinkish mask on the face. Therefore, I have to refer you again to the three primary colors and their adjustment on the canvas.

Portrait painters differ in their choice of colors and in their techniques of painting. Some suggest the use of complementary colors like cadmium orange and cadmium green with a touch of burnt sienna, some use yellow ochre pale, cadmium yellow pale, cadmium red pale, alizarin crimson, and cerulean blue. Still others use the combination of Venetian red, rose madder, cadmium red light, and black or raw sienna, cerulean blue, and rose madder. Later, as you progress, it would be wise to know and experiment with these various methods.

Keep the Palette Simple

In the beginning, however, it may be discouraging to face these various choices. To avoid unnecessary confusion, I suggest that you work first with the already familiar palette: yellow ochre pale, cadmium yellow pale, cadmium red light, alizarin crimson, burnt sienna, and, as a cool color, cobalt blue. This palette, with the addition of white, was used in *Numo*.

Arranging the Sitter

As you progress and acquire experience and skill in drawing from a live model and painting a head, you may wish to paint a larger portrait which includes the hands. An analysis of the portrait of *Mrs. J. Neighbor* (p. 64) will show what this involves. The fine features of her face called for an elegant setting. Her pale skin, platinum blond hair, and large eyes would be best emphasized by a black evening dress. Having set the color theme of these two dominant areas — head and dress — a suitable color had to be found for the third large area, the background. Checking through various color combinations, I felt that deep cardinal red would make a good contrast and at the same time be harmonious with the black of the dress and the gold of the hair.

After the general color theme of the large masses was decided, the positions of the head, body, and hands were defined. Experience will show you that one of the more difficult tasks in figure and portrait painting is to arrange the hands in a way that is both natural and suited to your design. If you are lucky enough to have a good model, whose movements are naturally graceful, just observe her in casual conversation and stop her at the right moment for the pose. More often, however, some adjustment in the position of the fingers, shoulders, etc., is required. Take ample time for this planning — you may need the entire first session for it.

Mrs. Neighbor appeared at first without a stole, but her black dress had an unfortunate shape for the composition of the painting. It was sleeveless with a narrow neckline, which, on the dark background,

Mr. B. Hwoschinsky, *38" x 32". This portrait has an immediate connection to the life pattern of this gentleman. After retiring from many active years in the banking business, he enjoys reading near the fireplace. This large canvas includes a comfortable chair, a part of a fireplace, bookshelves, and a constant companion, his dog. A strong* light from the right was added to the general soft light from the main window, which was located behind my left shoulder. This additional light brought out the modeling of the face. The head was set off against the dark area of the background. The second light source also highlighted the folds of the casual corduroy jacket. Private Collection.

would have created the impression of two light arms and a head mounted on a black torso without any connection. To soften the harshness of these lines, we tried a stole which added free, irregular shapes and contributed, with its folds, to the position of the hands and shoulders. By folding down the dress, we created a more open neckline, and with it a softer connection between neck and shoulders. The triangular composition was gracefully and harmoniously completed by placing one elbow on the arm of the chair and letting the other arm rest casually in the lap. Still, there was the need to add another touch of vivid color in the form of a bouquet of golden flowers in a bluish vase, thus softening the static formality of the composition.

Relaxing the Sitter

We cannot expect that after each recess a person who is not a professional model will find exactly the same position of head, hands, folds of dress, and so forth, again. Don't waste time on the effort to replace everything in exactly the same way. After the first distribution of colors, work on just one part at a time, asking the model to keep only that part still for the time being, and allowing her to relax otherwise. For example, if you are working on the hands, allow her to move her head freely. Naturally, you have to constantly refer to the whole painting while you are working on one detail to keep the color and value unity of the whole composition.

Here is where the special skill and the advanced craftsmanship of a portrait painter is required; he must be able to work with flexibility and freedom, capturing the desirable form without freezing the model to the conditions of a still life. As a matter of fact, to achieve a relaxed and lifelike expression, the painter should try to entertain the model with conversation or music, at the same time observing the characteristic expression.

Miss Suzy Richards, *38" x 32". The happy, carefree personality of a young girl, enhanced by her vibrant, colorful dress, suggested a brilliant, sunny day outdoors as a background. To emphasize the intensity of the colors, it was important to weaken the dark values of the shadows. This was achieved with the white surface of the table: highlighted by the sun, it throws reflected light on the figure, amplifying the bright colors of the dress. The bright, sunny green lawn also emphasizes these colors. The dark group of trees behind the head increases the contrast to the sunlit hair, and at the same time draws attention to the face.*

Take the same flexible and free approach to your painting. Don't hesitate to make considerable changes if necessary. Don't regard every stroke on the canvas as permanent. Be ready to change where you see the need for it, regardless of how much work has been involved already.

Use of Photography

A successful portrait painter, as he becomes better known, receives commissions to paint prominent personalities who usually do not have sufficient time and patience for sitting. This brings the painter into a situation where, on the one hand, he has to work under handicapped conditions and, on the other, his work is subject to the harshest criticism from relatives and friends of the subject, as well as the public, all of which puts additional pressure on the painter. He is often forced to work without the subject of the portrait, from photographs and sketches. Many painters have developed this skill and work under such conditions successfully, using the subject only in the end for one sitting, to check certain areas, especially the facial features and the expression.

Personally, I prefer to work directly from the subject. But I have occasionally been in the situation described above. Many years ago, working on the portrait of a high official who could not come to my studio for a sufficiently long period of time, I decided to work directly in his office, his typical surroundings. Even though he tried, he could not help being preoccupied with business.

I do not recommend using photographs to copy from until the student acquires extensive knowledge of drawing from nature. In the case of a portrait painting where the subject is not readily available, however, it is often necessary to work from photographs. When using photographs in portrait work, do not limit yourself to only one photograph; study the sitter's features from many different photographs taken from different positions. In certain cases, a good black and white photograph is helpful in that it preserves a quality of selected light and may be very useful for work on areas of clothing, the hands, or other details of a portrait. The face, however, should be painted directly from life, if this is possible, because a photograph just cannot convey the same qualities of the subject or elicit the same response in the painter that a live model would.

One thing to remember when using photographs is that the color in color photographs is very misleading. Black and white photographs are always preferable.

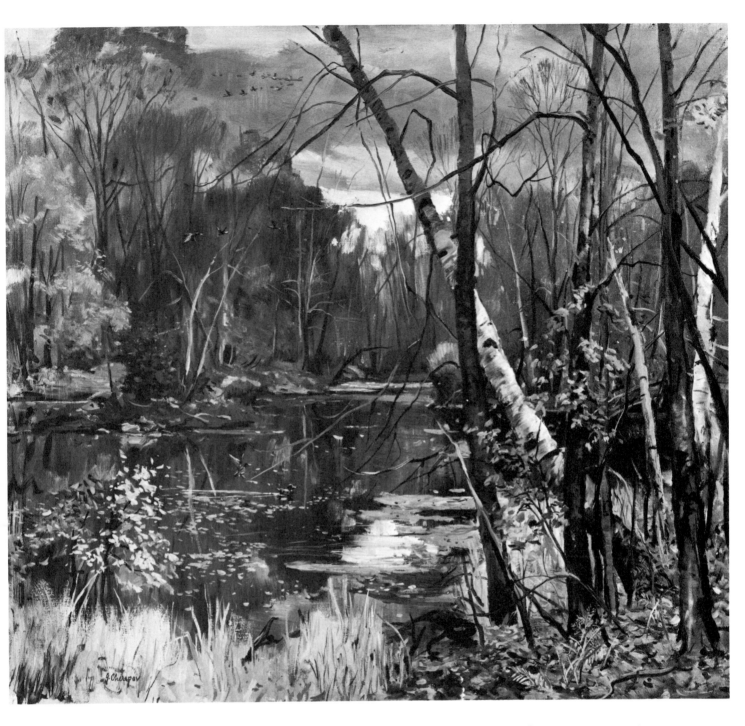

Duck Pond, *30" x 34". This space composition was analyzed and designed to express the intimate atmosphere of an enchanting pond in the woods. More space was allowed for the foreground, where the treetrunks and bushes have stronger colors and values, than for the colors on the opposite shore. The reflections under the influence of the distance (aerial perspective) are soft. The values in the painting are in very close and delicate relationship to one another; there are no strong contrasts. The highest value is in the light area of the sky, repeated in the reflection. The fallen birch trunk, usually seen as white, appears as a darker silhouette against the light sky. Courtesy Walter Wallace Galleries, Palm Beach, Florida.*

14. Parting Words

This book has covered a great deal about the art of oil painting; the most essential elements of painting have been analyzed and explained. It's difficult to present in one book, and to an audience with different levels of experience, this large volume of material — material which may require several years of intensive theoretical and practical work in art school. While some of the information may sound too difficult to follow for one reader, it may appear too elementary for another. But I hope that both beginner and advanced student, after reading and applying the methods suggested in this book, will benefit.

A difference of opinion exists about the proper method of teaching painting. Many teachers emphasize the need to preserve the individuality of the student. They encourage the student to "create" in the earliest stages of his study, cautiously protecting him against the influence of other painters. The advocates of this teaching method, who justify this approach as being their concern for the preservation of the student's individual creative freedom, seem to overlook the fact that the student isn't living in a vacuum, that he's constantly exposed to and influenced by his environment. The student instinctively seeks guidance, especially in his formative years. This is the time to offer him a constructive program of study of already existing methods of painting based on the experience of the past. In my opinion, the temporary influence of one or another good painter, regardless of period, doesn't destroy the student's creative ability; it may be, on the contrary, a helpful contribution to the development of his personal artistic expression.

Common sense, as well as years of painting and teaching experience, suggest a familiar method of teaching, in which the subject to be studied is divided into its separate parts. Starting first with the easier steps, the student is gradually guided to a higher level of achievement by adding more difficult material according to his capacity. Naturally, the more capable student will progress more quickly, and when he reaches mastership, he will begin to contribute to the improvement of existing ideas as well as to the development of new ones. It's the difference of personal ability between individual students which determines the learning speed and which makes a talented individual rise above the average to the stage of constructive creativity. The instruction of painting cannot be limited to the manual use of tools only and then followed by an immediate request for creative participation.

Many misunderstandings and unnecessary debates could be avoided if the vocabulary of the art field were correctly used. The meaning of the expressions "creative," "imaginative," "progressive," "contemporary," have become misleading through their application primarily to paintings of the abstract or nonobjective variety. To deny these attributes to painting done in a realistic manner, to label such painting old fashioned, passé, or reactionary is not only incorrect, it's not in the spirit of freedom in art.

The desire to search for new ways and a tendency toward detachment from traditions in painting is strongly emphasized at the present. At the same time, the formation of a representative twentieth-century style is of great concern to many. This moves me to offer a few thoughts to the reader on this subject.

We all know that certain periods of history have paintings which reflect the same style found in all the other art forms of the time — in sculpture, architecture, music, etc. Paintings of the Gothic period, for example, have a pronounced style which is also recognizable in architecture and sculpture. We not only see this style in the objects presented, but in their whole manner and composition as well as in the presentation of individual details (shapes, figures, faces, hands, the folds of the garments). The same can be said of the Baroque style, which is so rich and pregnant in its expression in architecture

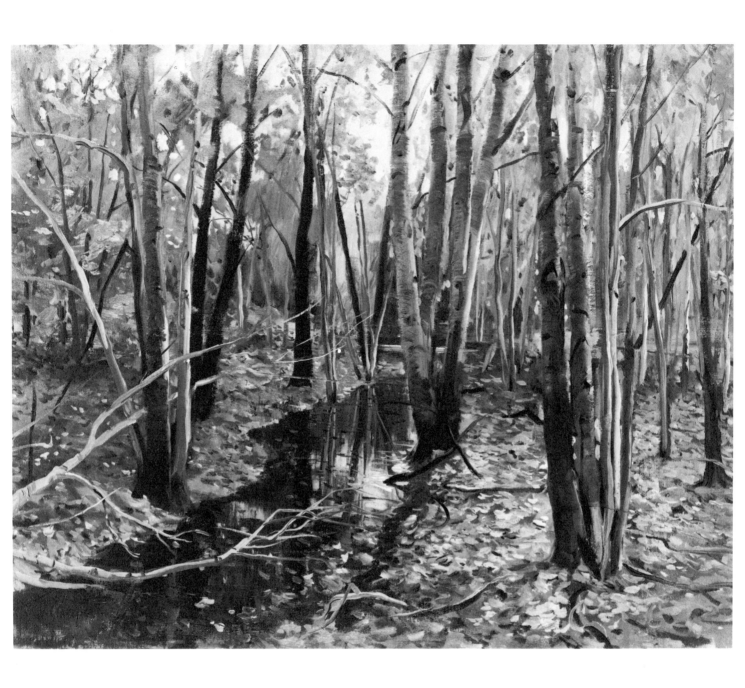

Silver Birch Grove, *24" x 30". The light color of the silver birch trunks against the autumn foliage created a unique mood, one which could only be captured on the spot in the direct method of painting. It was a challenge, in the short time available, to render the intricate design of trunks and branches in their relationship to perspective and to light and shade. First, the location of the dominant trees was indicated with a light color, then the distant plane (sky, woods, and ground) was painted with a large bristle brush. Then I worked on the trees in front and the reflections in the brook. To express the roundness of the birch trunks, I applied the paint in horizontal strokes. Private Collection.*

and music, and which found an equally strong, full expression in painting.

An intellectual wealth of imagination — works of art masterfully created — is preserved in museums and art galleries all over the world. The shining example of the eighteenth-century masters inspired and laid the foundations for schools of painting in the Western world. Students were exhorted to study, and very thoroughly, anatomy, perspective, and the manual technique of handling the material. At the end of the last century, a group of painters called "Les Fauves" (the wild animals) broke with academic tradition. They took the position that this long and thorough system of schooling set up by the academies repressed artistic intuition. They began to experiment; they gave more emphasis to the importance of color in the expression of light than to value relationships, and so detached themselves from the three dimensional, realistic presentation of objects. This movement has followers, and some painters to the present day are searching for a "new style" and a suitable trademark for it. Starting with the impressionists, a great variety of forms of painting has developed and been recorded: Impressionism, Pointillism, Expressionism, Futurism, Surrealism, Cubism, and many others. And an opinion which suggests that every painter today should conform to the present trend in art may be confusing, because styles are changing with increasing rapidity — in cycles similar to those of the fashion world. Obviously, this makes it difficult to form a constructive teaching method. It seems to me that every form of expression which develops now, in our time, which is based on the five basic elements of painting which I've outlined in this book, will certainly — and all by itself — reflect our time and thus be in a twentieth-century style.

The development of photography has influenced some painters to detach themselves from a realistic way of painting. One may draw the conclusion that all great works of art done by the masters of the past might not have come into existence if the camera had been invented in their time. The assumption that, by leaving the realistic form of expression to photography, one may escape its competition is wrong. Photography, too, is able to create abstract compositions through all sorts of technical methods. Does this mean that, because of the presence of photography, painting as a visual art should cease to exist? In spite of the mechanics, or perhaps because of them, photography has had difficulty receiving recognition as an art form on the same plane as painting. Even when the camera in the hands of an artist, a good painter has no reason to worry about competition!

While, in the past, painters chose their subjects from historical, religious, or otherwise significant events, and made a thorough study of them in order to render them in the most realistic way possible, many voices today oppose this approach, arguing that this descriptive kind of painting belongs to the field of literature and illustration. There are those who suggest that the subject matter and the planning of a painting ahead of time should be eliminated altogether, that similar to the musician who uses tone for purely abstract composition, a painter should use color and design as his only means of expression. While this philosophy may sound convincing in theory, applied to canvas it usually doesn't reach the understanding of a very broad audience. In music, it's not necessary to communicate a particular image; in visual art, however, a viewer instinctively seeks a familiar form in which to understand the message.

Above all, it's important for the art student to familiarize himself as much as possible with the best achievements of literature, music, and the performing and visual arts. This can have a deep influence on his growth as a painter and on his whole life. It will open the door to great treasure — treasure that has a magic fascination from which he will find it increasingly impossible to separate himself.

Index

H

I

L

M

N

O

P

R

S

T

glazing, 99; imprimatura, 97; palette knife, 99;
slow, 97, 99; slow demonstrated, 95-96; varnishing,
101
Texture, and brushstroke, 109-110
Tintoretto, 32
Tone drawings, 131-132; highlights in, 132
Triangle, the, in composition, 31-32

V

Value, 49-56; of color, 65; in drawing, 132
Vanishing point, 39
Varnishing technique, 101
View-finder, 115
Visual center, in composition, 31

W

White, 69

Edited by Margit Malmstrom
Designed by James Craig
Set in ten point Melior by Wellington-Attas Computer Composition, Inc.
Printed and bound by Halliday Lithograph Corp.

BRUNSWICK COUNTY LIBRARY
109 W. MOORE STREET
SOUTHPORT NC 28461